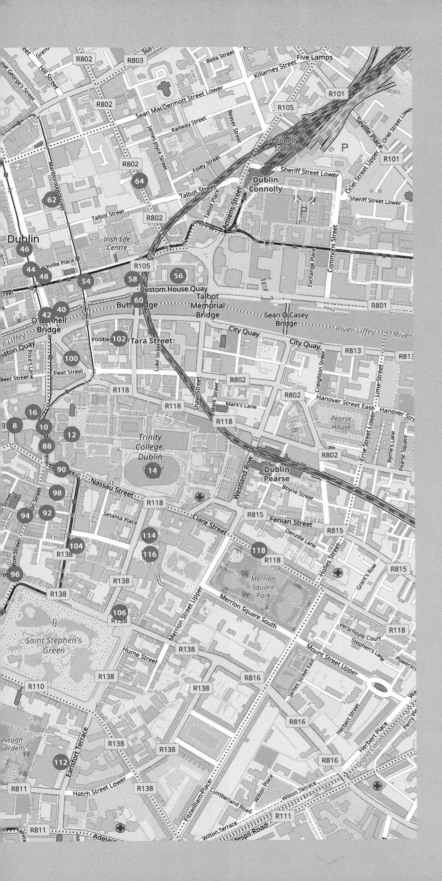

GW00500204

DUBLIN THEN AND NOW

You can find most of the sites featured in the book o

Numbers in red circles refer to the pages where sites appear
in the book.

* The map is intended to give readers a broad view of
where the sites are located. Please consult a tourist map
for greater detail.
Map is courtesy of www.openstreetmap.org

DUBLIN

THEN AND NOW®

ACKNOWLEDGEMENTS
There are a number of historians who I would like to thank for their assistance. Thanks to Orla Fitzpatrick who provided her photo history expertise, Ciarán Wallace who helped me pinpoint some tricky Dublin streets and junctions and John Gibney who gave me his practical advice for carrying out this project. Thanks to Kevin Kearns who generously gave permission for one of his images, Smithfield Horse Market, to be reproduced in this book.

We are lucky in Ireland to have access to rich photo archives. They are really wonderful resources. Thanks to staff at the National Library of Ireland and Dublin City Library and Archives who provided images for inclusion here.

I would also like to thank the staff at Pavillion Books Group for all of their guidance and assistance, particularly David Salmo who has shown great enthusiasm throughout this project.

I would like to thank my husband Ciaran for all his help and support. Thanks to my family for their continual interest in projects I am working on- to everyone in Cork, Dublin, London, Monaghan and Waterford. A special thanks to my nieces and nephew who gave me lots of excuses to take breaks from work; Mia, Skye, Cara, Eva, Abi, Ferdia and Katie. This book is dedicated to my Mum and Dad, Christina and John.

DUBLIN
THEN AND NOW®

LISA MARIE GRIFFITH

PAVILION

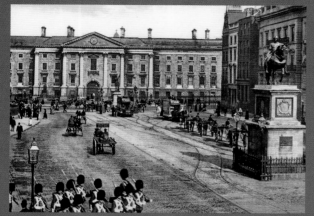

College Green, c. 1895 p. 8

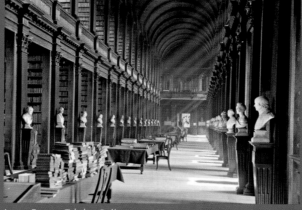

Long Room, Trinity College, c. 1895 p. 12

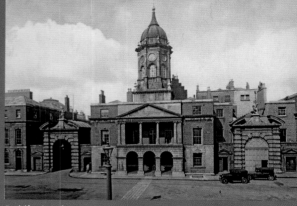

Dublin Castle, c. 1920 p. 20

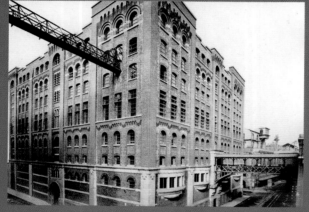

Guinness Storehouse, c. 1910 p. 30

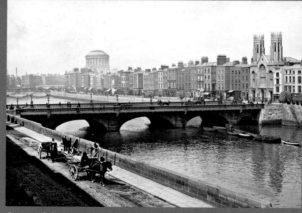

Ormond Quay, c. 1900 p. 38

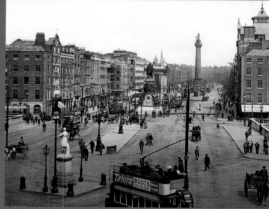

Sackville Street and Carlisle Bridge, c. 1900 p. 42

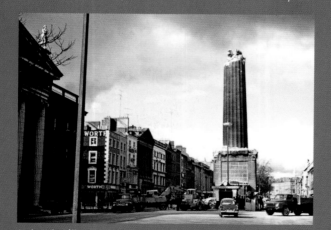

Nelson's Pillar, 1966 p. 46

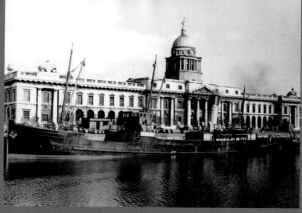

Custom House, c. 1950 p. 56

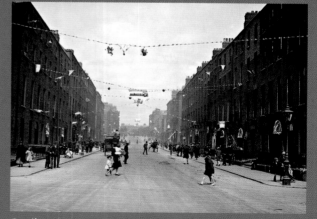

Gardiner Street, 1929 p. 64

Dublin Zoo, c. 1900 p. 78

Ha'penny Bridge, 1947 p. 82

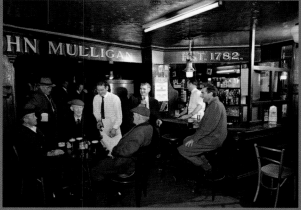

Mulligan's, 1970 p. 102

Mansion House, c. 1910 p. 104

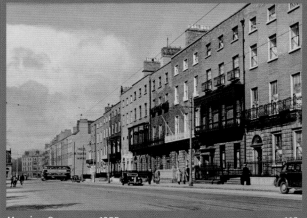

Merrion Square, c. 1955 p. 118

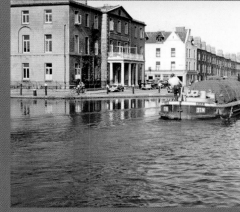

Grand Canal, Portobello, 1959 p. 124

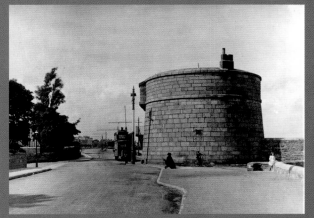

Sandycove Martello Tower, c. 1910 p. 128

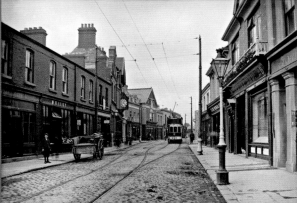

Castle Street, Dalkey, 1910 p. 130

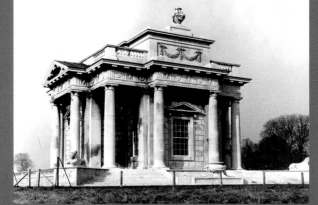

The Casino at Marino, c. 1910 p. 140

DUBLIN
THEN AND NOW INTRODUCTION

The most significant geographical boundary in Dublin is the river Liffey which divides the city north and south. As well as being an important method of transportation and communication, the river was probably the reason that some of Ireland's earliest inhabitants chose this area. The earliest settlement in this part of Ireland was called Áth Cliath (Ford of the Hurdles) and these early Dubliners fished on the Liffey. The modern Irish name for the capital, Baile Átha Cliath, owes its origins to this early settlement (Baile meaning 'town'). The Liffey also attracted the Vikings to the area. A Viking longphort (or winter settlement) was established in this area by AD 841. These Vikings were pushed out by locals but they returned in AD 917, and there has been continuous settlement in Dublin ever since. An early Christian monastery was established in this area in the ninth century called Dubhlinn (Black Pool). It was close to the Viking longphort (on the current site of Dublin Castle) and gave rise to the modern anglicised name of the city.

Although Dubhlinn was a significant settlement in its own right before the arrival of the Anglo-Norman War in the twelfth century, it was a visit from the English king, Henry II, that would help to make Dublin the most important settlement on the island. Henry II proclaimed himself king of Ireland and made Irish chieftains and the Anglo-Normans pay homage to him at Dublin. In the early thirteenth century Dublin Castle was built on the orders of King John, and the castle, and subsequently the city, became the seat of royal power in Ireland. This made it the political centre of Ireland and the centre of Irish trade and communications with England.

While the English colony declined during the fourteenth and fifteenth century a re-conquest of the island was undertaken by the Tudors in the sixteenth century. This brought Ireland more closely under English rule than ever. Dublin Castle was home to the Viceroy (the king's commander in chief in Ireland) and so was the source of much of this change. When Henry VIII broke ties with the Roman Catholic Church and began to create his own Anglican Church, attempts to convert the Irish people also came from Dublin. The city's churches and cathedrals were seized by the government, and if the clergy did not conform, Anglican clergy were installed. A Protestant university was founded to provide ministers for this new religion. While this gave Ireland the appearance of

a Protestant country, much of the population refused to conform and the Catholic Church moved underground.

The city did not flourish under these circumstances. In the late seventeenth century, in an attempt to suppress Catholics, who were at the centre of these rebellions, a Protestant parliament located in Dublin began to pass a series of repressive anti-Catholic laws which became known as the penal laws. Over a hundred years of peace followed. Ireland also boomed economically and what followed were decades of growth and expansion in Dublin. It was during this period that some of Dublin's most architecturally significant buildings were erected. As well as improving the overall aesthetic of the city, these buildings influenced architecture and design in Britain and America. Three-storey, terraced, red-brick houses were erected in the city's residential estates. These houses make up the city's celebrated Georgian core. They would become home to some of the city's most celebrated figures such as Thomas Moore, Oscar Wilde and Daniel O'Connell.

In the aftermath of the Act of Union in 1801, when the Irish parliament was dissolved and Irish MPs moved to Westminster, Ireland went into economic decline. Ireland's gentry moved out of the city to the countryside or to England. The city's most beautiful Georgian buildings became tenements for Dublin's poorest inhabitants. The buildings were gutted and subdivided.

The famine (1845-49) marked a watershed in Irish politics. It drove many of the countryside's poor population to cities, including Dublin. The historic pictures in this collection date from the 1870s, when the effects of the famine were still being felt. While industrialisation is evident, and the trams and railway give the city an appearance of a thriving modern European capital, Dublin struggled financially. Belfast was, by this time, the capital of Irish industry. Irish politics resided in Westminster. Irish people were emigrating to North America, Australia and throughout the British colonies. Irish nationalism was gaining wide support, and nationalists such as Charles Stewart Parnell were calling for the right of Irish people to govern themselves in a parliament located in the Irish capital. The influence of politics could clearly be discerned on the streets on Dublin. Statues to Irish nationalist leaders were erected

by Dublin City Council on principal thoroughfares such as Sackville Street (O'Connell Street today) and College Green while statues of the British royalty were confined to private institutions.

Politics spilled on to the streets in 1916 when Irish republicans seized key buildings across the city and proclaimed a republic in Ireland. Although their rebellion lasted just six days, it prompted a larger and longer conflict with the British during the War of Independence (1919-1921) and brought the army onto the streets of Dublin. This conflict led to the foundation of the Irish Free State in 1921, which provided a practical, but not total, independence for twenty-six of the thirty-two counties on the Island. Dublin would be the capital of this new state.

The treaty signed with Britain did not lead to a full peace, however, and a minority of Irish republicans fought on seeking recognition for a full republic on the whole island. During the Civil War that resulted the rebels were defeated by the new state. When the civil war ended in 1922, the capital was badly damaged and the country in debt. Some of Dublin's most important architectural buildings such as the Four Courts, the GPO and the Custom House had to be rebuilt. Ireland remained an economically underdeveloped country for much of the twentieth century. Agriculture, the mainstay of the Irish economy throughout the nineteenth century, remained the largest export. The dominance of agriculture could be seen on the capital's streets where horses and carts were used to transport food and produce around the city.

The country remained neutral in World War II when tourism became an important source of income. Some of the photographs in this collection were shot to entice international visitors to Ireland. In the second half of the twentieth century the Irish diaspora began to return and visit Ireland to discover their roots, and many made their way to the capital's archives (including the National Library of Ireland) to find traces of their ancestors.

Ireland joined the European Economic Community in 1973 which helped to develop the country's infrastructure and economy. By the late 1990s Ireland was experiencing unprecedented growth, and technology, financial services

and the property market all expanded at a rapid rate. This led to a further wave of building and development, which can be seen most clearly in the modern photographs in this collection. This growth was abruptly halted in 2008 when Ireland, along with many of the world's economies, went into recession. Over the last few years there has been more investment in infrastructure. This is reflected in the expansion of the Luas tram lines. The tram now runs across the city, from the south suburbs to Dublin airport in the north of the city.

As well as marking the historic timeline of the capital, the photographs in this book also reveal many cultural and literary connections. Dublin has been home to many intellectuals and literary figures such as Edmund Burke, Oliver Goldsmith, W. B. Yeats and Edna O'Brien, and it was the birthplace of Jonathan Swift, Oscar Wilde, George Bernard Shaw, Samuel Beckett, Brendan Behan, Anne Enright and Roddy Doyle. James Joyce is the writer most closely linked with the capital, because his novels are set on Dublin's streets. Joyce was said to have proclaimed 'when I die Dublin will be written on my heart'. *Ulysses*, Joyce's greatest novel, is the story of two men walking the streets of the city over the course of a day, and is a useful reminder that Dublin is best viewed and appreciated on foot. To walk the streets is to see what these great writers saw and what they were influenced by. Dublin is a historic city, one with culture very much at its heart.

The photos in this collection reveal the changing face of the city, its expansion, its modernisation, the impact of industrialisation and developments in transportation. If you look more closely you will see the political and religious changes in the country as well as the scientific achievements and literary events that occurred on the streets of the capital and within its buildings. These photos also allow us a glimpse of what day-to-day life was like for ordinary Dubliners: what they wore, where they worked and how they made their way across the city and through their lives. They offer an opportunity to view how Dubliners of the past lived, how they live today and what has changed in the intervening years.

c. 1895

COLLEGE GREEN

Named in the 1590s after the green outside Trinity College

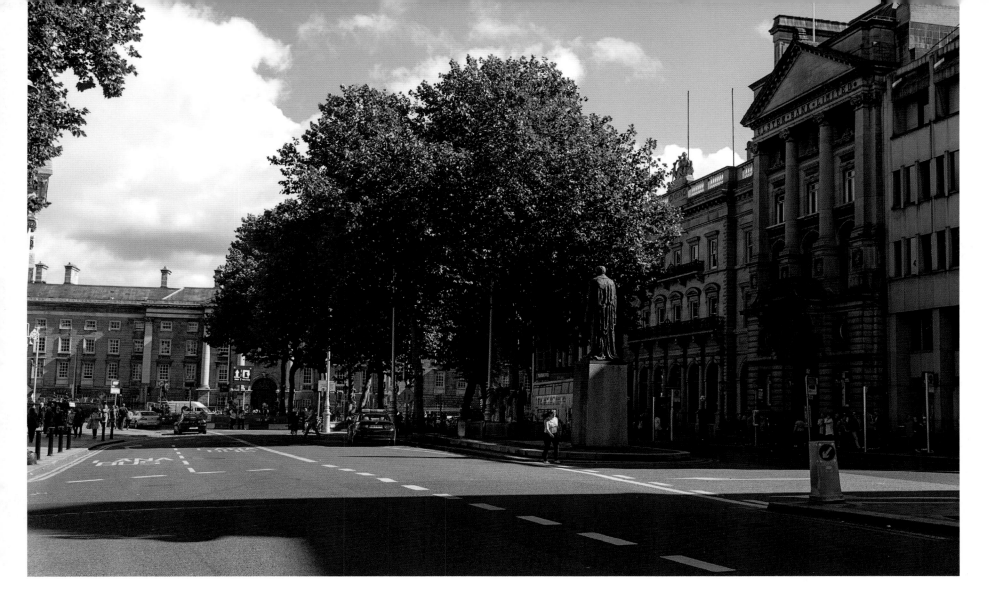

LEFT: College Green lay outside city boundaries, and the area was used as a burial ground from Viking times to the fourteenth century. It became known as College Green when Trinity College Dublin was established there in the 1590s. In the seventeenth century the Irish parliament took up residence in a townhouse on the square. The townhouse was replaced by a purpose-built parliament house in the eighteenth century and parliament stayed on the square until it was dissolved by the Act of Union in 1801. College Green became an important site for displaying loyalty to both the British monarch and the Protestant faith. These displays centred on the statue of King William (right foreground of this picture), who was considered defender of that faith. Less visible in this image is a statue of Henry Grattan from 1876. Grattan led the legislative independence movement in the Irish parliament, which resulted in a 1782 law prohibiting British interference in the Irish parliament. The two statues represent two opposing political strands in Irish politics, unionism and nationalism.

ABOVE: College Green has remained a central and busy part of the city. Many of the great buildings depicted in the original photograph remain, but one of the significant changes to this area was the removal of King William's statue. The statue had a long history of being defaced. In the eighteenth century, Trinity students would often play pranks on the statue. It had a religious and political symbolism for those Catholics who could not sit in parliament until 1829 and for those nationalists who called for greater freedom from Britain. In 1928 the statue was blown up by republicans. While the statue was not completely destroyed, it was deemed too much of a target for republicans and was removed. Grattan still oversees College Green and is a reminder of the political history of the green. He is joined by Thomas Davis, a Young Irelander, whose statue was erected in 1966. In 2015, during building works to lay tracks for the Luas tram system, Viking bones were uncovered at College Green, just outside the gates of Trinity College, a reminder of how long this part of the city has been inhabited.

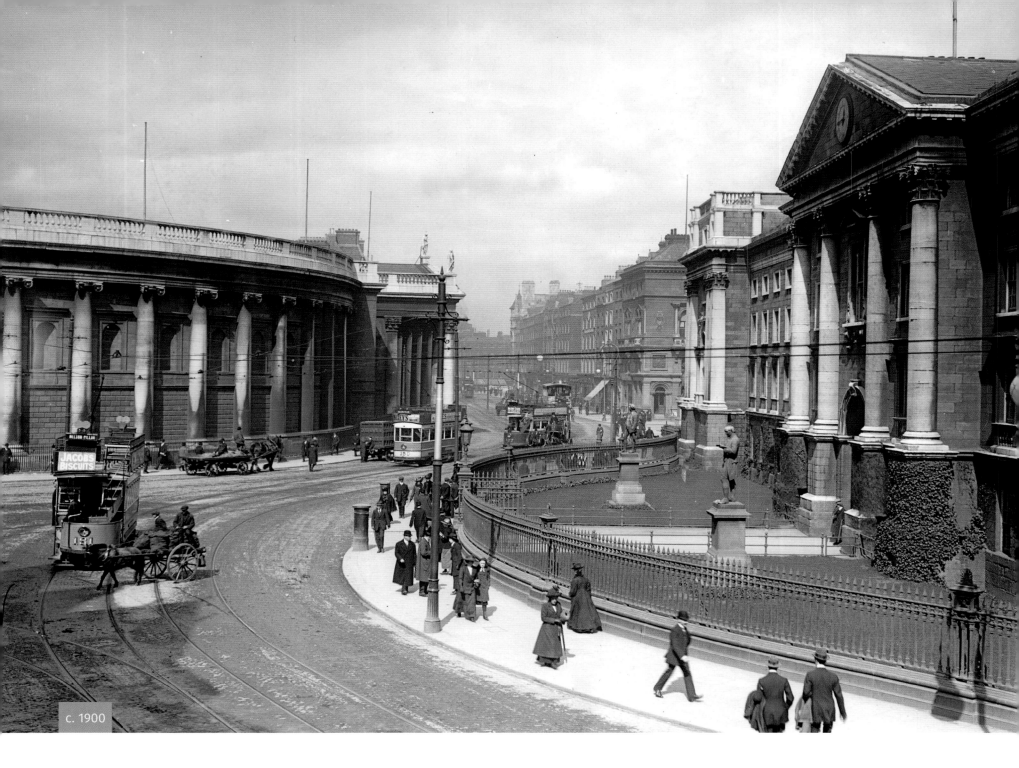

c. 1900

COLLEGE GREEN AND WESTMORELAND STREET FROM GRAFTON STREET

An important tram route has been reinstated in the twenty-first century

c. 1962

LEFT: The Irish parliament, seen at left, was completed in 1739, while the west front of Trinity College, right foreground, was finished in 1759. When they were completed this vista was considered one of the finest in Ireland. The country experienced an economic boom in the eighteenth century, and parliament found itself with revenue surpluses, which were reinvested in public buildings such as these. Many of the city's finest buildings date from the Georgian period. Westmoreland Street, which ran north from the parliament house, acted as an important avenue and joined College Green, a political and educational hub, to Sackville Street (now O'Connell Street). The trams in the picture are travelling from the river Liffey to the terminus on Sackville Street. The tram to the fore of the image advertises Jacob's Biscuits, a company which was founded in Waterford city in 1851.

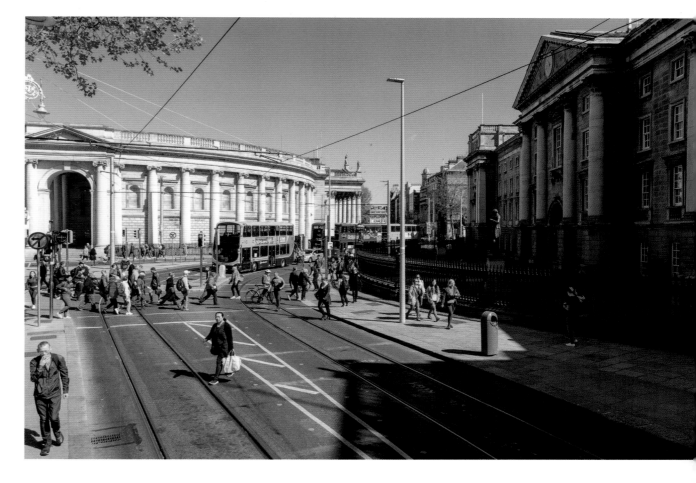

c. 1966

ABOVE: Westmoreland Street has remained a busy avenue. It connects the busy commercial south side of the city to the north side. Horse-drawn trams were in use in Dublin from the 1870s, and by 1901 the majority of trams were electric. They were an important method of transport for the city and ran from parts of County Dublin through the suburbs to the city centre. From the 1920s buses began to eclipse trams and on 9 July 1949 the last tram ran in Dublin city centre. Traffic congestion, which has always been a problem in the city centre, worsened into the late twentieth century, and by the 1990s Dublin Corporation was discussing the return of the tram. In 2004 the Luas, Dublin's twenty-first century tram, arrived in the city centre, and in 2017 the tramline returned to College Green to once again connect the south-central city to the north, this time crossing the Rosie Hackett Bridge.

LONG ROOM, TRINITY COLLEGE DUBLIN
The largest single-chamber library in the world

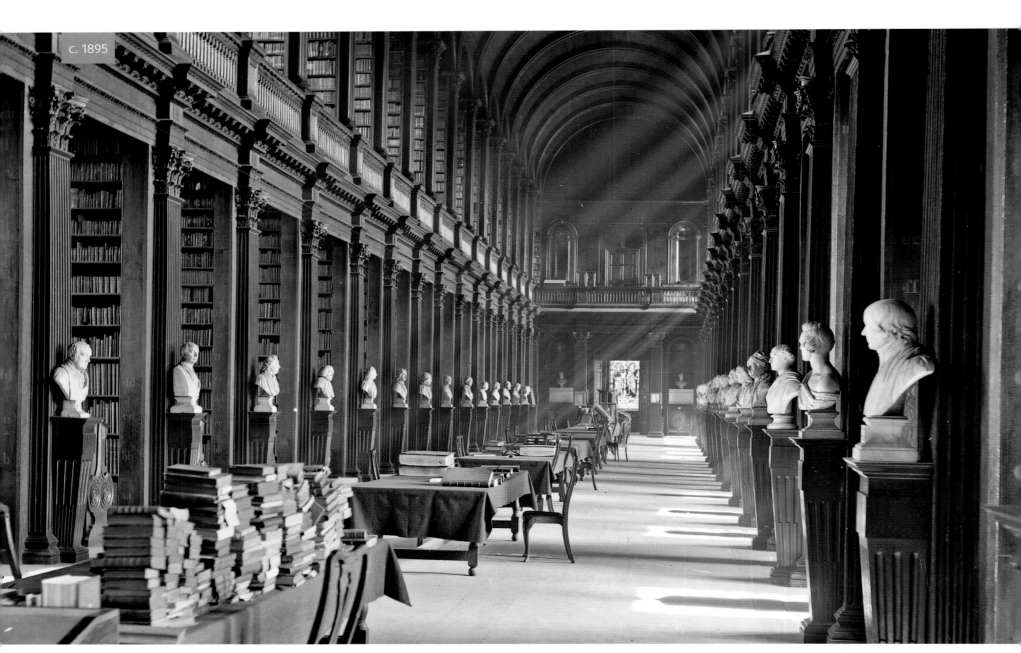

c. 1895

LEFT: Trinity College Dublin was founded in 1591 and is the oldest university on the island of Ireland. By the 1690s the original library was in bad condition and in 1709 parliament granted £5,000 for a new library. Two more grants of £5,000 had to be given to finish Thomas Burgh's Library Building, which was completed in 1733. The Long Room is the name given to the main reading room within the library. Fourteen marble busts of great western philosophers and writers were added to the library in 1743 and can be seen in this picture. In 1801 it became a copyright library, meaning that one copy of every book printed in the British Isles is held by the library. This put huge pressure on space within the building. The layout was altered and a second floor added to accommodate these books. These alterations were carried out in the mid-nineteenth century by architects Thomas Dean and Benjamin Woodward. They added a barrel oak-vaulted ceiling, which dramatically altered the view of the Long Room and, although it was controversial at the time, enhanced an already beautiful room.

BELOW: The Long Room remains one of the largest single-chamber libraries in the world but it is not Trinity's only library. By 1908 there were more than 300,000 books in the library and storage had become a problem once more. The university favoured building a new library, but this plan was disrupted by the outbreak of World War I. In 1920 a new library was opened in Front Square, with a Hall of Honour at the entrance listing the names of Trinity's 450 staff, students and graduates who died fighting in the war. The library building is also home to the Book of Kells. These are four gospels dating from the ninth century that are elaborately decorated with Irish and mythical birds and animals. The library is an important, internationally recognised research centre and a major visitor attraction. Over 500,000 people visit the library each year. Representations of the library have been used in films and it is believed that Lucasfilm borrowed heavily from its appearance to create the Jedi library in *Star Wars, Episode 2, Attack of the Clones.*

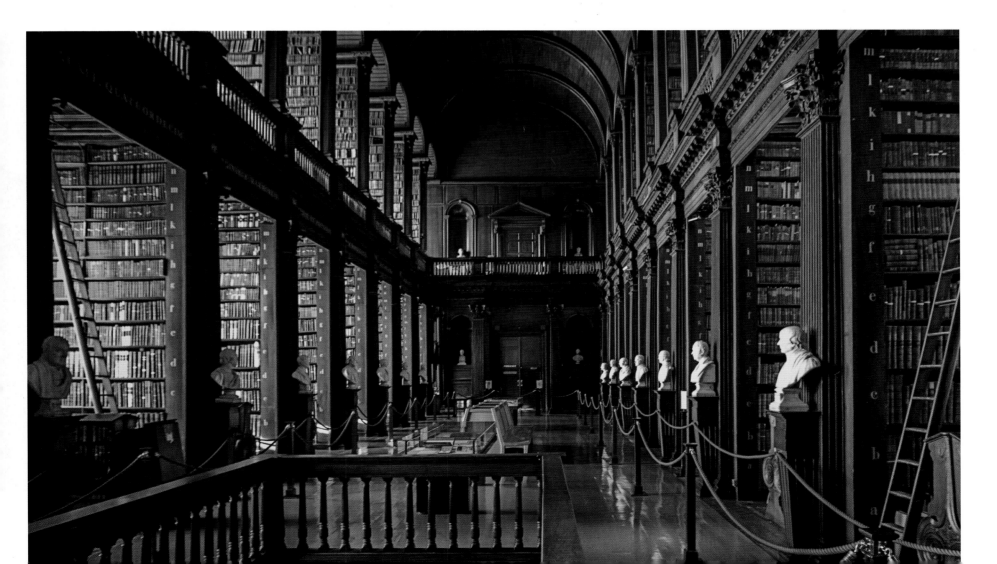

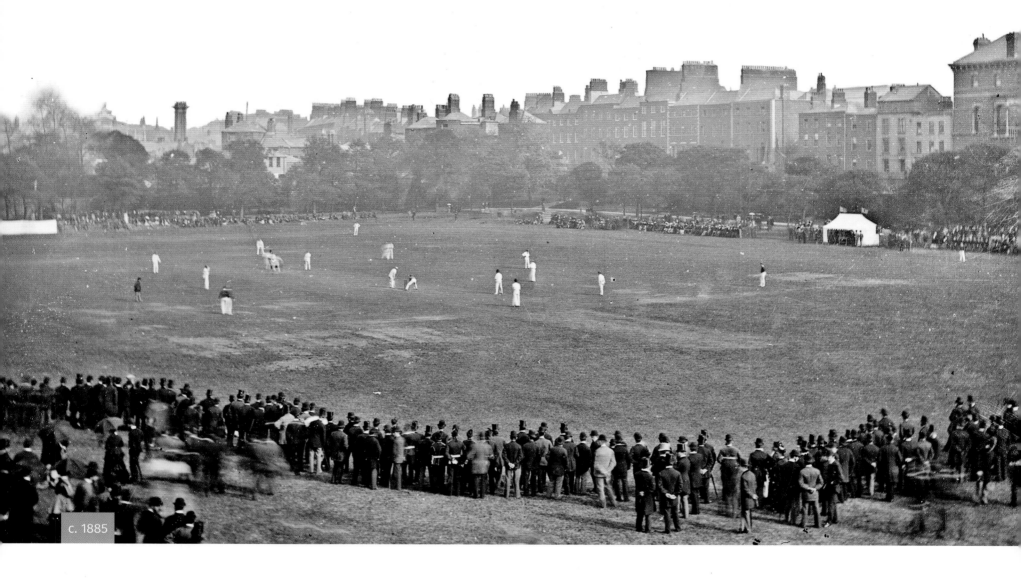

c. 1885

CRICKET PITCH IN COLLEGE PARK, TRINITY COLLEGE

Cricket was popular in the nineteenth century and is making a comeback

ABOVE: Trinity College Dublin has been described as 'one of the most significant centres of sport in Ireland' by sports historians Mike Cronin and Roisín Higgins. By the eighteenth century the university had bowling greens and tennis courts, and in 1842 the cricket pitch was laid out in College Park. A rugby pitch was added in 1854 (it lies just outside this photograph). Cricket was a popular Irish sport in the nineteenth century and into the early twentieth century. During this period, sport was modernised. Organisations were established to provide rules and a framework for games. Clubs were formed. The University Athletic Club was founded in 1872 to organise and promote sport in Trinity. It was highly successful and raised enough income to build a pavilion clubhouse. The building was designed by Thomas Drew and cost £1,500. It was added to the east end of the cricket pitch in 1884, a few years after this photo was taken.

14

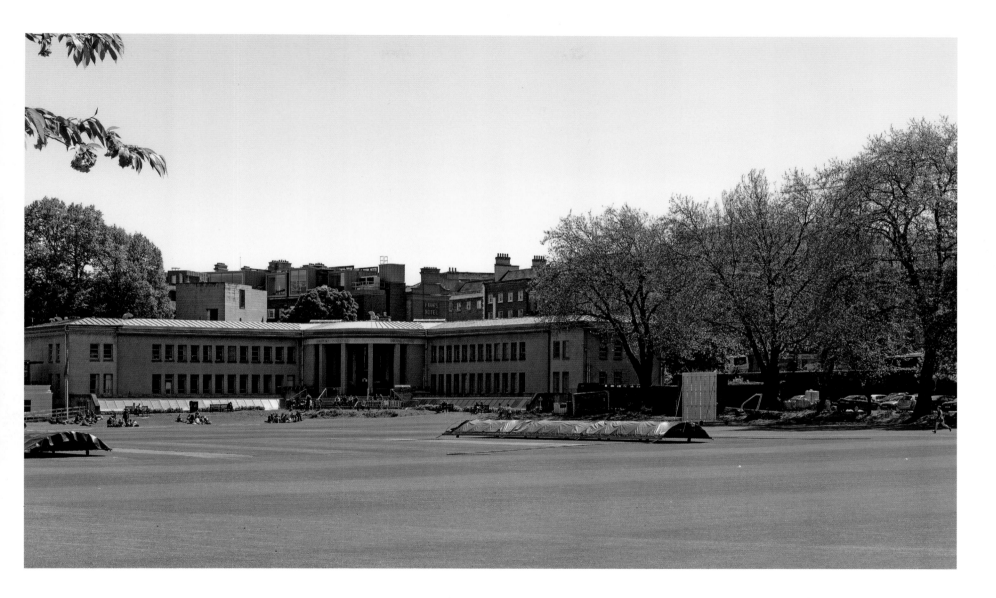

ABOVE: In the years after this photo was taken in the 1880s, sport in Ireland was badly affected by the politics of the day. During World War I sheep were put to graze on the cricket pitch, while the tennis court was abandoned. Although the Gaelic Athletic Association (GAA) was not political when it was founded in 1884, it was infiltrated by nationalists and became politicised in the aftermath of the 1916 rising. The GAA undermined cricket, one of the most popular games played in Ireland, and cultural nationalists favoured Irish sports such as hurling and Gaelic football. Cricket lost players and supporters, and the game was increasingly seen as a Protestant imperial sport. During the War of Independence fighting broke out on nearby Nassau Street, and a gunman opened fire through the railings, hitting and killing a female student who was watching a cricket match in College Park. Although cricket lost many supporters in the century since the first image was taken, it is still played throughout Ireland, and in the past decade the Irish cricket team has had great international success. In 2017 they became the eleventh nation to be awarded Test cricket status and narrowly lost their first Test, a match against Pakistan, in 2018.

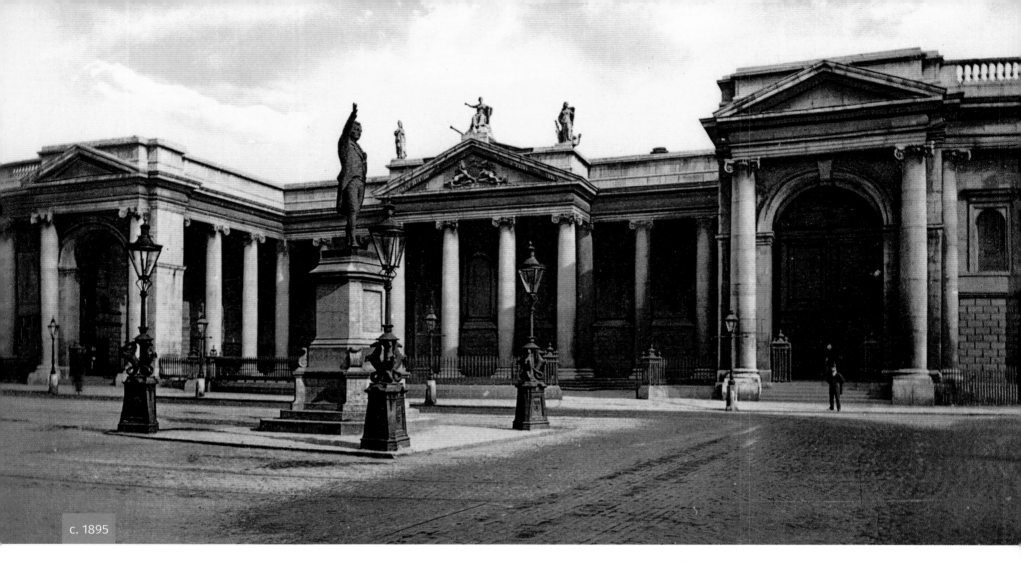

c. 1895

PARLIAMENT HOUSE / BANK OF IRELAND, COLLEGE GREEN
A building said to have influenced the design of the U.S. Capitol

ABOVE: By the early eighteenth century Chichester House on College Green, home of the Irish parliament, was falling down. Parliament allocated £6,000 from the national budget to construct a new purpose-built parliamentary house on College Green, which they started in 1729. This new home was completed in 1739, for the then-colossal sum of £34,000. Parliament would only spend another sixty-two years in the building. In 1801 the Irish parliament passed the Act of Union and voted itself out of existence. The Bank of Ireland bought the building in 1803 and set about transforming

the interior to make it serviceable as a bank. Despite this change in ownership, the building was closely linked in many Irish minds with the parliament they had lost. Rallies for the Repeal movement (which sought to overturn the Act of Union) and later the Home Rule movement, were held on College Green. The insignia of the nationalist newspaper *The Freeman's Journal* was the sun rising behind the building. The inset photos show the 1876 Henry Grattan statue outside.

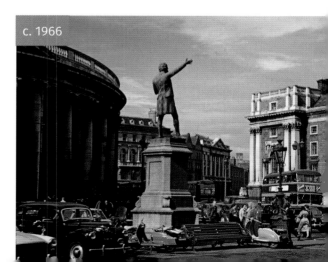

c. 1966

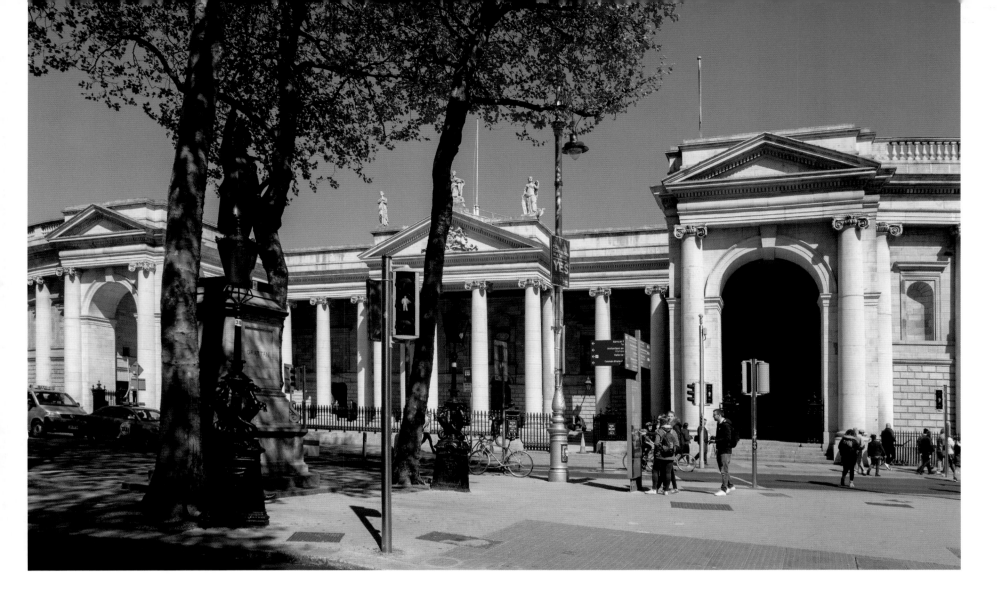

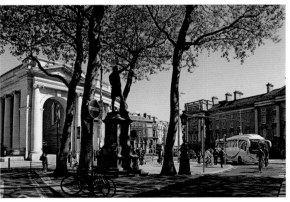

ABOVE: The building has a significant place in Irish architectural history, and Edward Lovett Pearce, the building's architect, has been described as the finest architect in Irish history. His design was recognised internationally as important. Sir Robert Smirke borrowed heavily from the design of the parliament house when he designed the British Museum. Capitol Hill in Washington, D.C., built in 1793, was also strongly influenced by the design of the Irish parliament house. While some people wanted parliament to return to College Green when the Free State was established in 1922, Bank of Ireland was not as keen to give up its headquarters. The bank has been in the building twice as long as parliament. Parliament found its new home in Leinster House, where it remains to this day. Bank of Ireland still owns the building. Although the chamber of the House of Commons was altered after the bank bought the building, the chamber of the House of Lords is intact and open to the public.

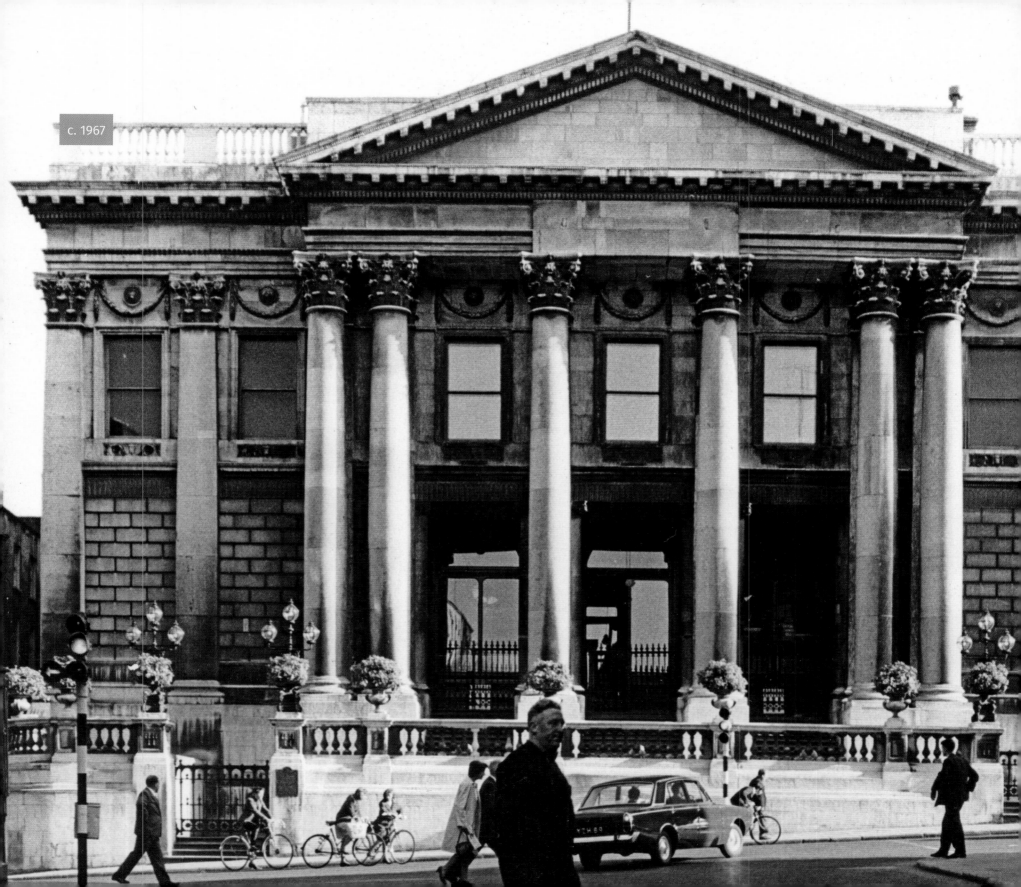
c. 1967

CITY HALL
Originally built as the Royal Exchange

LEFT: In 1761 a group of Dublin merchants founded the Committee of Merchants. Ireland's international trade expanded dramatically in the eighteenth century, and city merchants sought to better organise and represent this trade. They felt that parliament, in particular, often ignored their voices. The location of the Royal Exchange, which the merchants built, in front of Dublin Castle, indicated that they sought to align themselves with the Viceroy (the king's representative in Ireland), who resided in the castle, rather than with parliament. The building's design was selected by competition, which was won by Thomas Cooley, a little-known British architect. James Gandon, who was yet to put his mark on the city, came second. The building was completed in 1779. It was an important site for city-wide meetings, but by the middle of the nineteenth century trade had declined and the building had fallen into disuse. It was purchased by Dublin Corporation, and in 1852 it became Dublin City Hall. Irish nationalist figures Charles Stewart Parnell, Jeremiah O'Donovan Rossa and Michael Collins all lay in state in Dublin City Hall before being interred at Glasnevin Cemetery.

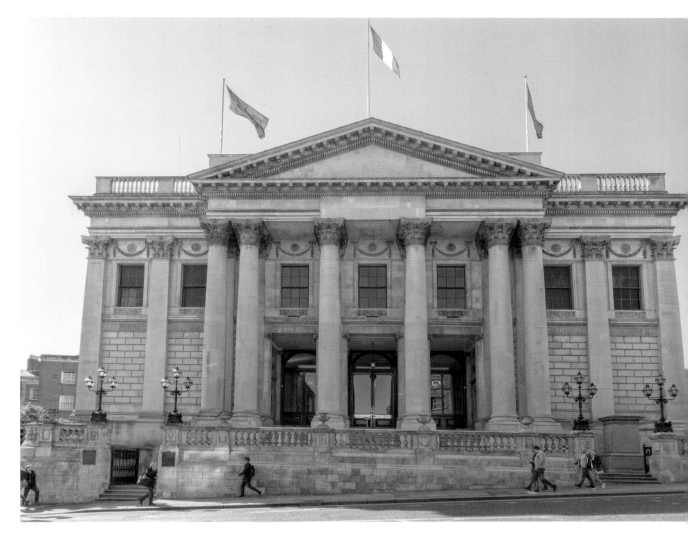

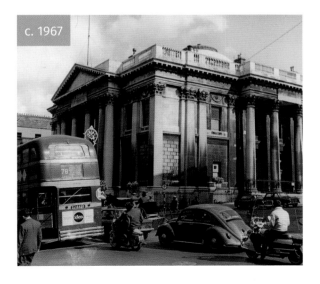

c. 1967

ABOVE: City Hall is located on Dame Street, one of Dublin's busiest thoroughfares. When Dublin Corporation purchased the building it divided the building's beautiful main entrance into partitioned offices. The building underwent extensive restoration work between 1998 and 2000. A key part of that work was restoring the main entrance to its original appearance. That original design and rotunda can now be appreciated. A floor mosaic in the centre of the hall displays Dublin's coat of arms and the city motto, *Obedientia Civium Urbis Felicitas*, which translates as 'obedient citizens, happy city', and dates to the seventeenth century—a period when rebellions led by Dubliners were more common. Dublin Corporation became Dublin City Council, which continues to use the building (which is open to the public), and Dublin councillors hold their meetings in a chamber on the top floor. City Hall is now a popular venue for weddings, festivals and other events.

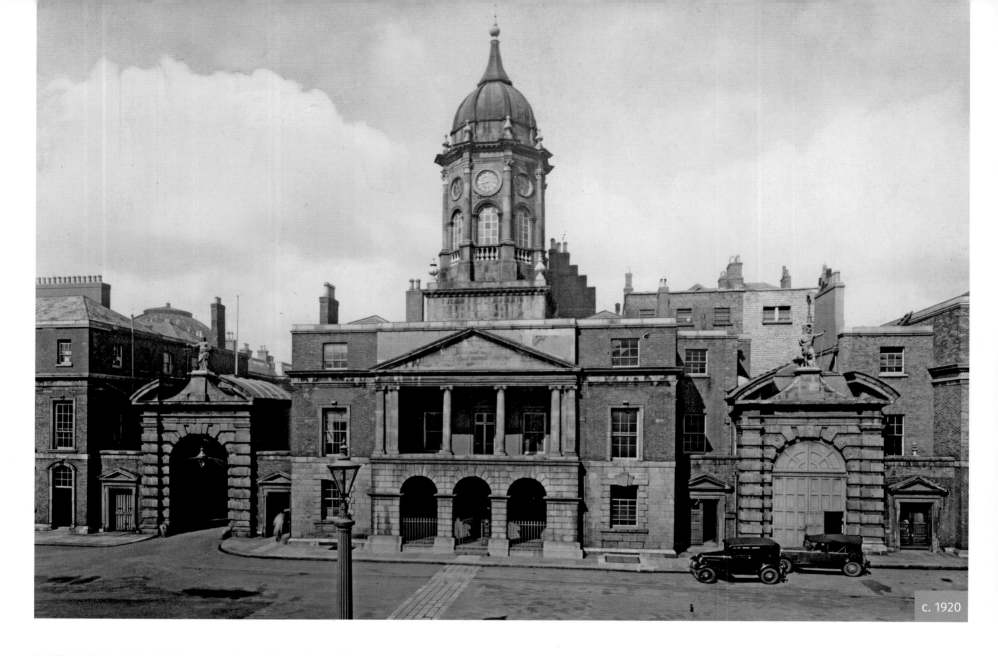

c. 1920

UPPER YARD, DUBLIN CASTLE

A castle built piecemeal over the centuries

ABOVE: Dublin Castle dates from 1204, when King John decreed that a castle be built in Dublin to defend the city and the monarch's interests. The castle would be occupied by the Viceroy, who was the King's representative in Ireland. A moated enclosure was built, and while little of this medieval castle has survived, we know it stood where the castle's upper yard (depicted in this image) now lies. Offices including the treasury were located in the castle, making it more of an administrative centre than a residential palace. The building was improved and expanded in a piecemeal fashion, depending on the finance of any given monarch and the energy of the Viceroy. The upper yard dates largely from the eighteenth century and this image features the Chief Secretaries Office, which was constructed in the 1740s. After the Act of Union in 1801, Dublin Castle became the centre of politics in Ireland. The castle was a busy complex, with government officials coming and going at all times.

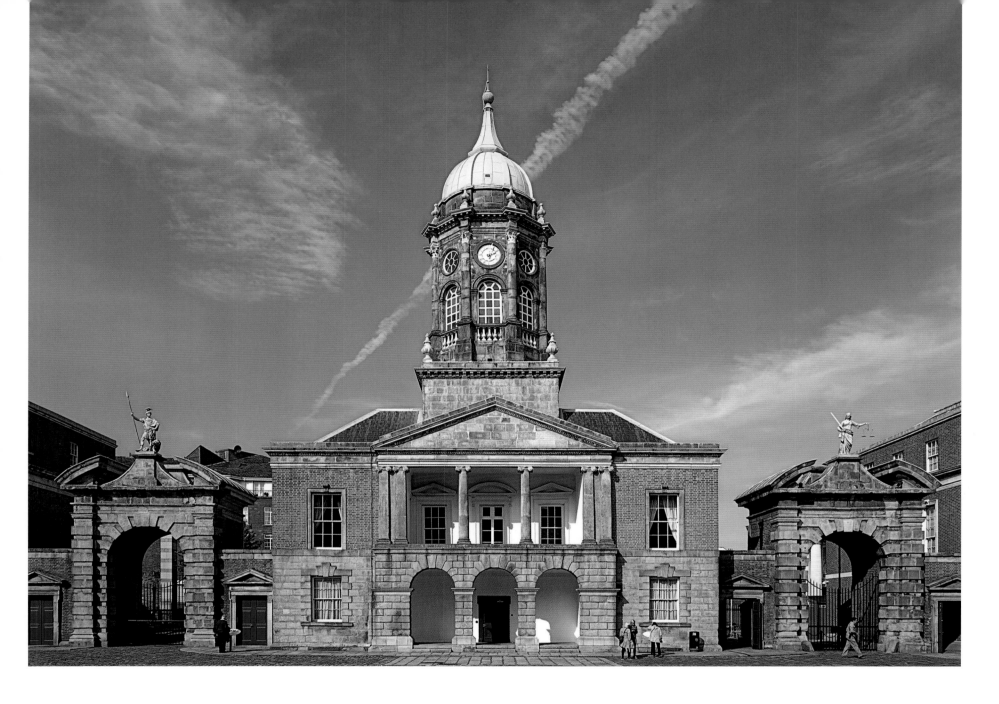

ABOVE: Historically Dublin Castle had often been a major focus of attacks and rebellions. An attempt to take Dublin Castle during the 1916 rising failed. The castle was central to the British effort to suppress Irish republican forces during the War of Independence. The Dublin Metropolitan headquarters and British Army Dublin Command were located in the castle. As the fighting progressed, they were joined by the often brutal auxiliary police force. G-Division, the office where the British government collected information against republicans, was also housed within the castle walls. David Neligan, a Dublin policeman, joined the G-Division in 1919. His republican sympathies grew, however, and he fed intelligence to the republican leader Michael Collins throughout the War of Independence. As republicans gained the upper hand, Neligan said that British officials 'lived in terror of their lives' and were afraid to leave the safety of the castle. On 16 January 1922, at a ceremony in the upper yard, the British government handed the castle over to Michael Collins, and the Free State was founded.

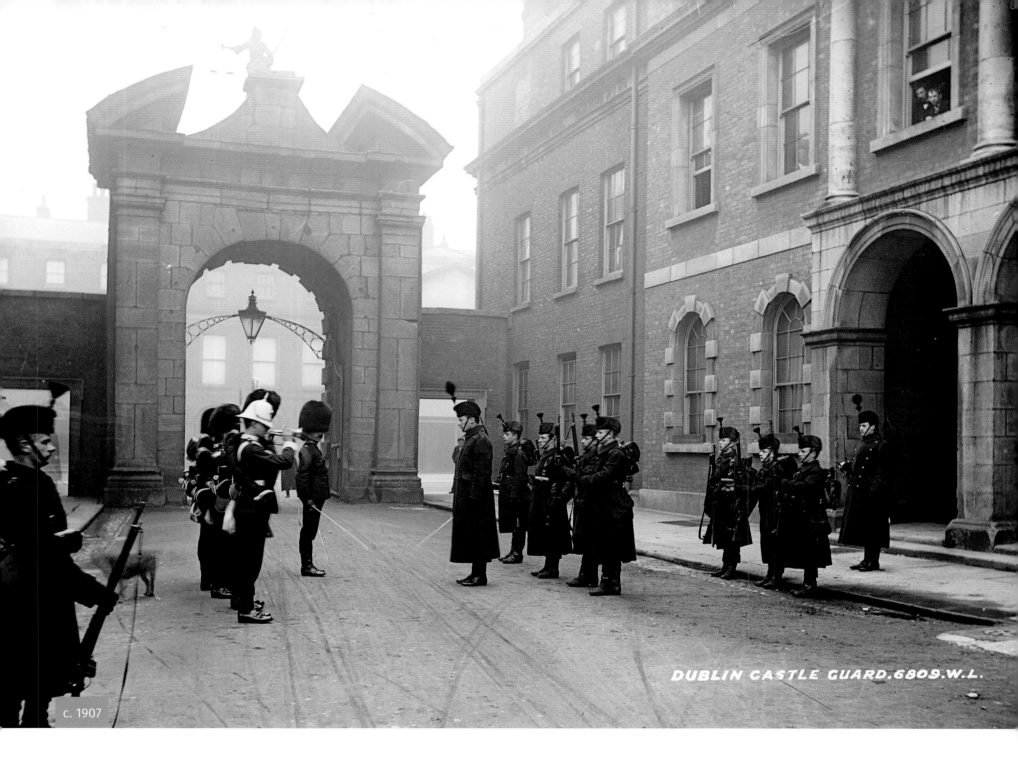

c. 1907

DUBLIN CASTLE GUARD. 6809.W.L.

DUBLIN CASTLE, CASTLE STREET ENTRANCE
Previously guarded by the 'Irish Beefeaters' known as the Battle Axes

LEFT: The Battle Axes were the force dedicated to protecting the castle and can perhaps best be described as the Irish Beefeaters. In the late eighteenth century a guard house was added to the complex on Castle Street, where a changing of the guard took place each day. The Battle Axes were disbanded in 1831 due to the cost of maintaining this unique castle force. They were replaced by twenty-four RIC (Royal Irish Constabulary) sentries. The men in this image are military, however. It is often forgotten that many Irish men served in the British Army, and the military provided welcome jobs for many Irish families. The statue above the castle entrance is the personification of Justice. It is a controversial statue—nationalists used her as a symbol of British rule in Ireland. Although the statue overlooks the work being done in the castle, it was pointed out that she had her back to those outside the castle, ignoring their presence.

ABOVE: One of the biggest scandals to hit the Dublin Castle administration occurred shortly after this photograph was taken in 1907, when the Irish crown jewels were stolen from under the nose of Sir Arthur Vicars, Chief Herald. When the theft was investigated, it was uncovered that Vicars had been hosting homosexual parties in the castle late at night. The story was covered up so as not to cause the castle administration more embarrassment. The jewels were never found, and their disappearance remains one of the great mysteries of Irish history. There are a number of museums within the castle complex today, including the Garda Museum, the Revenue Museum and Chester Beatty Library. The castle gardens were restored in the 1990s. About 300,000 tourists visit the State apartments each year. Key government offices still operate from here, including Irish Revenue, and the castle is used when Ireland hosts the presidency of the EU. It is also used for state banquets and events.

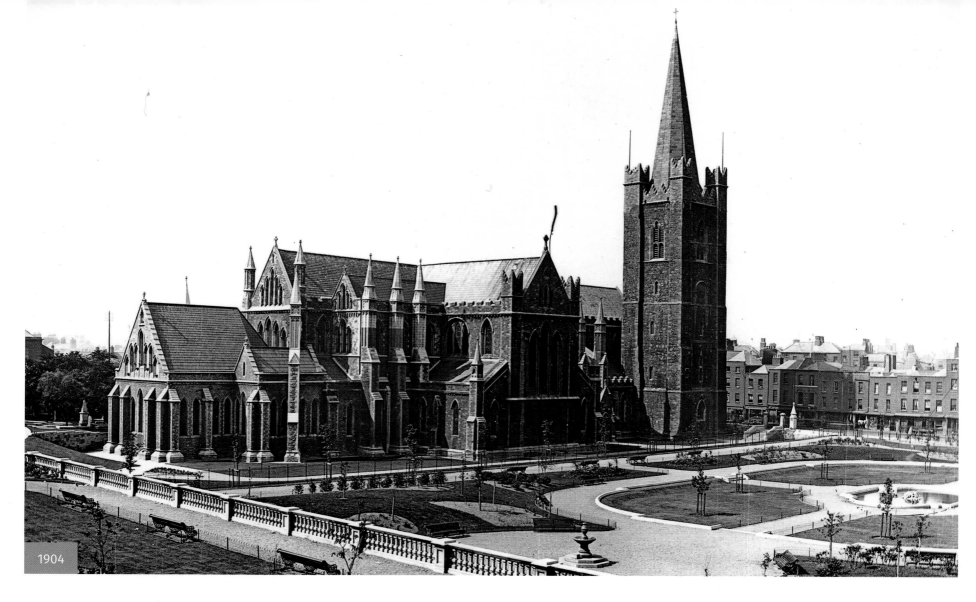

1904

ST PATRICK'S CATHEDRAL
One of Dublin's two Protestant cathedrals

ABOVE: St Patrick's Cathedral dates from the twelfth century, but it is likely there was a church on this site as early as the tenth century. The cathedral is near the city's other Anglican cathedral, Christ Church. St Patrick's Cathedral was outside the city walls to service a County Dublin community, while Christ Church was in the heart of the medieval city. The medieval cathedral was enlarged and expanded numerous times over the course of its history but by the nineteenth century it was in poor condition and parts of it were close to collapse. Benjamin Lee Guinness became a patron from the 1860s and he invested a huge amount in saving and improving the cathedral. His family had a long association with the area, and during the urban regeneration undertaken by Lord Iveagh, St Patrick's Park, seen here in the foreground, was opened up. The hoarding to the right of the inset photo shows that the park had not yet opened.

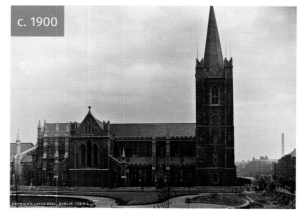

c. 1900

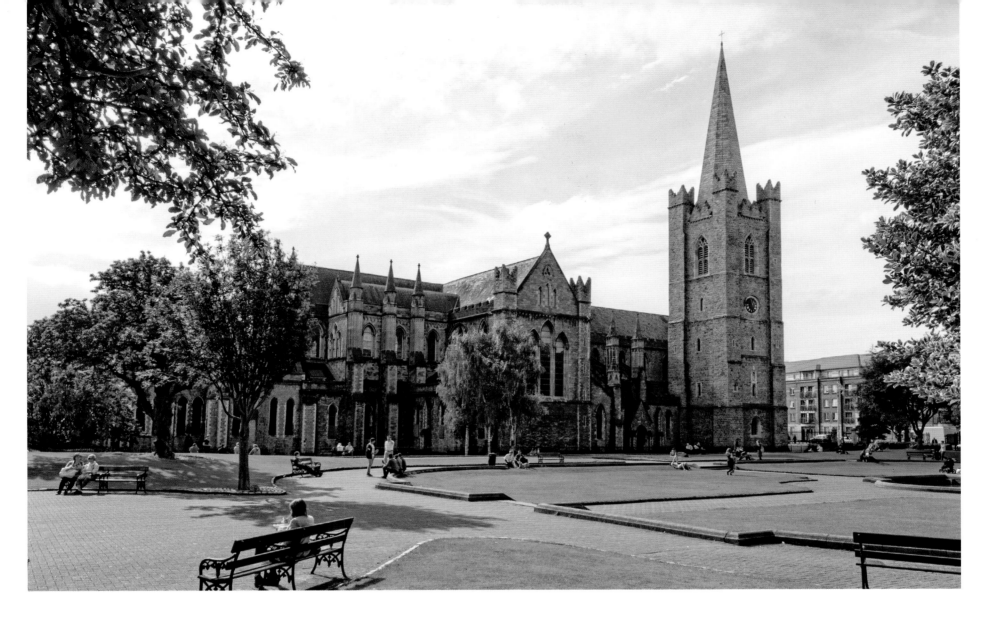

ABOVE: The Catholic population of Dublin began to eclipse the Anglican population during the eighteenth century, and by the nineteenth century Protestants were a minority. The Protestant community continued to diminish across Ireland into the twentieth century and this has made it difficult for Anglican churches with small congregations to finance themselves and remain open. St Patrick's has developed into a major Dublin tourist spot, however, which has helped the cathedral to survive financially. The cathedral hosts over 400,000 visitors each year. Their choir, which performs in the cathedral and has a school nearby, is an important part of Dublin's vibrant music life. St Patrick's Park, which can also be seen in this picture, was maintained by the Iveagh Trust for a number of years but passed into the hands of Dublin Corporation (later Dublin City Council) in the 1920s, which maintains the park to this day. It is an important recreational space in the city centre.

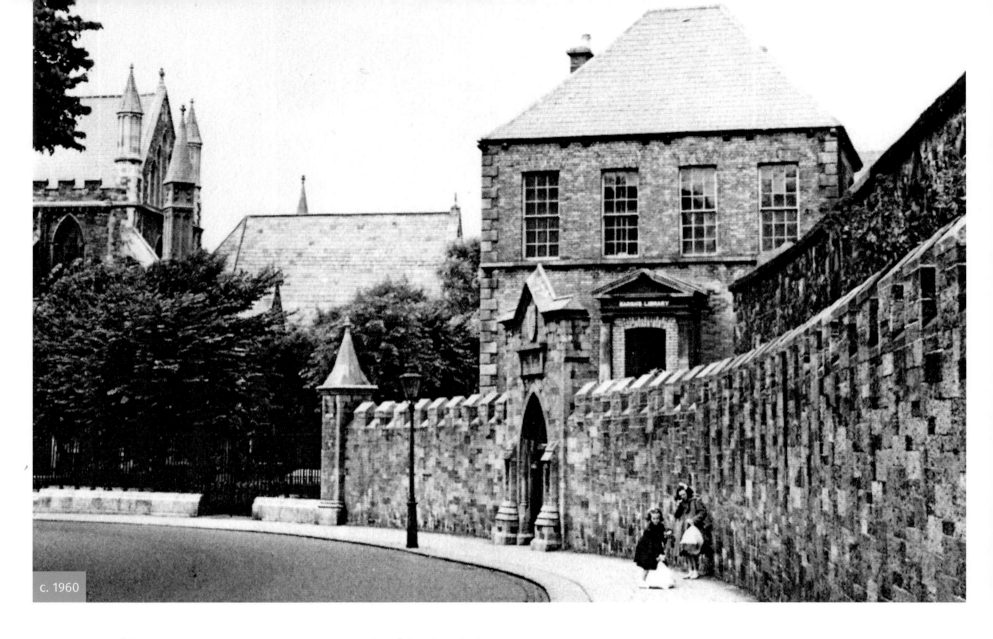

c. 1960

MARSH'S LIBRARY, ST PATRICK'S CLOSE
Ranking among the best-preserved eighteenth-century libraries

ABOVE: Marsh's Library, the first public library in Ireland, was founded by Narcissus Marsh in 1701. Marsh had served as provost of Trinity College and had been a reforming influence on the university. A lover of books and libraries, he bemoaned the lack of a public library and took the opportunity while serving as archbishop of Dublin to found one in the capital. It was not public in the modern sense but was actually restricted to 'all graduates' of the university and 'gentlemen' who lived in the city. The library was built in the grounds of St Patrick's Cathedral, in St Patrick's Close, binding the cathedral and library together. Jonathan Swift, author of *Gulliver's Travels*, would have used the library during his time as Dean of St Patrick's Cathedral. Books were an expensive commodity, and there was a fear that in a public library, such as Marsh's, they could be stolen or damaged. Readers who came to use the library were locked into these book cages and checked as they left to make sure the library collection was protected from thieves.

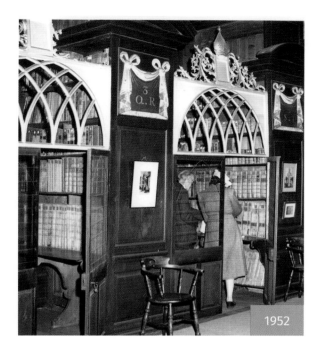

1952

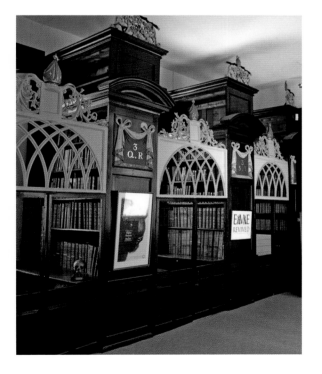

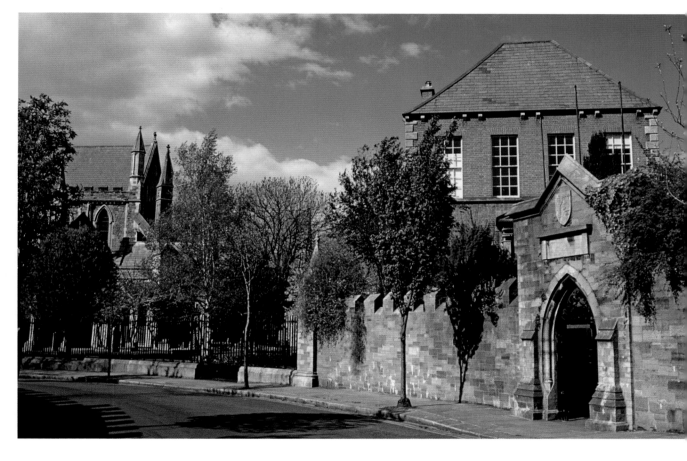

ABOVE: Marsh's Library has a long and close association with some of Ireland's most renowned writers and intellectuals. William Wilde, father of Oscar, was known to use the library. James Joyce mentioned the library in both *Ulysses* and *Finnegans Wake*. In the 1860s Benjamin Lee Guinness undertook extensive work on St Patrick's Cathedral and Marsh's Library. Although Guinness's work in the cathedral was not always restorative, his work in Marsh's was to the exterior of the building; the interior remained virtually untouched. It is excellently preserved and brings the visitor back in time, re-creating the experience of visiting an authentic eighteenth-century library. As well as being a visitor attraction, the library is a research centre and one of the most important archives of early printed books in Europe. There are over 25,000 books dating from the medieval period in the library. Marsh's also holds eighty incunabula (books printed before 1501) in their collection.

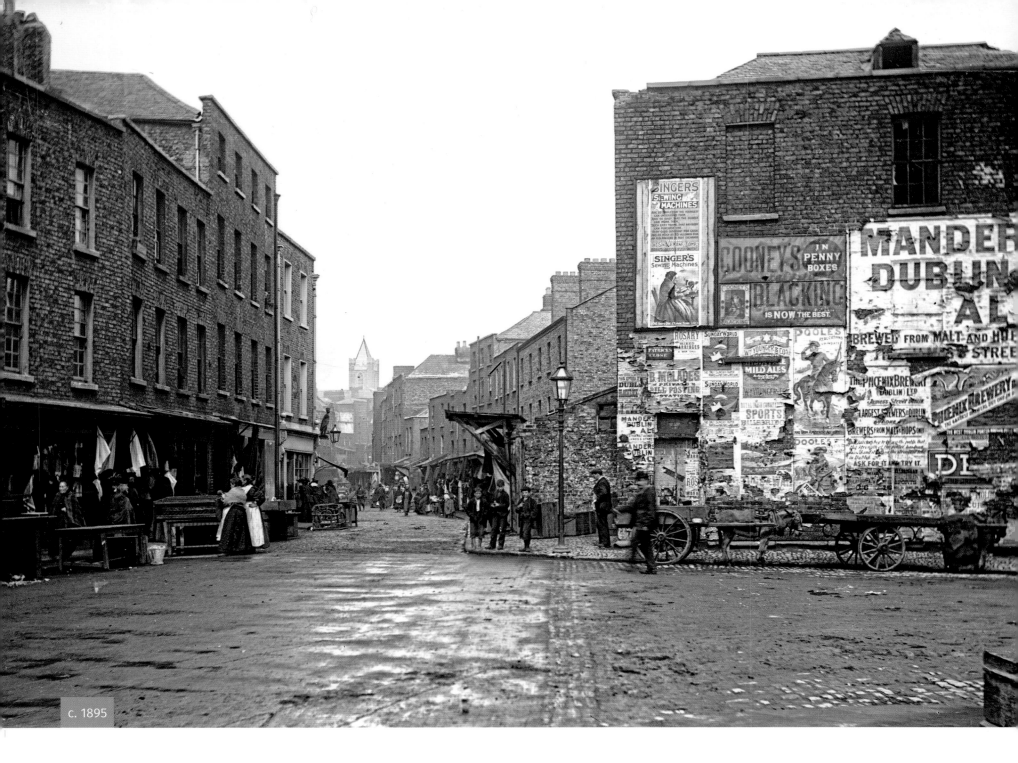

c. 1895

PATRICK STREET, THE LIBERTIES
The road linking the two Anglican cathedrals

28

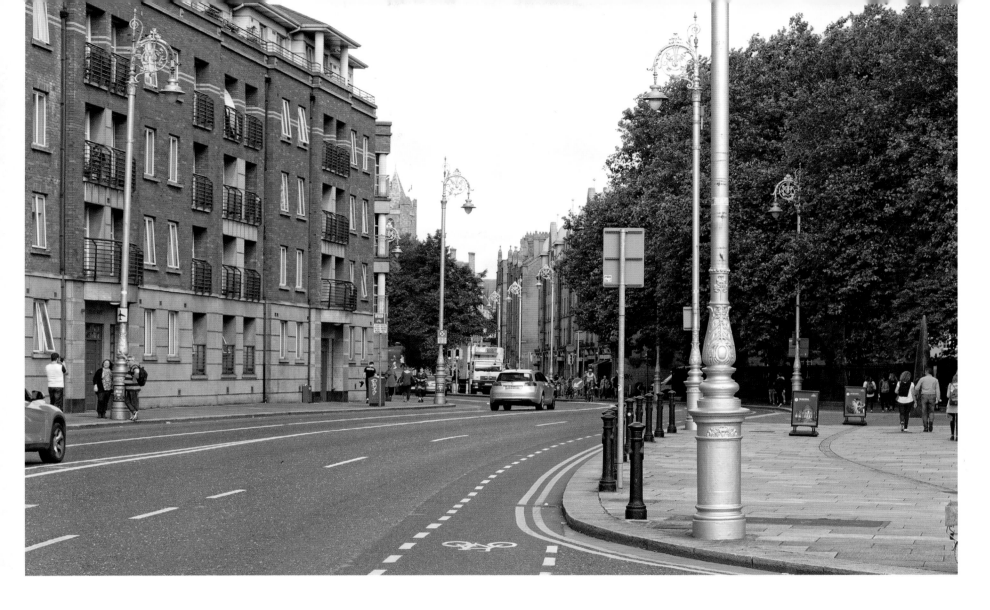

LEFT: This photograph was taken shortly before the Iveagh Trust developments began, and it provides a rare glimpse of what this area was like before redevelopment. Many tenement inhabitants ran small local shops to generate or augment their income. These shops had wooden frontage and coverings, which facilitated the display of shop items. They sold a variety of items, from food and second-hand clothing to household goods. Christ Church Cathedral can be seen in the background of the picture, while a wall of advertisements on an industrial building occupy the foreground. These posters include advertisements for Irish and British commodities such as Singer Sewing Machines, Cooney's Blacking (for stoves), the *Sunday World* newspaper and a company offering cycling tours. The advertisements for beer are a reminder of the large number of breweries that existed in Dublin before the dominance of Guinness in the twentieth century; among them are adverts for the Phoenix Brewery (which claimed to be the largest brewery in Dublin), Mander's Dublin Ale and William Younger & Co's Mild Ales.

ABOVE: Patrick Street has undergone extensive changes since the Guinness family and Iveagh Trust involved themselves in attempts to improve the area. The street today is unrecognisable from its earlier form. Nevertheless, the street retains its residential and commercial character, and a number of small shops are present beneath the large apartment blocks on the street. It is a central route across the city and creates an impressive view that connects the city's two Anglican cathedrals, Christ Church Cathedral and St Patrick's Cathedral. When Ireland's economy began to grow in the 1990s, many apartment blocks were built in Dublin city centre. These apartment blocks were located in traditionally working-class areas such as the Liberties. The apartment block to the left of this picture is indicative of this changing face of the inner city and how such areas can be changed by a high demand for city centre residences.

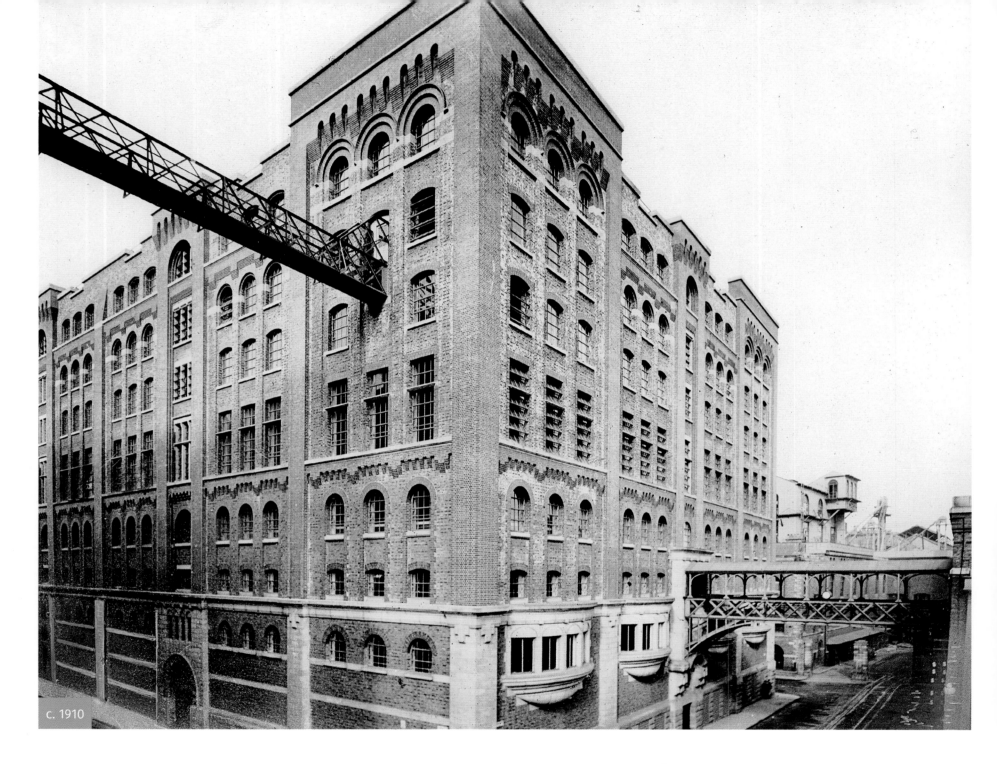

c. 1910

GUINNESS STOREHOUSE, MARKET STREET, ST JAMES'S GATE
The storehouse's main function was not storage

c. 1910

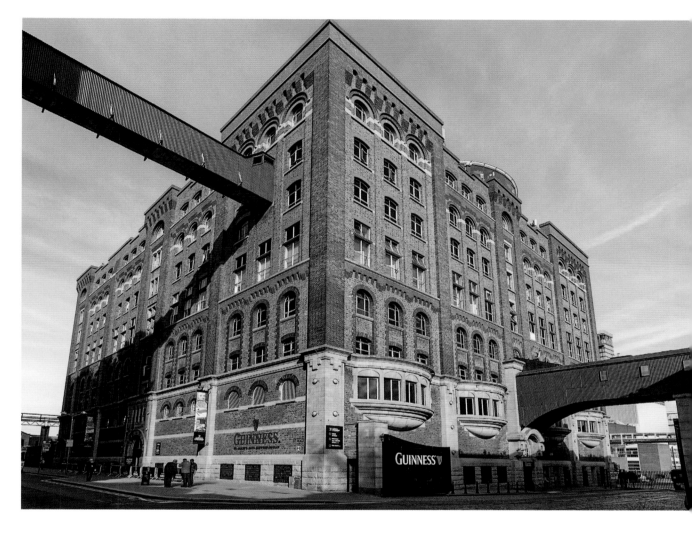

LEFT: On New Years' Eve in 1759 Arthur Guinness purchased a lease on a brewery on James's Street for just £45 for a period of 9,000 years. It was a modest beginning: the site was just over four acres when Guinness founded his brewery there. By 1833 St James's Gate production had grown steadily to become the largest Irish brewer. The Guinness Storehouse was completed in 1905, during a pre-war period of expansion. It was not used for storage, as its name suggests, but for fermentation. To ensure they could expand to meet the market demand, the brewery was constantly innovating. By World War I St James's Gate was the largest brewery in the world, but it was also the most technologically advanced. Guinness became one of the most important employers in Dublin. One of the consequences of the dominance of Guinness was that smaller brewers were pushed out of the market. Many of those Dublin-based brewers were gone by the beginning of the twentieth century, with Guinness holding a virtual monopoly on the Irish market.

ABOVE: In the 1930s Ireland embarked on a trade war with Great Britain that led to Britain retaliating with steep trade tariffs on Ireland. This was not good for Guinness exports and in 1932 Guinness relocated its headquarters to London. Production centred on Dublin until 1937, when a brewery was opened in Park Royal in London. Guinness was still produced in Dublin but primarily for the domestic market—it remained a favourite of Dublin drinkers. A 1947 guide book to Dublin warned visitors to the city not to expect a choice of beer in Dublin bars: 'Draught beers and ales are not much drunk, Guinness being the popular beverage of the masses.' Following a number of mergers in the twentieth century, Guinness is now owned by Diageo, which has its Irish headquarters at St James's Gate, although its European headquarters remain in London, at Park Royal. The Park Royal brewery ceased production of Guinness in 2005, and St James's Gate is once again the largest producer of the famous stout. The brewery covers almost 60 acres in the city centre. The Storehouse is now a visitor centre where visitors can learn about how Guinness is brewed.

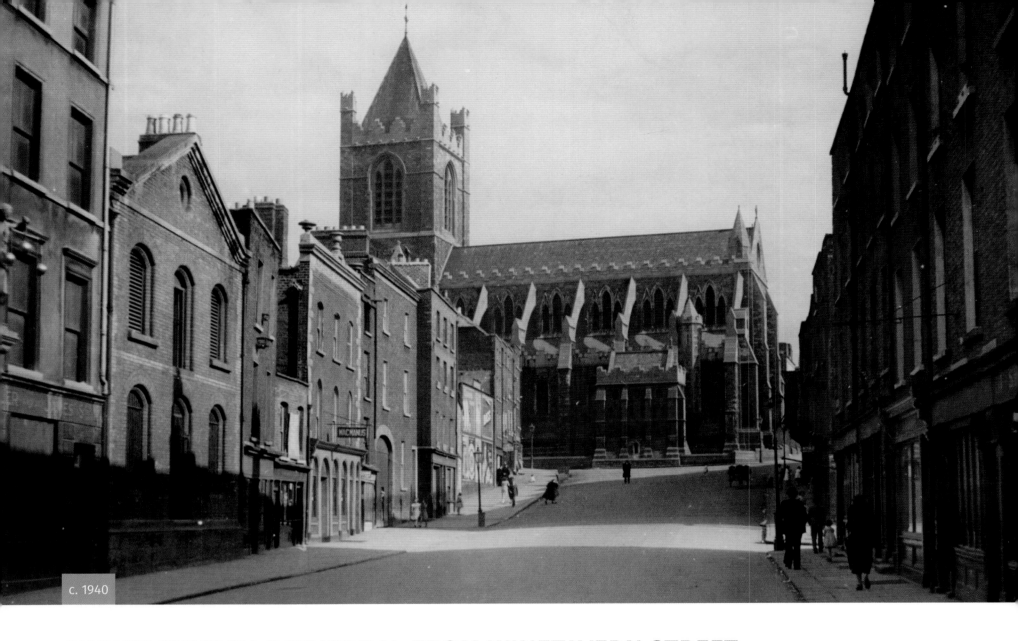

c. 1940

CHRIST CHURCH CATHEDRAL FROM WINETAVERN STREET

Once an important thoroughfare, Winetavern Street was widened by the Wide Streets Commission in the eighteenth century

ABOVE: In the early eleventh century the Hiberno-Norse king Sitric Silkbeard went on a pilgrimage to Rome to gain papal permission for a cathedral in Dublin. The cathedral of the Holy Trinity, which became known as Christ Church, was founded in 1030 in the heart of the medieval city. Dublin grew up around the cathedral, making it the centre of all life in the city. While little remains of the original structure, the cathedral site is one of the most important links to the early medieval city. Winetavern Street was important because the Tholsel, the home of civic government in the city, was located close by, and much of the city's civic, political, and commercial business was carried out in the pubs on Winetavern Street throughout the medieval and early modern period. One English visitor to the city in the seventeenth century, who certainly spent time in some of the pubs on this street, remarked 'there is no merchandise so vendible in Dublin as alcohol...the whole profit of the town stands upon alehouses and the selling of ale'. All of this had changed by the 1940s when the city centre had moved further east and Winetavern Street had transformed into a quiet, residential district.

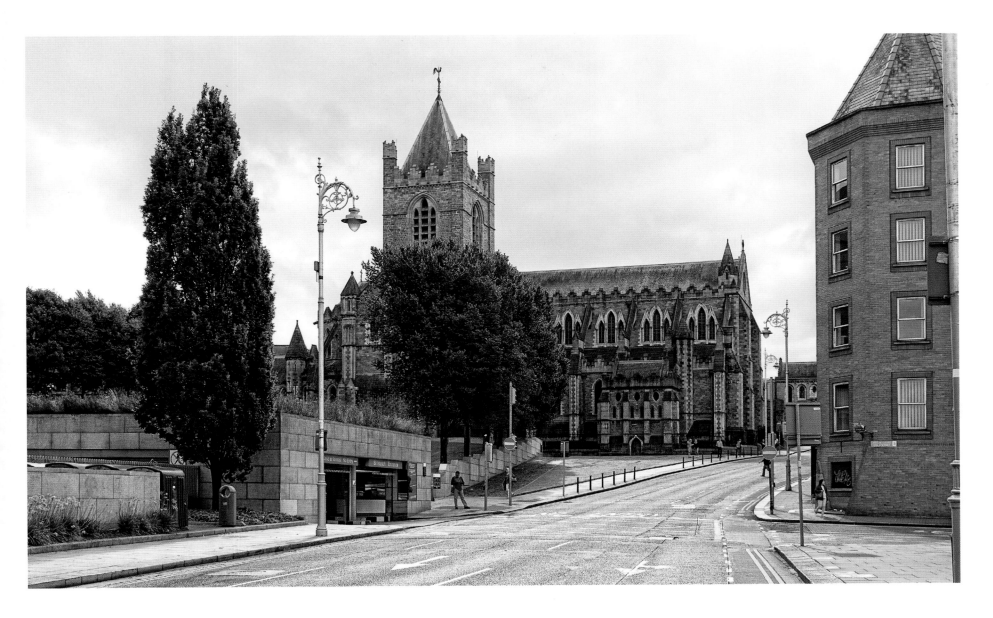

ABOVE: The area surrounding Christ Church had become overcrowded from centuries of continual habitation but these had been cleared by the middle of the twentieth century. During the eighteenth century the Wide Streets Commission, a board established by Dublin Corporation, worked to create wide thoroughfares in the city and to remove much of these overcrowded districts. The centre of the city was also moving eastwards from the eighteenth century, away from Christ Church Cathedral towards College Green and Sackville Street (now O'Connell Street). Today Winetavern Street affords a beautiful view of Christ Church Cathedral, much altered since the medieval period. One side of Winetavern Street is populated by offices while the other side has an entrance to Civic Offices. Although there are no longer any pubs on the street, the name of the street offers a reminder of what the street once was.

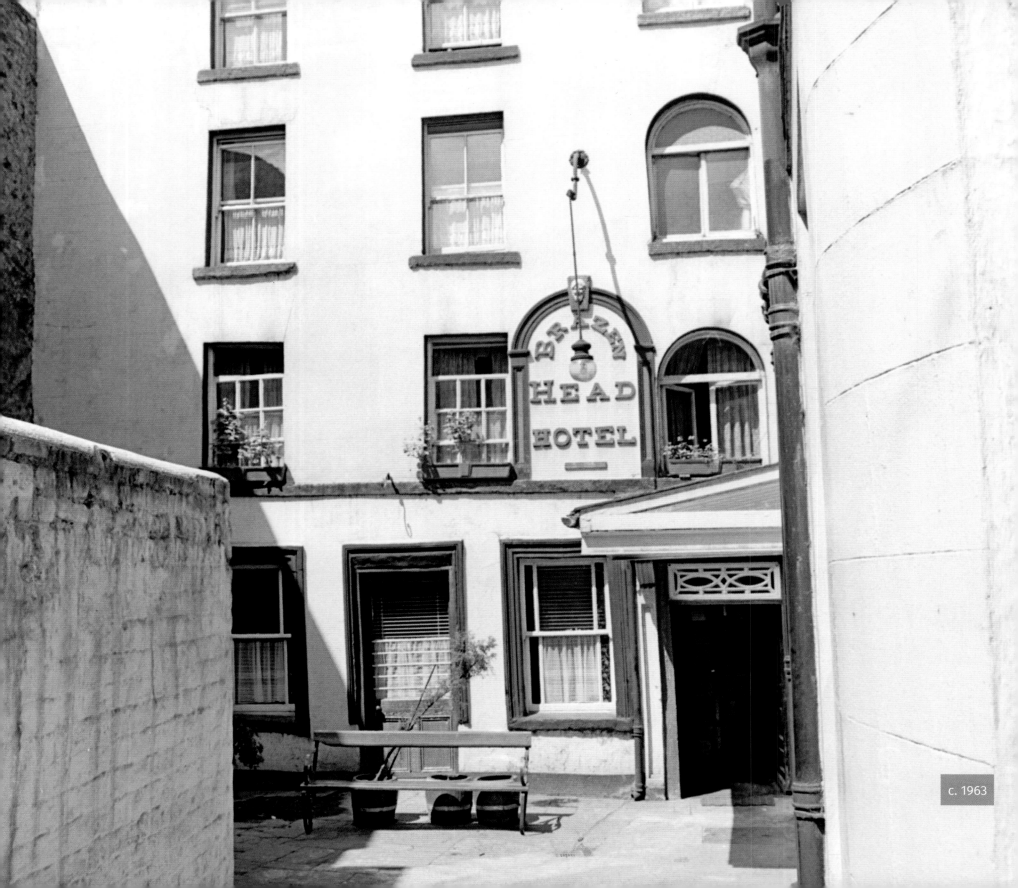

c. 1963

BRAZEN HEAD, LOWER BRIDGE STREET
Claiming to be Ireland's oldest pub

LEFT: The Brazen Head is in the heart of medieval Dublin and claims to be the oldest pub in Ireland. Although the owners claim there was a pub on the site from 1198 to the present, this is impossible to prove. Do not be fooled by the medieval-looking exterior, which was added in the nineteenth century. The pub is first mentioned in records from the seventeenth century, when it served as one of the many coaching houses in the city that offered food, lodgings and beer to visitors. The pub was substantially rebuilt in the mid-eighteenth century. The establishment has strong links with some of Ireland's most important revolutionary leaders. The United Irishmen, a republican group committed to establishing an Ireland independent of British rule, held some of their secret meetings in the inn. They rebelled in 1798, but the rebellion was violently suppressed. Robert Emmet, a republican of the same ilk, was a regular of the Brazen Head. He was executed after his unsuccessful city-centre rebellion of 1803.

RIGHT: The pub's very old origins and political credentials have attracted the attention of some of Dublin's most famous writers. The pub was mentioned (along with many of the city's most treasured drinking establishments) in James Joyce's *Ulysses*, and later in the twentieth century Brendan Behan and Flann O'Brien both frequented the pub. Although today it lies outside the commercial heart of Dublin, in a more residential part of the city centre, the Brazen Head is today a busy destination. Many visitors come to partake in the city's culture and the Brazen Head is certainly drenched in that. As well as food and drink, the pub holds traditional music and storytelling evenings. Whether or not its medieval origins can ever be proven, nonetheless the Brazen Head has become an important part of Dublin's medieval trail.

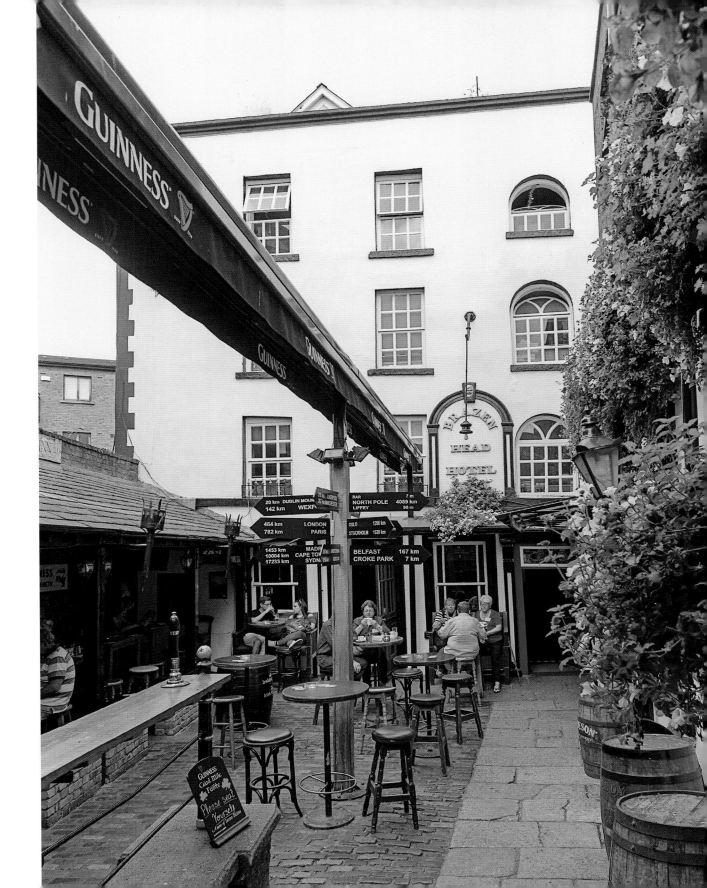

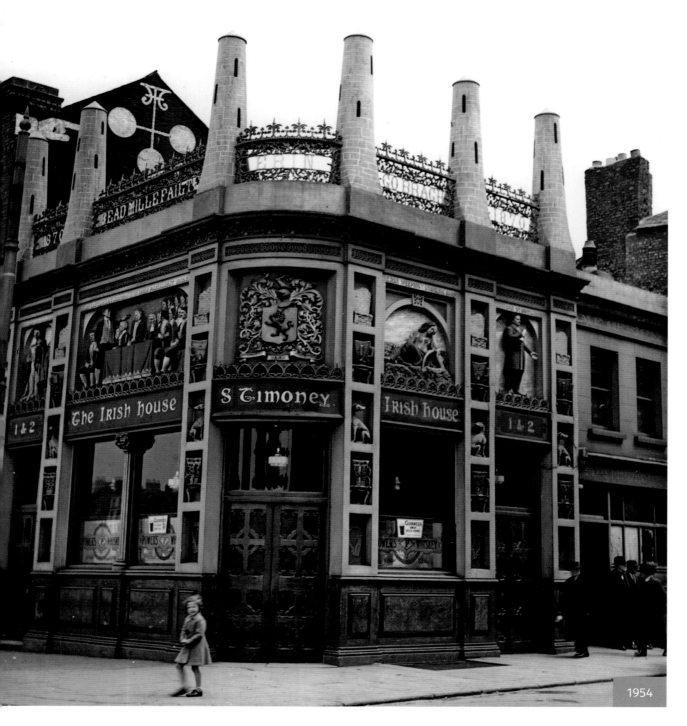

1954

THE IRISH HOUSE, WOOD QUAY
One of the city's controversial losses

LEFT: The Irish House was a Victorian pub on the corner of Wood Quay and Winetavern Street facing on to the river Liffey. The pub, named by the O'Meara family, dates from the 1870s and was famous for its remarkable decorative plasterwork. There is a clear nationalist slant to this plasterwork; the owner of the pub was making clear where his political allegiances lay. The figures featured on the pub's exterior included a life-size version of Daniel O'Connell clasping the Catholic Emancipation act of 1829. The plasterwork design was heavily influenced by the symbols of the Gaelic revival and included six Irish round towers on the roof, while the stucco beneath included Irish wolfhounds and a weeping lady (inset), a popular personification of Ireland in Gaelic mythology. The plasterwork was very much of its time; the Home Rule Party was founded in the 1870s and there were renewed calls for the return of a parliament to Ireland and even full independence. Although civic-sponsored statues were being erected to figures such as O'Connell on Sackville Street by Dublin Corporation, the plasterwork on the Irish House was an unofficial homage to pro-independence figures and gives us an insight into popular representations of nationalism in the city.

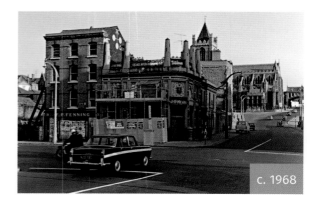

c. 1968

ABOVE: The Irish House did not survive the march of change in the city. Wood Quay was designated as the site of new offices from the 1940s, but with little money for building them these plans did not gain ground until the 1960s. In 1968 the Irish House was demolished to make way for the new offices. The pub had gained such legendary status that when news of its demolition emerged, Lord Moyne, vice-chairman of the Guinness brewery, had the plasterwork preserved and it is now in the possession of Dublin Civic Trust. When the pub closed its doors for good, it was the last remaining alehouse on Winetavern Street. As the foundations were being prepared for the new building, workers uncovered the remains of Viking material dating from as far back as the tenth century. Archaeological excavations were carried out on the site, and finds included remnants of Viking houses, streets and defensive works as well as everyday artefacts such as clothing, household objects and even beer tokens used in the nearby taverns. Despite the emergence of a grassroots movement to protect the site, the Civic Offices were erected on the site. Some of the findings from the excavation are on display in the National Museum on Kildare Street, but the erection of Civic Offices remain one of the most controversial planning decisions in the history of the state.

ORMOND QUAY

Now the centre of the city's legal sector

BELOW: Ormond Quay was developed in the late seventeenth century by Humphrey Jervis, a merchant and property developer who laid out the northside developments of Smithfield and the Ormond Market. This photograph was taken ten or fifteen years after Grattan Bridge was enlarged and improved by Bindon B Stoney. The substructure of the bridge, which was designed by the self-taught engineer and architect George Semple, was maintained in this renovation. The striking green lattice work on the new bridge was not just decorative, but acted as girders to support the brackets attached to the bridge's piers. When it was officially opened in 1874, the bridge was named after

Henry Grattan, the celebrated eighteenth-century MP. The bridge joins Capel Street and Parliament Street, two busy-commercial streets. A Presbyterian church can be seen on Ormond Quay to the left of Capel Street. In this image boats can be seen tied to the bridge (centre, right). Crossing the Liffey was a difficult task, and at peak times traffic congestion could make it impossible. Throughout the city's history and up to the early twentieth century, ferrymen took passengers across the Liffey.

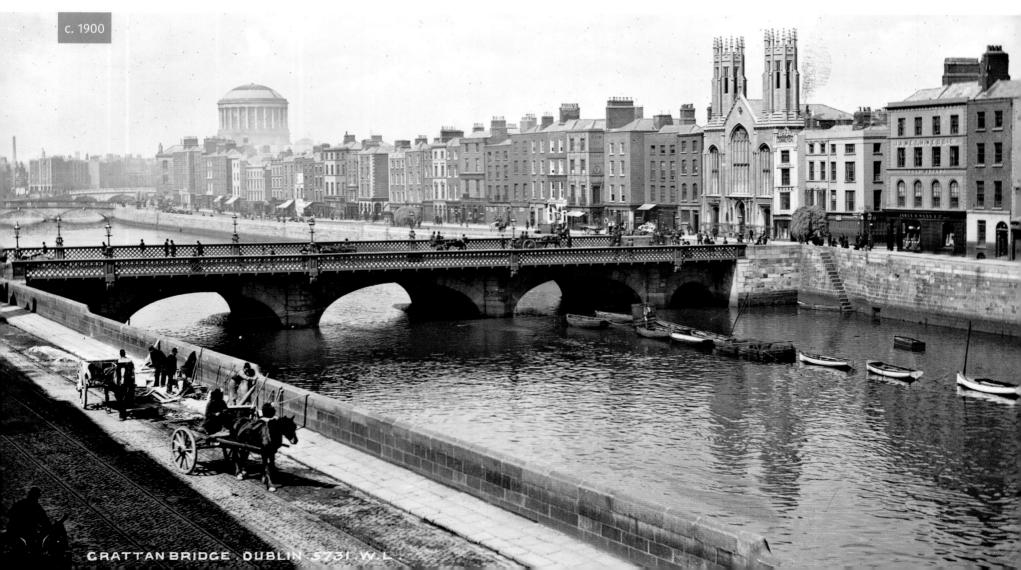

c. 1900

GRATTAN BRIDGE DUBLIN 5731 W.L.

BELOW: Ormond Quay's close proximity to the Four Courts means is has evolved into a legal area of sorts, and there are a large number of legal firms in and around the quay. There are also a number of city hotels there. The river has always been an important geographical marker for the city. In the early twentieth century bridges became the primary method of crossing from northside to southside. These bridges have increased in number to keep pace with the city's rapidly expanding population. Five bridges have been added to the Liffey in the past twenty years, including the Millennium Bridge in 1999, the James Joyce Bridge in 2003, the Seán O'Casey footbridge in 2005, the Samuel Beckett in 2009 and the Rosie Hackett Bridge in 2014.

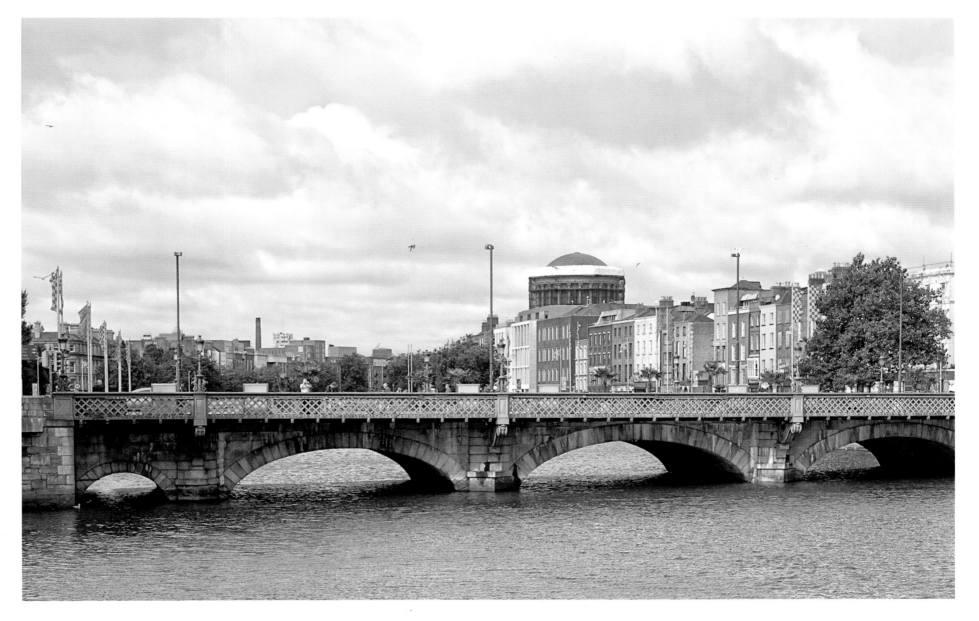

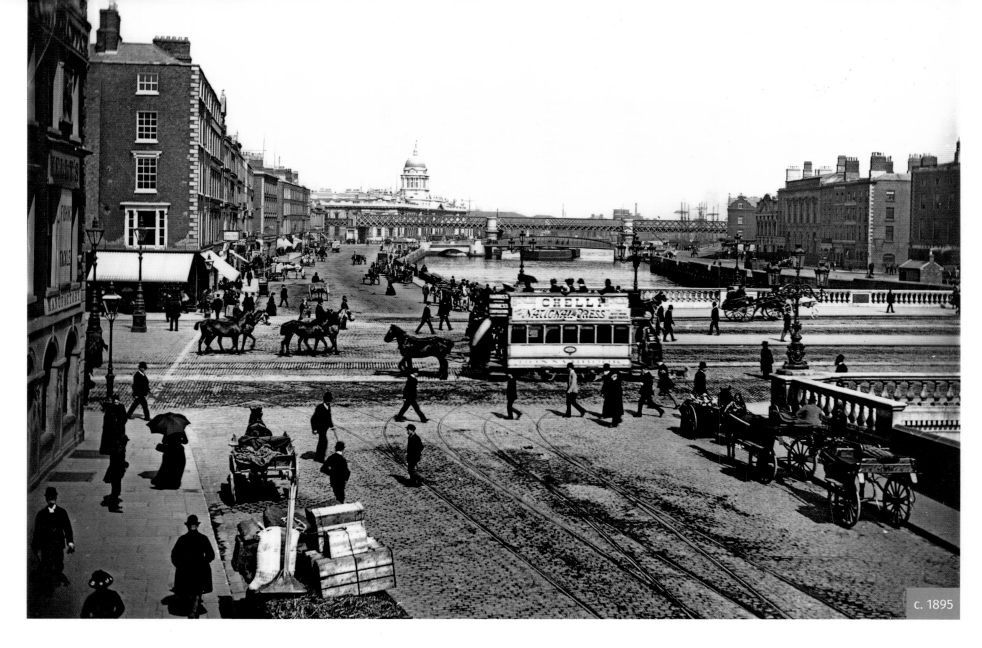

c. 1895

EDEN QUAY

Looking towards the Custom House

ABOVE: The Custom House moved from the southside of the city (where Temple Bar is today) to its current location in 1791. Until this time, Eden Quay had primarily been a residential area and would not have seen a high volume of commercial traffic or trade. The quay was planned in the 1790s and was constructed and built in the early nineteenth century. This image shows the extent to which the quay had changed over the hundred years since it was first laid out. Sackville Street (now O'Connell Street) was a commercial hub, and a large number of banks, insurance brokers, hotels and shops were located on the street, which would have drawn pedestrian and commercial traffic. One of the most striking features of the image is the large number of horses on the streets. Horses were used to transport people, pull carts, carriages and even trams. The first railway line in Ireland opened in 1834 and ran between Kingstown (now Dún Laoghaire) and Dublin. Butt Bridge (known locally as the Loop Line railway bridge) can be seem in the background of this picture, a reminder that technological developments were changing how people moved around the city.

ABOVE: The view of Eden Quay has altered in a number of ways in the past one-hundred-and-twenty years. The street was badly damaged in the 1916 Rising, and although a number of nineteenth-century buildings have survived, many of the buildings in the modern picture have been erected in the past century. Liberty Hall, Dublin's only skyscraper, now dominates this view. Travelling around the city centre has also changed dramatically since the introduction of the motor car, and later buses, to Dublin's streets. In 1915 there were 9,850 cars registered in Ireland. By 2014 there were 1,900,000. Horses are a more novel sight on the city's streets, although a number of operators offer tours by horse-drawn carriage to visitors in and around the centre. Although trams were considered unfashionable in the middle of the twentieth century and were dismantled, they have in recent times been reinstated and now transport Dubliners across the city once more. The Luas tram system crosses the Liffey over the Rosie Hackett Bridge.

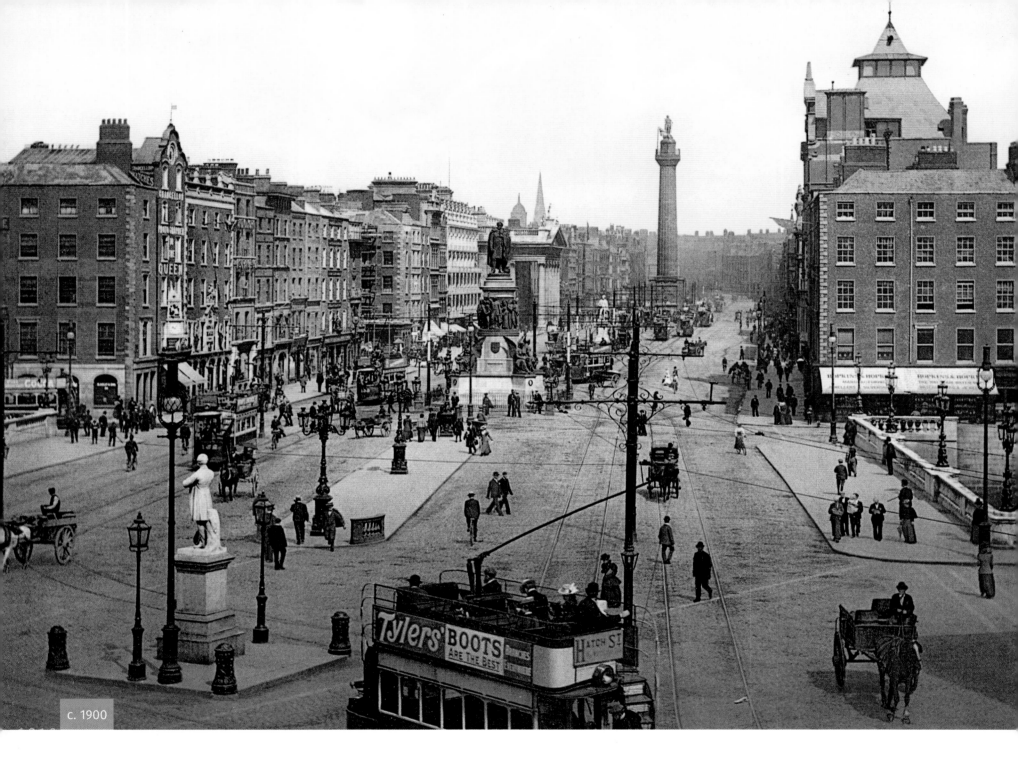

c. 1900

SACKVILLE STREET AND CARLISLE BRIDGE / O'CONNELL STREET AND BRIDGE

Dublin's main thoroughfare

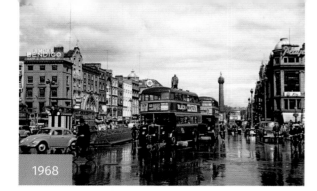

1968

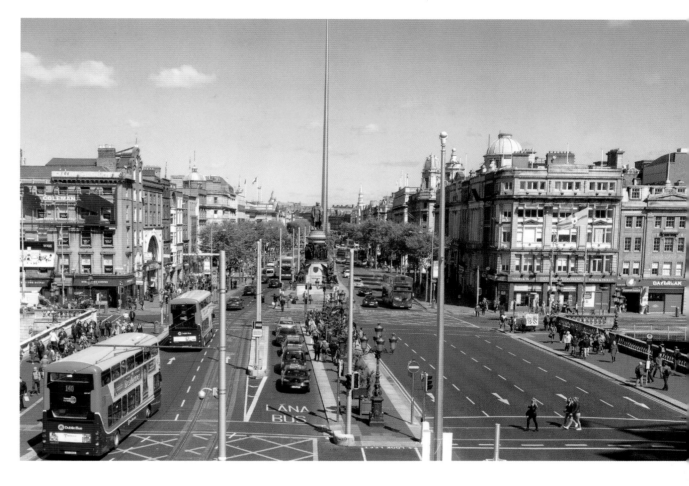

LEFT: Sackville Street evolved from two streets, Sackville Street and Drogheda Street. These streets were built during the eighteenth-century property boom, when developers such as Luke Gardiner built high-class residential areas. Carlisle Bridge (now O'Connell Bridge), designed by James Gandon, opened in 1794 to connect Sackville Street and Westmoreland Street. In the eighteenth century the houses on the street would have attracted some of Dublin's richest citizens, but by the nineteenth century the street was no longer residential and had become more of a commercial hub. A key event in the development of Sackville Street was the opening up of the General Post Office in 1818. This put Sackville Street at the heart of communications for the capital. Mail coaches leaving the GPO provided transport for the general public, a function that was later replaced by the tram line, although by the 1960s (see inset above) trams had been removed. By the late nineteenth century hotels, theatres and clothing departments had joined many of the businesses on the street and Sackville Street was one of the busiest entertainment and shopping streets in the city.

ABOVE: Street names and statues became highly politicised during the nineteenth century and this street is a prime example of that process. In the second half of the nineteenth century a monument to Daniel O'Connell was planned, publicly funded and built there. The positioning of the statue at the top of Sackville Street meant that it could be seen from a number of key points at this busy intersection. It was also felt that the Catholic and nationalist leader offered an opposing view to the imperialist figure of Nelson high atop his pillar. From this point on, the street and bridge were informally called O'Connell Street and O'Connell Bridge. A number of other nationalist figures were given statues on the street, including Charles Stewart Parnell (completed in 1910) and Sir John Gray (1879). When Dublin Corporation voted to have the street renamed O'Connell Street, the street's inhabitants strenuously objected and the decision was overturned, an indication of how politically divided the city was. Sackville Street did not officially become O'Connell Street until after the Civil War, in 1924. Although the street went into decline somewhat in the late twentieth century, it has undergone a regeneration, as well as work to return a tram line to the street.

THE GPO, SACKVILLE STREET

Symbol of the 1916 Easter Rising

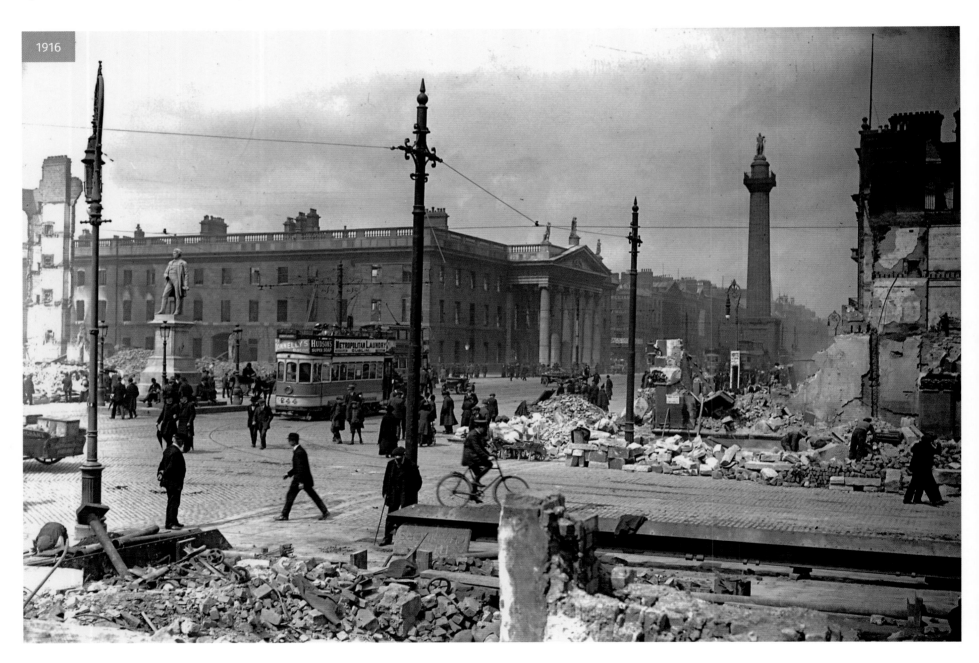

1916

LEFT: Although Sackville Street was a busy residential and commercial hub in the city by the start of the nineteenth century, one plot on the street remained vacant as late as 1814. It was purchased by the government for £50,000 to allow for the erection of the General Post Office, which was completed in 1818. Francis Johnston's GPO, paired with Nelson's Pillar, created a remarkable vista. Transport and communications for the capital centred on the GPO. As well as being the central sorting depot for most of the capital's mail, it housed the first telegram exchange. The GPO was also the terminus for many of the city's trams. Its importance to the city's communications made it an appealing headquarters for the leaders of the 1916 Rising, who occupied the building on Easter Monday of that year. They remained there until Friday of that week, when fires caused by British artillery forced them to abandon the building. Once the fires were put out, all that remained of the building was the Portland stone facade. The rubble in the foreground is the remains of Clerys department store.

BELOW: James Connolly wrote from his station in the GPO during the Rising 'we are hemmed in, because the enemy feels that in this building is to be found the heart and inspiration of our great movement'. In the aftermath of the executions of the rebel leaders, the GPO took on new significance as the headquarters of the failed uprising. During the War of Independence a cult grew around the executed men and this continued when the Free State was established in 1922. The GPO remained a shell until 1924, when rebuilding began. The building was completed in 1929 and while the facade remained true to Johnston's designs, the interior was vastly altered. The GPO was central to state events throughout the twentieth century and remains a focal point for veneration of the 1916 Rising leaders. This was best seen in 2016 when state commemoration of the centenary of the Rising focused on the GPO and a new museum to commemorate the event was opened within the building. The GPO remains a functioning post office. Although the tram was dismantled in the middle of the twentieth century, in 2017 O'Connell Street became a tram stop again.

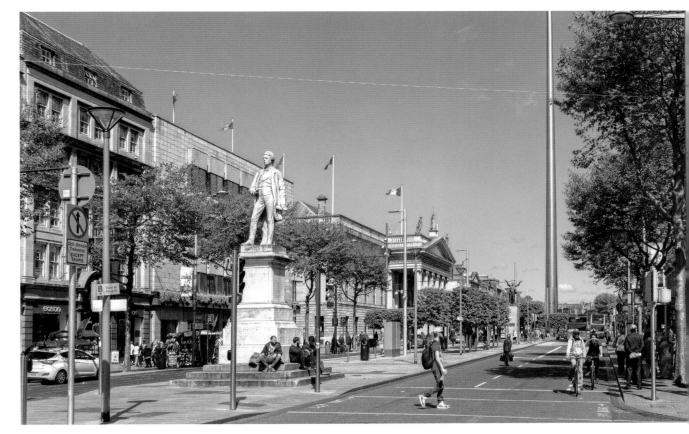

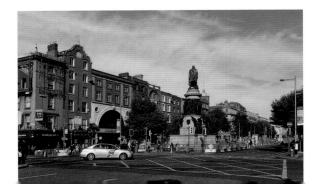

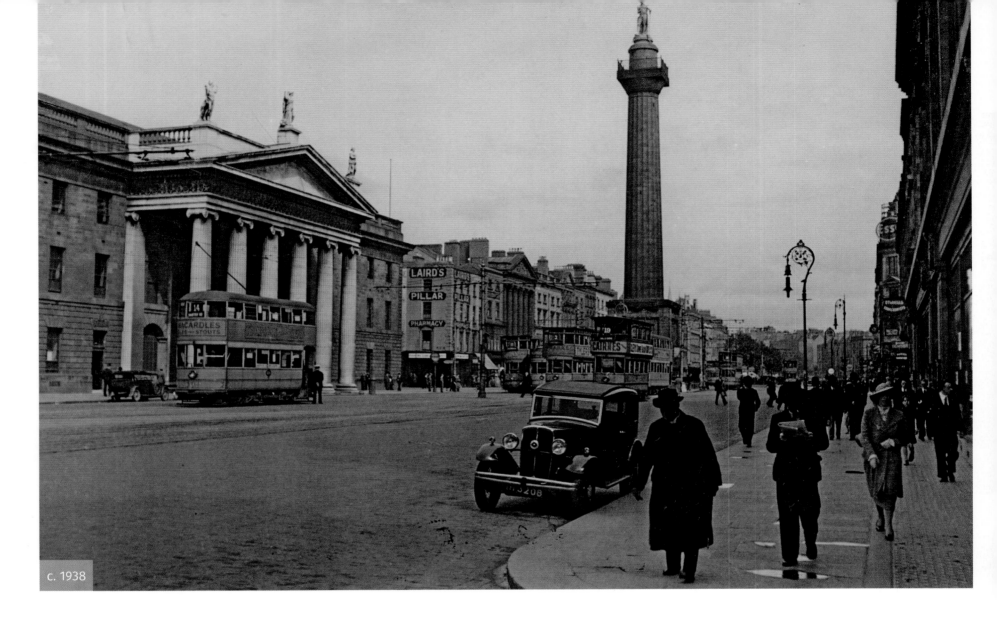

c. 1938

NELSON'S PILLAR, O'CONNELL STREET

The classical Greek column has been replaced by 'the stiletto in the ghetto'

ABOVE: The most iconic – and controversial – monument on Sackville Street was Nelson's Pillar. The monument was paid for by a public fund headed by prominent citizens seeking to commemorate Nelson's great victories, which had brought peace to Britain and Ireland as well as reopening access to European trade routes that had been blocked by Napoleon. When the monument was unveiled in 1809, it consisted of a Doric column 111 feet high topped with a statue of Admiral Horatio Nelson. The column contained a viewing point with a panoramic view of the city. After the Free State was founded in 1922, many of the city's streets were renamed in line with the outlook of the new state. Nelson's Pillar had always been controversial, and in the nineteenth century the journalist Watty Cox wrote that it was a reminder 'our independence has been wrested from us, not by the arms of France but by the gold of England'. Some argued that it was an important architectural feature and that the column should be kept but Nelson's statue removed. These debates ended in March 1966 when, on the fiftieth anniversary of the 1916 Rising, the IRA blew up the pillar.

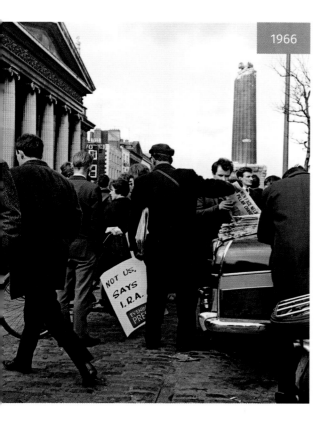

1966

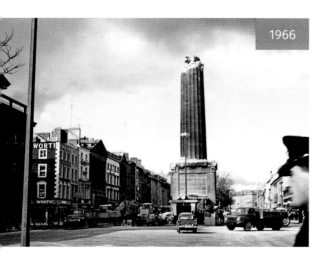

1966

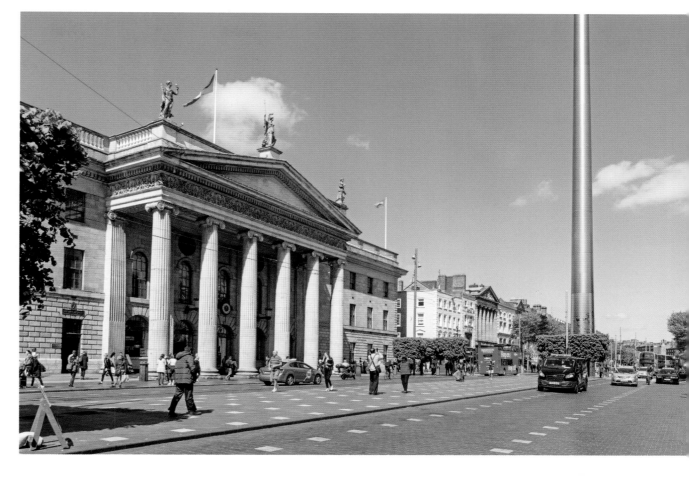

ABOVE: *The Irish Times* reported 8 March 1966: 'The top of Nelson's Pillar, in O'Connell Street, Dublin was blown off by a tremendous explosion at 1.32 o'clock this morning and the Nelson statue and tons of rubble poured down into the roadway.' It was a miracle that no one was injured. A dance was just about to let out at the Metropole ballroom, and crowds were heading home after their evening socialising. Before the debate about the pillar could open again, the state army was sent in to destroy the stump. For all its controversy, with the pillar gone it left a vacuum on O'Connell Street. In the 1990s the government unveiled plans for a new monument, called the Spire, which would occupy the space where Nelson's Pillar had once been. The monument was intended to be politically impartial, modern and to commemorate the millennium. The 'stainless-steel needle' was designed by Ian Ritchie and erected in 2003. It is six times higher than the nearby GPO. The Spire has attracted much praise and criticism. Dublin wits have a number of nicknames for the structure, including 'the stiletto in the ghetto', 'the nail in the Pale', and the 'pin in the bin'.

c. 1914

CLERYS DEPARTMENT STORE, O'CONNELL STREET

A Dublin fixture, Clerys finally closed the doors in 2015

ABOVE: The department store on O'Connell Street dates from 1853, when the 'New or Palatial Mart' opened up on the present site. It was one of the largest department stores in Dublin, but was not the oldest. Arnotts on Henry Street first opened its doors in 1843, and Brown Thomas first began trading on Grafton Street in 1848. The store was renamed Clerys when it was taken over by M.J. Clery in 1883. Stores began taking off across Europe and North America in the 1840s and provided a one-stop-shop for a range of goods, including household items, clothes, shoes and accessories. This was a move away from the specialised shops of the eighteenth century. Clerys was not only one of the most popular shops in Dublin but also became a meeting point for Dubliners. Trams into the city stopped at Nelson's Pillar, adjacent to the department store, and in a time where wrist watches were uncommon people would arrange to meet under Clerys clock. The store was destroyed during the 1916 Rising, and the current building was completed in 1922.

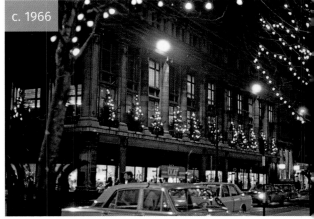

c. 1966

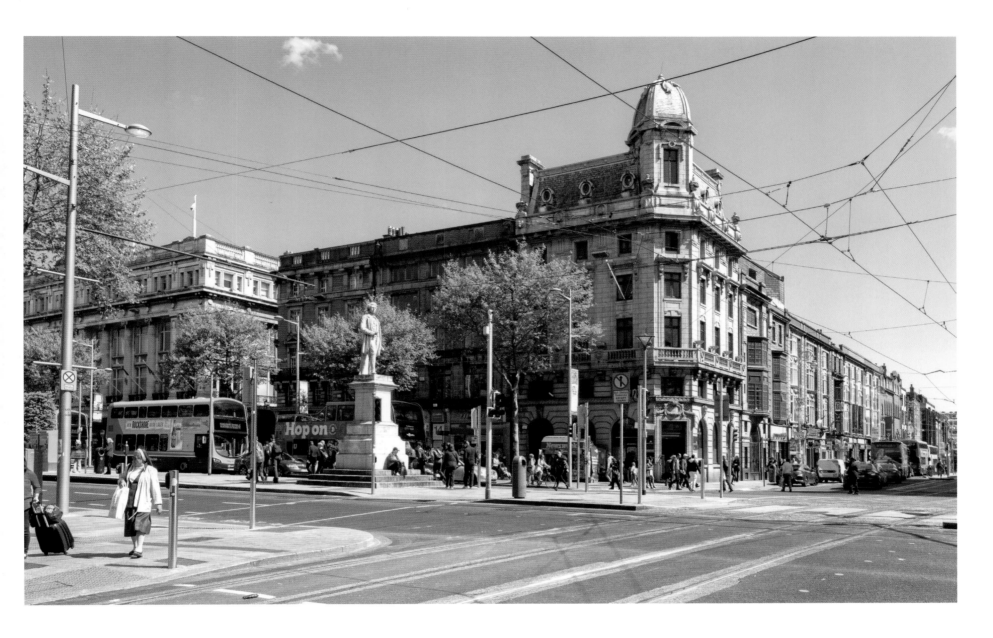

ABOVE: Clerys struggled during the Emergency in Ireland (the name given to the second world war in Ireland as the country was not officially involved in the hostilities) and in 1941 it went into receivership. It was bought out by Denis Guiney, who returned the store to profit. Dublin was a shopping destination for people all over Ireland, and Guiney hit on the ingenious marketing ploy of refunding country visitors' train fare if they spent over £5 in the store. Clerys remained a popular store into the second half of the twentieth century but financial problems returned to the store. These were exacerbated by Ireland's economic woes from 2008, and in 2015 Clerys went into receivership once more. The company was sold for just €1, while the building was sold for €29 million, and Clerys workers were left without redundancy pay. This was a sad end to an iconic store that had resided on the city's premier street for over one-hundred-and-fifty years.

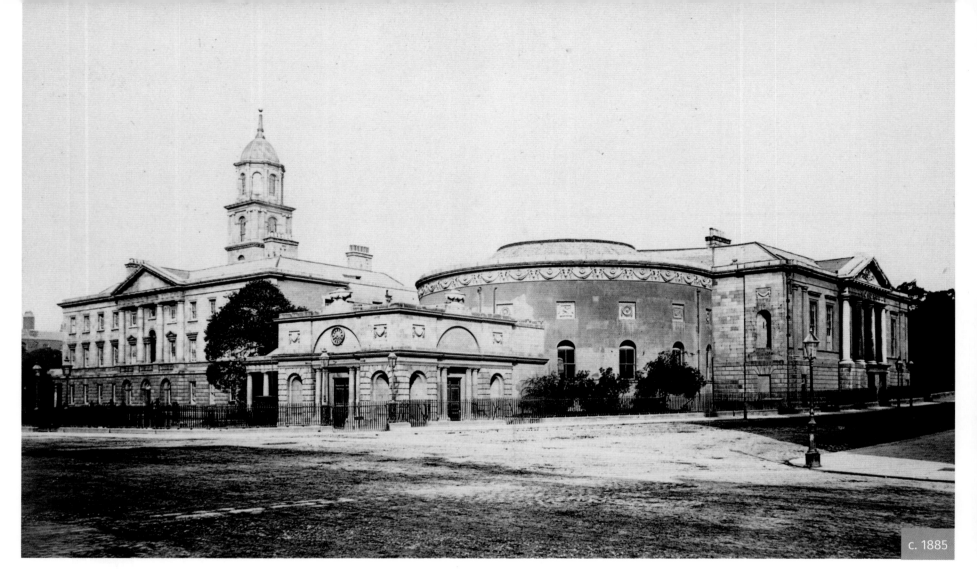

c. 1885

THE ROTUNDA AND THE GATE THEATRE
A maternity hospital for over 250 years

ABOVE: In 1745 Bartholomew Mosse, appalled by the conditions in which Dublin's poor were giving birth, founded a lying-in hospital on George's Lane where they could seek medical assistance. The lying-in hospital moved into this hospital complex on Rutland Square (Parnell Square today) in December 1757. The building was designed by Richard Cassels, who was one of the pre-eminent architects of his day and also designed Leinster House, Russborough House and Powerscourt House. Mosse's hospital was a charity,

and to fund it he laid out a leisure garden behind the hospital and charged an entrance fee. The gardens, located near Dublin's most fashionable eighteenth-century residences, were a stroke of genius. Dublin's most fashionable citizens visited them to see and be seen. There were also assembly rooms within the hospital where political and social gatherings were held in the eighteenth and nineteenth centuries. The hospital was named the Rotunda after the assembly room rotundas, which were open to the public.

c. 1885

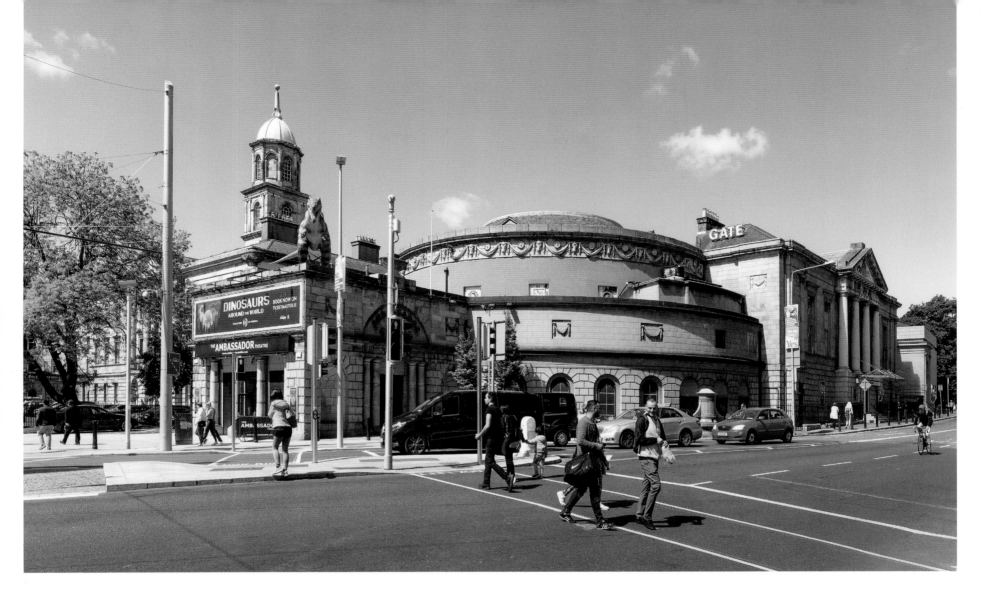

ABOVE: The Rotunda Hospital is still one of the main maternity units for Dublin. The complex has changed, however. The Gate Theatre, founded in 1928, moved to the assembly rooms of the Rotunda in 1930. Although the Gate developed its own reputation for staging international plays and the works of nineteenth-century Irish writers, it was quite unlike the productions of the national theatre, the Abbey. One of the Gate's most remarkable legacies must be the resurrection of Oscar Wilde in Ireland. Wilde's reputation had been destroyed after a trial in 1895 where his homosexual activities were exposed. Despite the fact he was born in Dublin, his death in 1900 had not been marked in the city, as people seemed content to forget him. But the Gate staged a number of successful productions of Wilde's plays, and by the 1930s his work was being recognised, produced and praised once more. *The Importance of Being Earnest* was produced in 1933, and has been hailed as 'one of their most successful productions ever'. It was restaged in 1935, 1936 and 1938 and toured as far as Egypt in 1937.

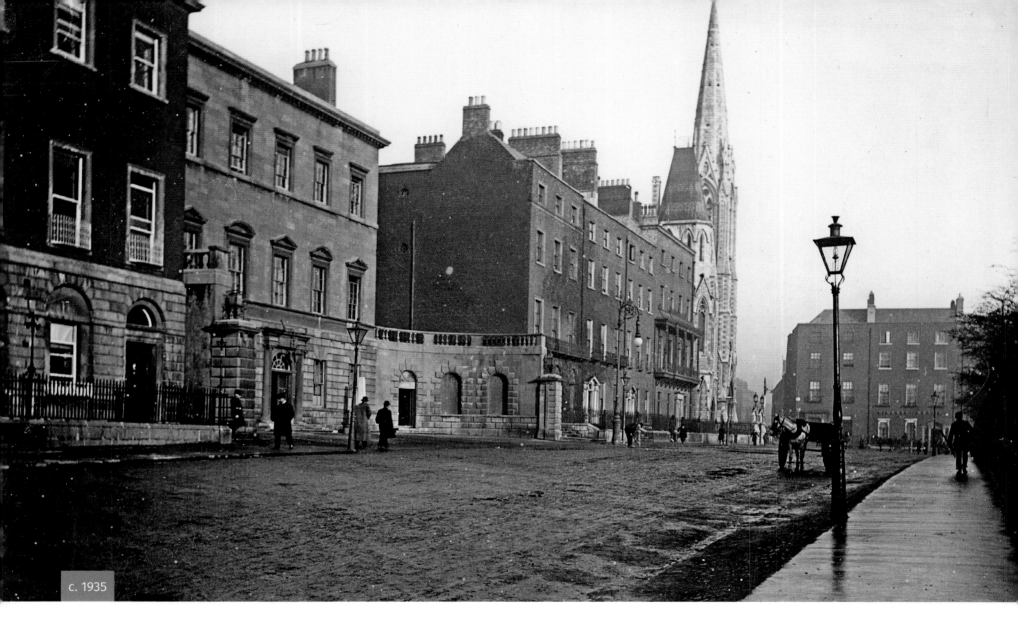

c. 1935

CHARLEMONT HOUSE / HUGH LANE GALLERY

Home to the Hugh Lane Gallery, the first public gallery of modern art in the world

ABOVE: James Caulfield began Charlemont House (left of centre in the photo above) in 1763, the year he was made first Earl of Charlemont. The house took up two vacant plots on the north side of Rutland Square (now Parnell Square), breaking from the traditional uniform-looking Georgian townhouses around the square, which were the fashion of the day. In moving away from this design, Charlemont House became a focal point for the street. Caulfield was a patron of the arts and a lover of classical art and architecture. He travelled throughout Europe and brought European art and artefacts back to Dublin. The architectural historian Maurice Craig says that 'of all the building grandees in Dublin, Charlemont was the one most seriously interested in architecture'. He promoted classical architecture through the buildings he patronised. He is also responsible for financing the construction of the Casino at Marino (hailed as the most important neoclassical building in Ireland). Both buildings were designed by William Chambers. Charlemont House was used as a private residence until the late 1920s.

ABOVE: The Municipal Gallery of Modern Art, known locally as the Hugh Lane Gallery after its founder, took up residence in Charlemont House in 1933. After visiting an exhibition of local artists in Dublin in 1901, Hugh Lane began to campaign for a modern art gallery to be established in the city and did much to support this initiative. He encouraged Irish artists to donate paintings in order to form a collection and he held international exhibitions of Irish art. In 1908 the Municipal Art Gallery opened in a temporary location on Harcourt Street on the city's southside while a permanent home was sought. Lane was an avid art collector, and after he died on board the *Lusitania* in 1915, his collection, including a number of famous impressionist paintings, were bequeathed to the city for its collection. This collection forms the centrepiece of the permanent collection now on exhibition at the gallery. One of the most recent permanent acquisitions was the studio of Francis Bacon (who was born in Dublin), which has been re-created within the gallery space. The gallery was the first known public gallery of modern art in the world.

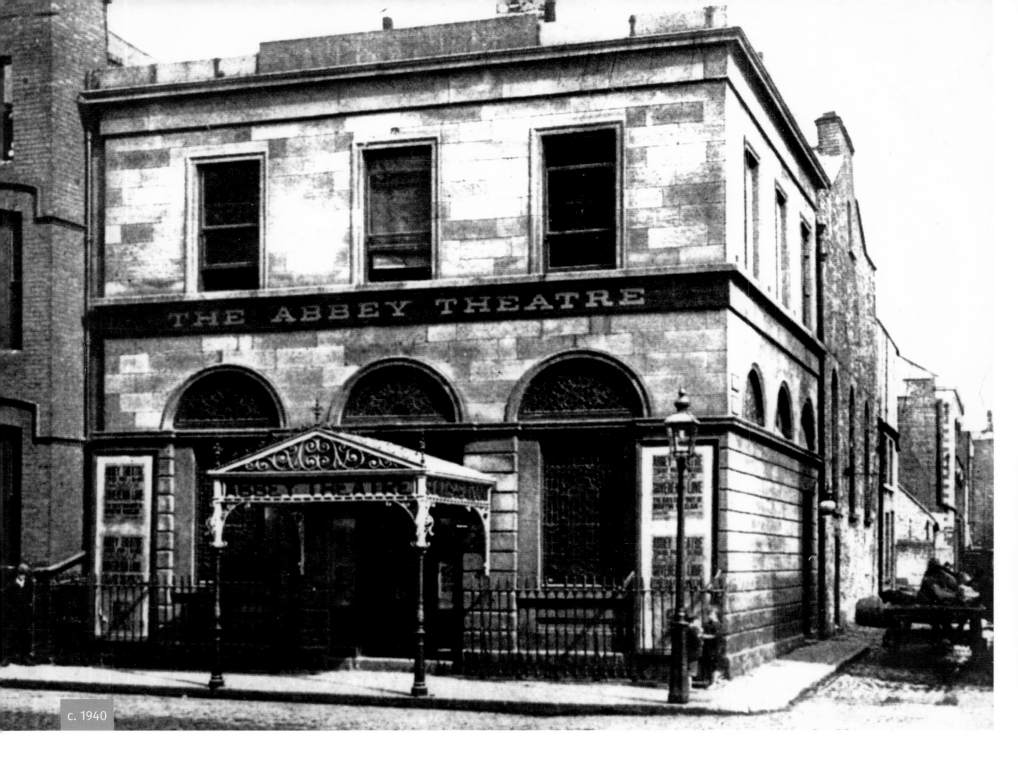

c. 1940

THE ABBEY THEATRE, ABBEY STREET

A theatre built in a morgue was a gift to city wits

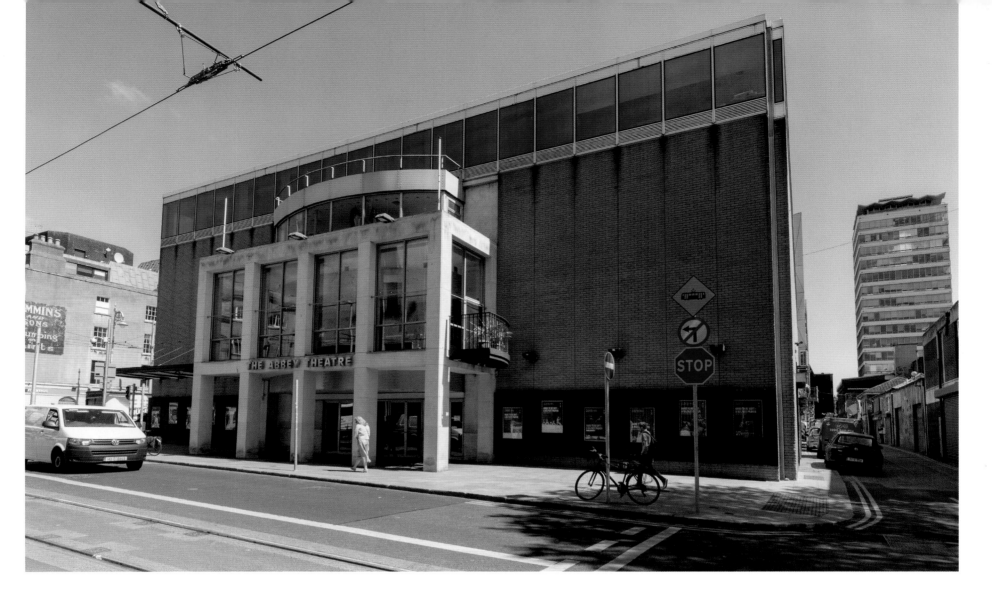

LEFT: In the 1890s Lady Augusta Gregory and W.B. Yeats rejected previous traditions of Irish theatre, seeing them as overly anglicised. They sought to stage plays that were literary rather than commercial and which drew on an Irish Gaelic tradition. Together they formed the Irish Literary Theatre in 1898. By 1903 this had become the National Theatre Society. With the patronage of English philanthropist Annie Horniman, the society was in a position to find a permanent home. It purchased the Mechanics' Institute on the corner of Marlborough Street and Abbey Street. The site had to be expanded, so the society acquired the building next door—the city morgue—to do so. The new entrance to the theatre was the old entrance to the city morgue, which provided much material for city wits. The theatre was given a special place within the new state, which sought to encourage Irish cultural activities, and so the Abbey became the National Theatre of Ireland and was given a state grant in 1925.

ABOVE: During the night of 17 July 1951, a fire broke out in the theatre. Actors and theatre employees rushed to the burning building to save what they could, but the auditorium, dressing rooms, sets and costumes were all destroyed. A number of historic paintings were saved, but the theatre was in ruins. The company moved to Queen's Theatre on Pearse Street, while theatre management struggled to come up with money to rebuild the theatre. The company did not return to Abbey Street until 1966, and the cost of rebuilding was £725,000, a huge strain on the Irish exchequer. The new theatre was designed by Michael Scott and Ronald Tallon and received mixed reviews. Architectural historian Christine Casey has described it as 'dull in the extreme'. But the design is modern, and the auditorium, which seats 628 people, has a steeped layout that is a dramatic change to the theatre of the past. Despite various government plans and suggestions that it should move to a more historic location, such as the GPO, the theatre remains on Abbey Street for the foreseeable future.

THE CUSTOM HOUSE
Designed by the architect responsible for the King's Inns and the Four Courts

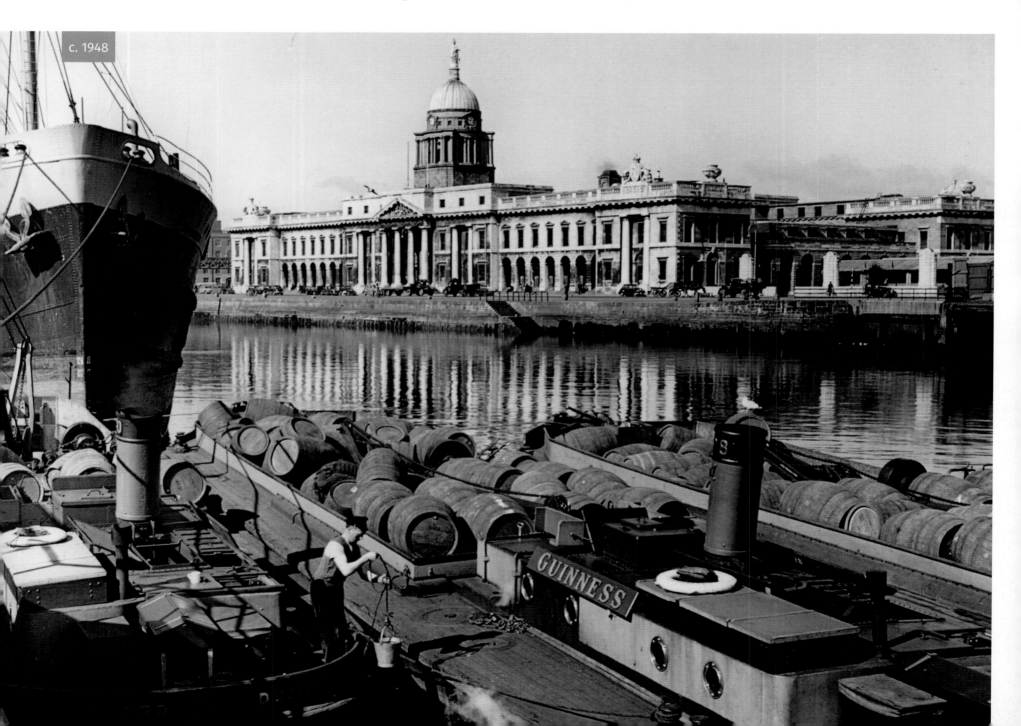

c. 1948

c. 1948

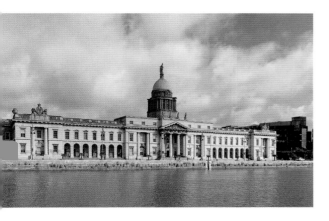

LEFT: The Custom House, designed by British architect James Gandon, was the office of Dublin port and home to the customs and revenue offices. When the building was completed in 1791 at a cost of £200,000 it was described as one of the most architecturally important buildings in Dublin. Coming at the end of a century of significant architectural development, this building marked Gandon out as an architect of great talent. He remained in Ireland and designed two of the city's other major public buildings: the King's Inns and the Four Courts. As the Custom House attracted a large volume of commercial traffic, the area around it, which had once been an upper-class residential district, changed. By the beginning of the twentieth century Foley Street and Gardiner Street was a densely populated tenement district. The port was important for providing employment for the inhabitants of the city's tenements, who worked as carters and labourers. The Custom House was burnt down by the IRA in 1921 during the War of Independence and Gandon's original interior was completely gutted. Its reconstruction was completed in December 1926 at considerable expense to the new Free State government, which was struggling financially.

BELOW: Port activities have been gradually moving east for the past few centuries. The unloading of freight was seen as a noisy and dirty activity that was undesirable in the city centre. This meant a loss of jobs for many of the area's residents, and the district surrounding the Custom House declined badly. There were calls for regeneration of the area, and many of the families who lived in the district were rehoused in Dublin's suburbs. Meanwhile the area adjacent to the Custom House was developed as the Irish Financial Services Centre (the IFSC). The building itself is home today to the Department of Housing, Planning, Community and Local Government. Pollution took its toll on the building, and by the 1980s the facade and structure were in need of work. This restoration was completed in 1991.

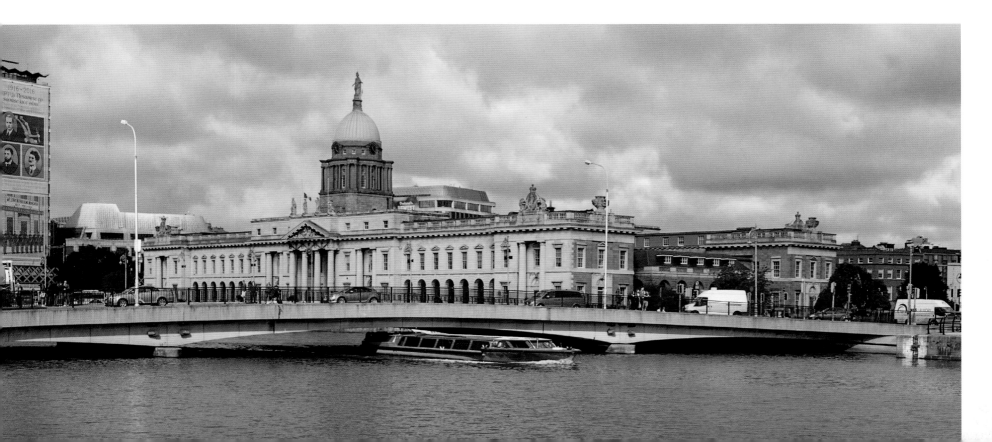

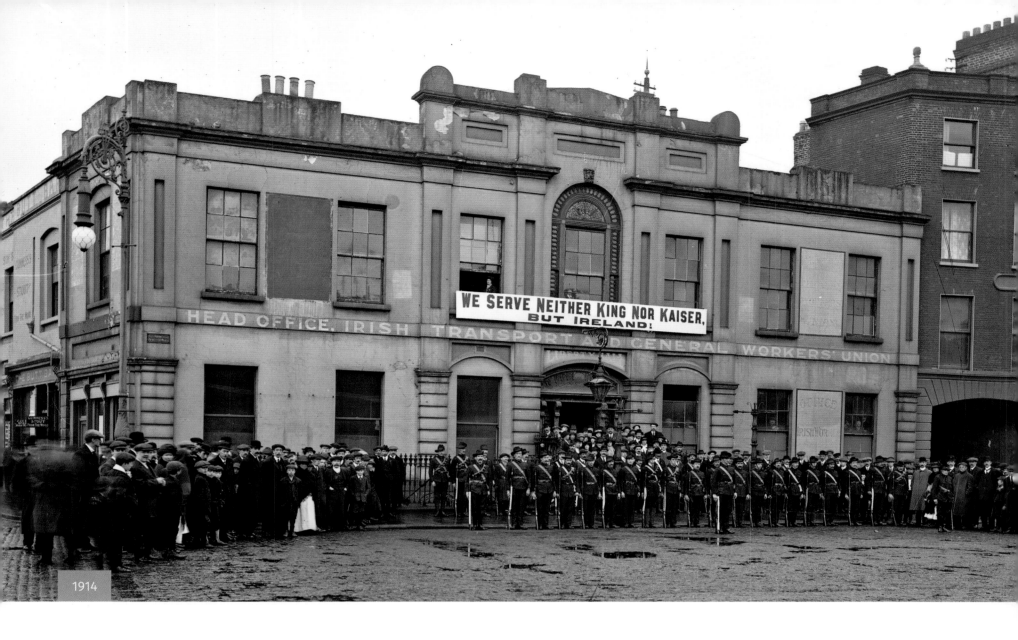

1914

LIBERTY HALL, BERESFORD AND EDEN QUAY
Championing the rights of workers in the bitter strikes of 1913

ABOVE: Liberty Hall started life as the Northumberland Hotel and Coffee House, which was built in the 1820s. In 1912 it was purchased by the trade unionist James Larkin and became the Irish Transport and General Workers Union (ITGWU) headquarters. Larkin led the Dublin Lockout, which began in August 1913, when more than 20,000 workers took on 300 of the city's employers. A soup kitchen was set up in Liberty Hall, where many of the families of those out on strike were fed. The Irish Citizen Army was formed to protect the strikers during this dispute. While the workers were forced to return to work in January 1914, it is generally agreed that conditions improved for workers after the Lockout. Labour leaders, particularly James Connolly, began to argue that for a true socialist state to be established in Ireland, the island would first have to be free from British rule. At the outbreak of World War I, a banner was hung outside the Eden Quay building stating 'We serve neither King, nor Kaiser, but Ireland'. The Irish Citizen Army and other workers can be seen outside the building.

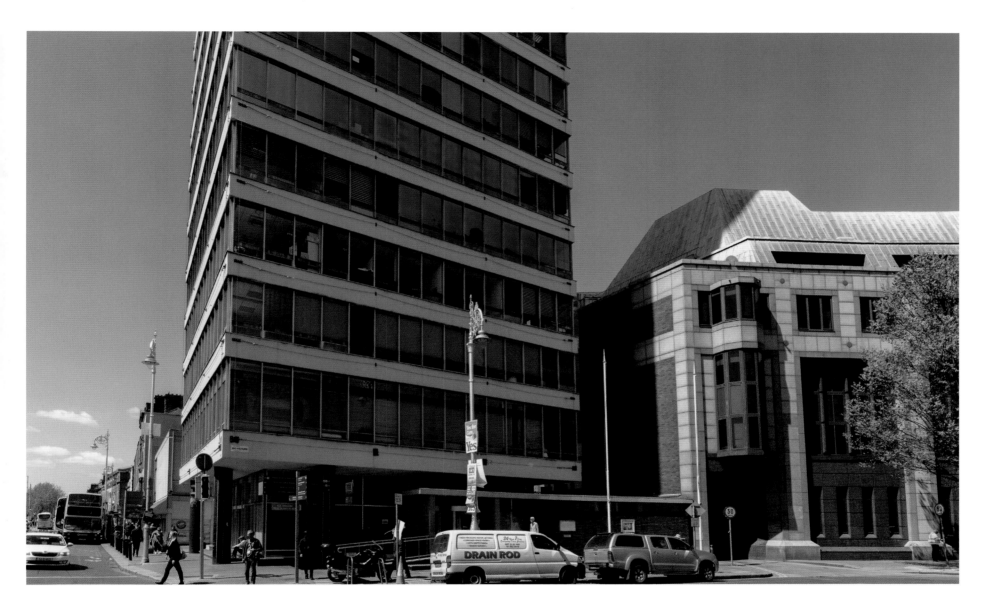

ABOVE: On Easter Monday 1916, the leaders of the Rising left Liberty Hall and marched to the GPO, where they proclaimed a republic. As the headquarters of the Irish Citizen Army, the British Army believed that Liberty Hall was occupied during the Rising, and it came under heavy fire. By the end of a week of fighting, the building was badly damaged but amazingly it survived until 1958. It was demolished and replaced on the eve of the 50th anniversary of the Rising by this building. Desmond Rea O'Kelly, the building's architect, was heavily influenced by post-war modernism. Dublin is not a high-rise city, and at 198ft, Liberty Hall is the tallest building in the capital. The building is home today to Ireland's largest trade union: Services, Industrial, Professional and Technical Union (SIPTU). Although SIPTU came close to demolishing the building in 2012, permission was overturned by the state planning agency, An Bord Pleanála. The building has been described by architectural historian Christine Casey as 'by no means a beautiful building, but not a bad one' and as the first—and so far only—skyscraper in the capital, it has become iconic.

LOOP LINE RAILWAY
Scene of a British checkpoint during the War of Independence

BELOW: Tensions had been rising between republicans and the British state in Ireland since the 1916 Rising. The official outbreak of hostilities began with the War of Independence on 21 January 1919. On this day two Royal Irish Constabulary men were shot and killed in County Tipperary. A meeting took place in Dublin of a parliament made up of Sinn Féin representatives (the political party's name means 'ourselves alone'). While the violent and political wings of the party were often led by different groups, the two movements were seen as one in the eyes of the British government.

The violence increased throughout 1920 and made its way onto the streets of the capital. Martial law was imposed in November 1920, meaning that British forces could stop and search Dubliners at will. In this photograph British soldiers watch as city workers lever up the cobblestones just outside the Custom House. There was a planned burning of the Custom House on 25 May 1921. The plan led to bad losses on the side of the volunteers: five volunteers and three civilians were killed, and eighty volunteers were arrested.

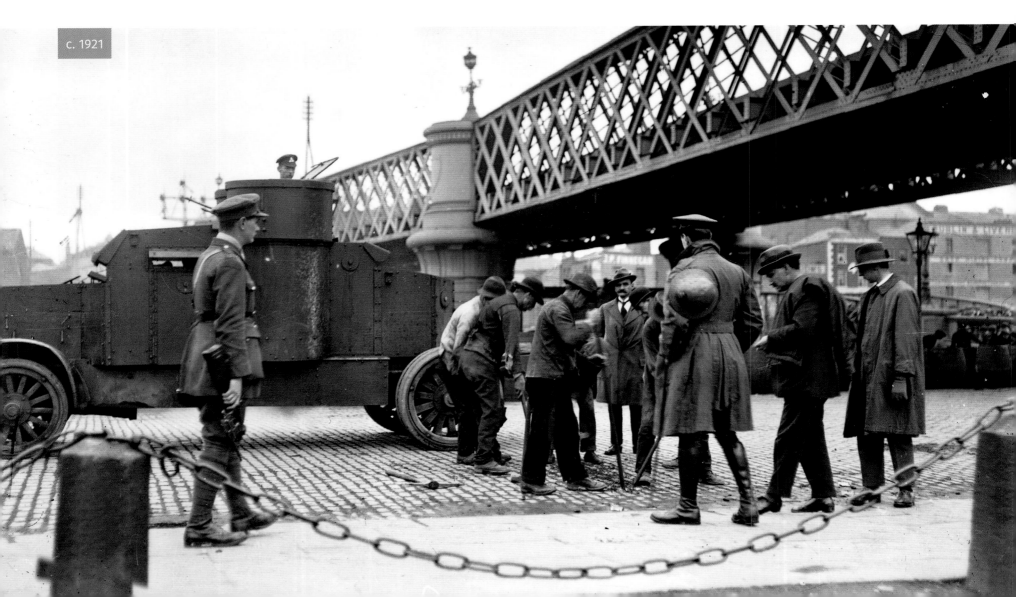

c. 1921

BELOW: On 11 July 1921, less than two months after the burning of the Custom House, a truce was called between the British government and the political assembly calling themselves the Irish Republic. This led to the signing of the Anglo-Irish Treaty in December 1921. Although the treaty meant a huge amount of autonomy and the creation of a Free State (with the promise that a border was to be negotiated at a later date), not everyone agreed with the treaty. Ratified by the Dáil and passed by the majority of the people in a referendum, the treaty led to British forces being withdrawn from Ireland in January 1922. Staunch republicans, angry at the compromises that the treaty introduced, occupied the Four Courts in Dublin and took up arms. The Civil War lasted from June 1922 to May 1923 as the new Free State army took to the streets. The republicans were defeated but the war cast a long shadow over Irish politics and society. This area saw much activity during the war years. It is now a financial services quarter in the capital. Ulster Bank's International Finance centre can be seen in the left background of this photograph.

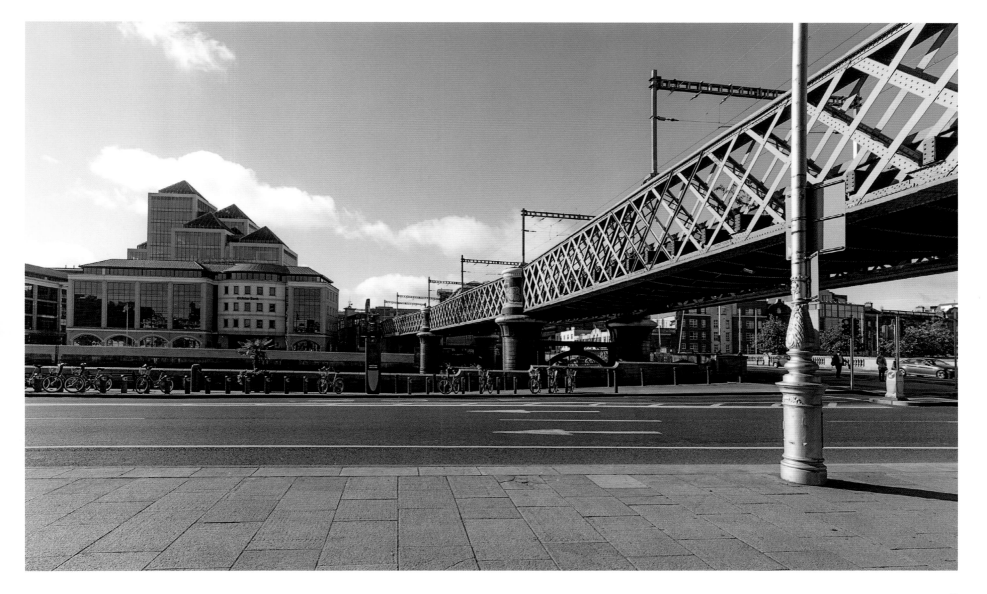

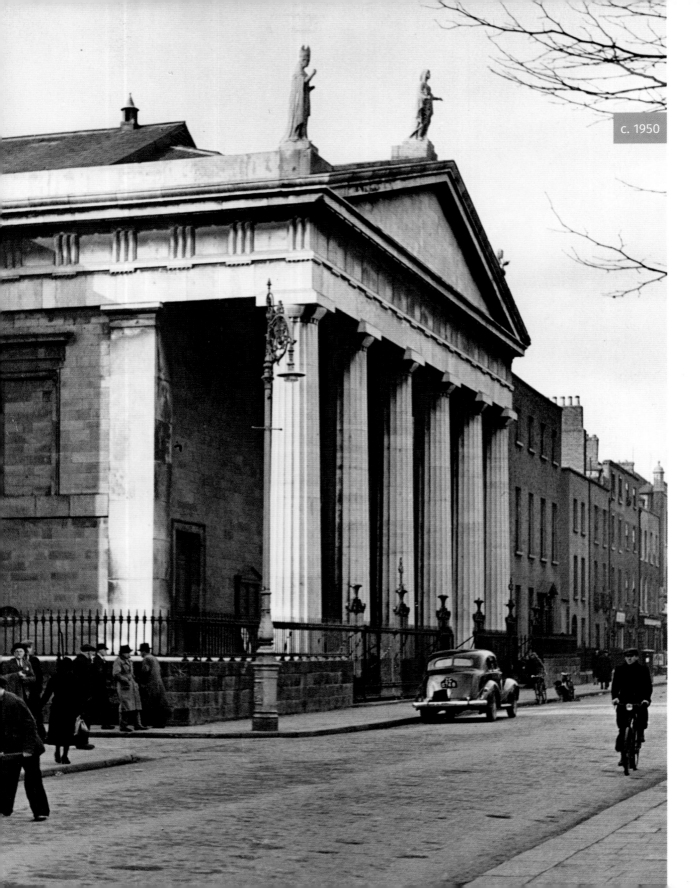

c. 1950

PRO-CATHEDRAL, MARLBOROUGH STREET

Despite its grandeur, St Mary's Pro-Cathedral is not a full cathedral

LEFT: Although Catholic emancipation did not arrive until 1829, in the 1780s there was significant relaxation of the Penal Laws that discriminated against Catholics in the 1780s. This enabled the emergence of a Catholic middle class and a more confident Roman Catholic Church. St Mary's Catholic Chapel or the Pro-Cathedral is a sign of this change in fortunes for the Catholic Church. It was built between 1814 and 1825 and provided, according to Christine Casey, 'an exemplar for Catholic Church building for over half a century'. the cathedral was the seat of the Catholic archbishop of Dublin and signified that the church had come out of hiding and was taking a central place within the capital. When Daniel O'Connell became the first Catholic Lord Mayor of Dublin, he is said to have celebrated his election by attending mass in the Pro-Cathedral. O'Connell lay in state at the Pro-Cathedral until he was taken to Glasnevin Cemetery, where his body was interred. The state funerals of Michael Collins took place in the Pro-Cathedral in 1922.

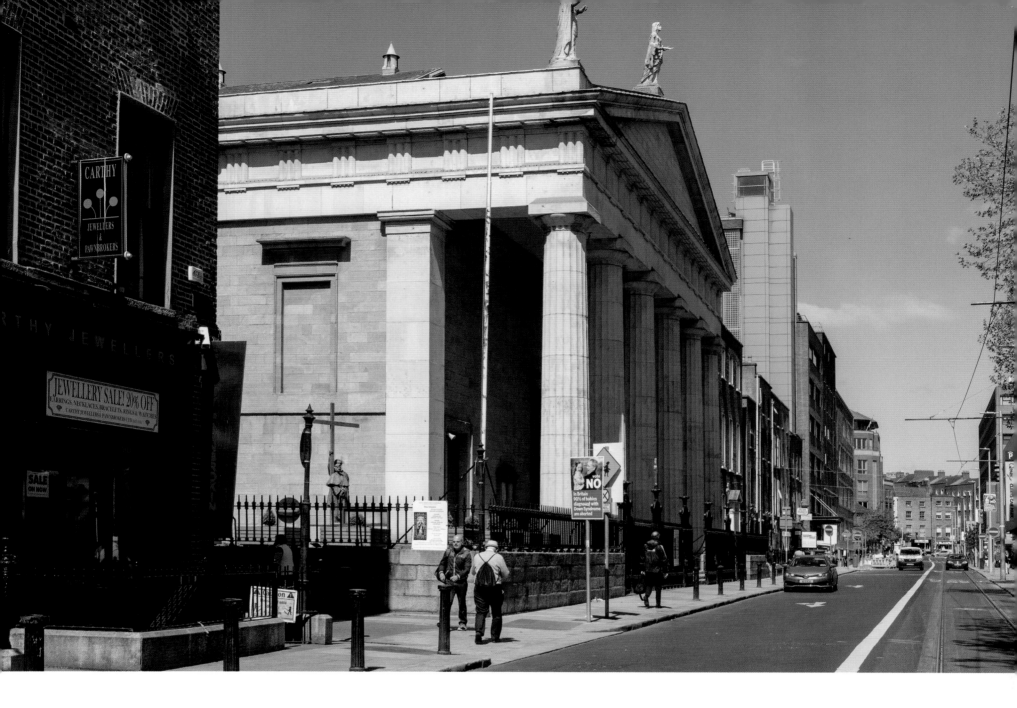

ABOVE: One of the surprising things about St Mary's Pro-Cathedral is that is not a full cathedral, although it is today treated as such. St Mary's Catholic Chapel was intended to be a temporary home for the archbishop of Dublin. It was expected that funds would be raised to build a grander, more permanent home for the archbishop. During the tenure of John Charles

McQuaid as archbishop of Dublin (1940-1972) there were attempts made to find a more prominent location. McQuaid had the gardens of Merrion Square purchased so that this new cathedral could be built. These plans never came to pass, however, and the square passed into the hands of the city. The Pro-Cathedral remains at the heart of the Catholic Church in Dublin and is still

the seat of the archbishop of Dublin. Three twentieth-century Irish presidents have had state funerals in the Pro-Cathedral, including Éamon de Valera, Sean T. O'Kelly and Patrick Hillery. The republican and former Lord Mayor Kathleen Clarke (wife of the 1916 Rising leader Tom Clarke) was also given a state funeral at St Mary's.

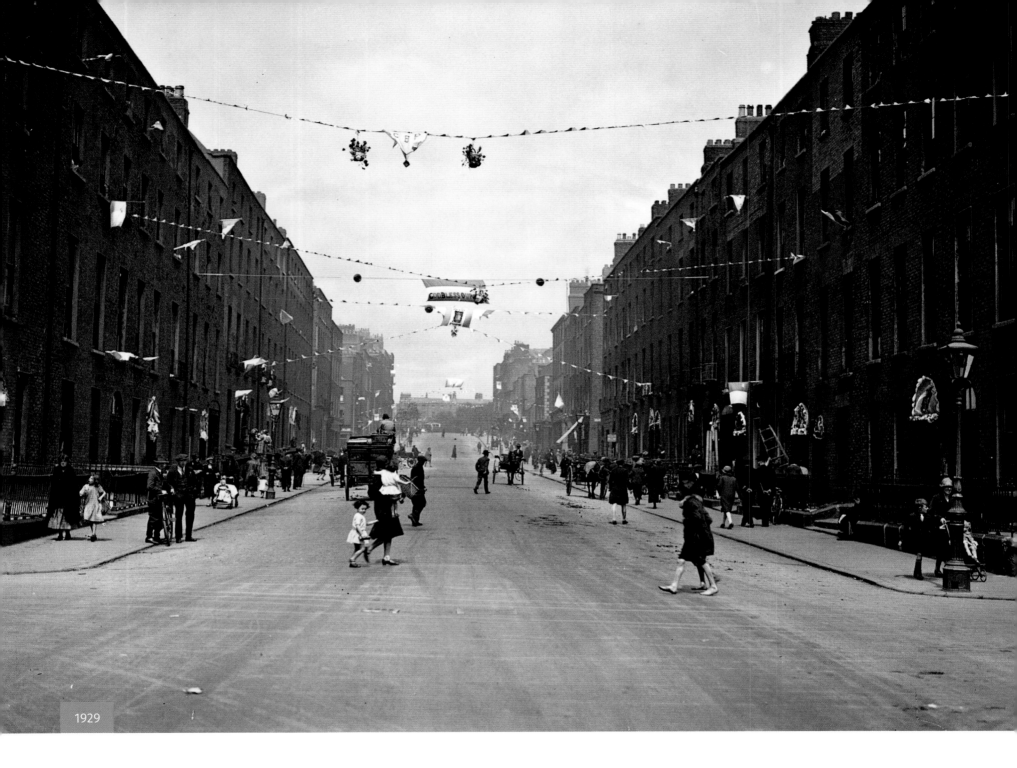

1929

GARDINER STREET

The Georgian houses on Gardiner Street have survived many incarnations over 200 years

LEFT: Gardiner Street is named after the Gardiner family of property developers. Luke Gardiner senior was the first of three generations, and Gardiner Street ran through the heart of his northside estate. The streets were laid out, the land was leased on terms of 99 years and the occupiers would build their houses in a uniform manner as stipulated by the lease. They also laid out Gardiner Place and Row, Montgomery Street, Mountjoy Square, Henrietta Street, Rutland Street and Sackville Street. The northside was by far the most fashionable side of the city until the arrival of the Custom House in the 1790s. Once the upper and middle classes began to move out in the early nineteenth century, Dublin's lower classes moved in to what were once the grand townhouses of the capital's richest. This image was taken on the centenary of Catholic emancipation in 1929. The exterior of the buildings look well-preserved, but the building interiors were changed beyond recognition, broken up into one- and two-room tenement apartments where large families would have lived.

ABOVE: The tour guides and architectural historians Gregory and Audrey Bracken have said 'when people think of Georgian Dublin they generally think of the southside: places like the Georgian Mile, Merrion Square and St Stephen's Green. In fact, Dublin's northside had much more accomplished architecture: it is here that you will see the city's acknowledged masterpieces.' Gardiner Street illustrates the decline of this Georgian architecture. Dublin was in decline in the nineteenth century and these grand townhouses were put to a number of uses. They were tenements in the nineteenth century, but became hotels and B&Bs from the 1940s onwards, when tourism became an important source of revenue for the city. They are the best surviving examples of late Georgian residential housing in the city centre. It is perhaps remarkable that these buildings—originally built to last for only 99 years and altered for so many purposes over the course of their lives—are still standing today. They are a testament to Georgian craftsmanship.

c. 1950

MOORE STREET

The longest-running outdoor food market in Ireland

ABOVE: Like much of the surrounding area, Moore Street dates from the early eighteenth century. The fruit and vegetable market located on the street is the oldest outdoor food market in Ireland and the most iconic market in Dublin. By the early twentieth century meat, poultry and fish were sold from the shops on the street, and fruit and veg was sold from the stalls outside. The street became embroiled in the 1916 Rising when the GPO was set ablaze. During the evacuation of the GPO 'The O'Rahilly', one of the leading figures of the Volunteer movement, died from wounds on the street. The leadership who had been stationed in the GPO assembled at No. 16 Moore Street, at the back of a poultry shop, to decide the fate of the new republic. It was from this street that Patrick Pearse surrendered to the British army on 30 April 1916. Heavy fighting on the street and in the surrounding area left the street badly damaged, and in the aftermath of the Rising many of the destroyed buildings were replaced with twentieth-century gabled houses. The food market remained one of the busiest shopping districts in the city centre throughout the twentieth century.

c. 1968

ABOVE: In the 1960s, during a time of huge change for Dublin's inner city, Corporation inspectors reported that they found the markets on Moore Street 'unhygienic and unsuitable' for food preparation, and there followed an attempt to redevelop the area. Permission was given to knock down buildings on the west side of the street, and the Ilac shopping centre was opened in 1981. Despite these attempts to sanitise the area, the markets have continued to this day and the street has retained much of its original character. The buildings that the 1916 signatories to the Proclamation of the Republic met in have survived, along with tunnels they made trying to escape British bombardment. Dublin City Council rezoned the buildings for a 1916 Rebellion Museum, but there has been much controversy and many protests about the integrity of these plans.

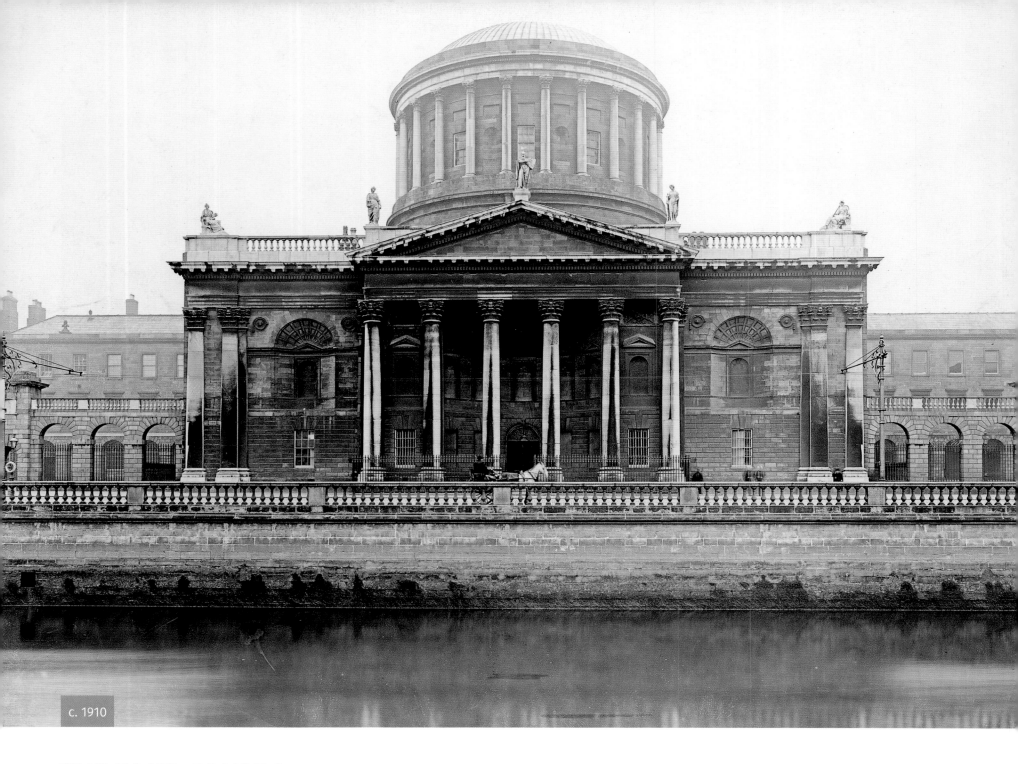

c. 1910

THE FOUR COURTS

A focus of fighting in both the War of Independence and the Civil War

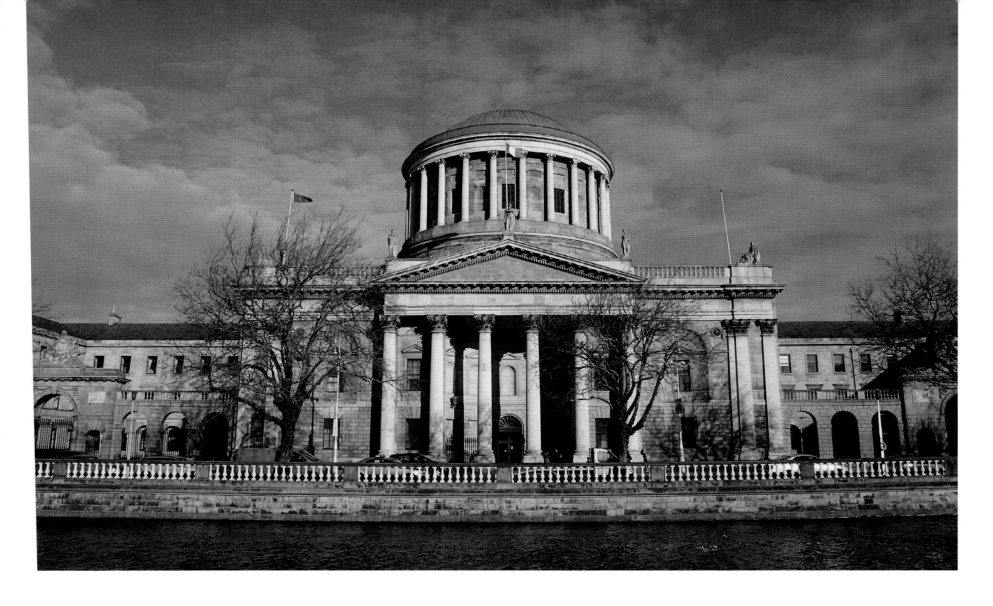

LEFT: The Four Courts, which started life as a record office, were designed by Thomas Cooley (architect of the Royal Exchange—now Dublin City Hall). The northwest corner of the building was the only section completed when Cooley died in 1784. Completion of the building fell to James Gandon, who was simultaneously working on the Custom House. Gandon's plans for the building were considered quite radical for the day and he came in for strong criticism for his 'geometrically complex plan' of symmetrical rooms. Dubliners complained in particular that the design had such a prominent place on the Liffey, but Gandon was supported by the viceroy, the Duke of Rutland, and he was allowed to carry out his plans without interference. The Four Courts' dramatic dome was based on the Pantheon in Rome and was the largest dome in Dublin when it was put in place. Despite initial hostility to the building it quickly won the city's inhabitants over. Dublin's law courts moved in during the 1790s, although the building was not fully completed until 1804.

ABOVE: Significant fighting took place around the Four Courts during the 1916 Rising. Areas behind the Four Courts such as North King Street and the Linenhall Barracks experienced intensive fighting. Nevertheless, the Four Courts emerged relatively unscathed from the conflict. The building was not so fortunate during the Civil War. In June 1922 it was occupied by anti-treaty forces, who rejected the agreement and called on the provisional government to do likewise. The government issued an ultimatum to the forces inside the building, and when that was rejected government forces opened fire on the Four Courts. After a day of bombardment, three anti-treaty fighters had been killed, and the building was on fire and badly damaged. The government forces took the building but a week of fighting in the capital, known as the Battle of Dublin, ensued. The building was restored in the late 1920s, but none of Gandon's interiors had survived. Among the most significant losses were the records housed within the Four Courts. Centuries of Irish records were destroyed in the fire.

SMITHFIELD
Home to the city's horse fair

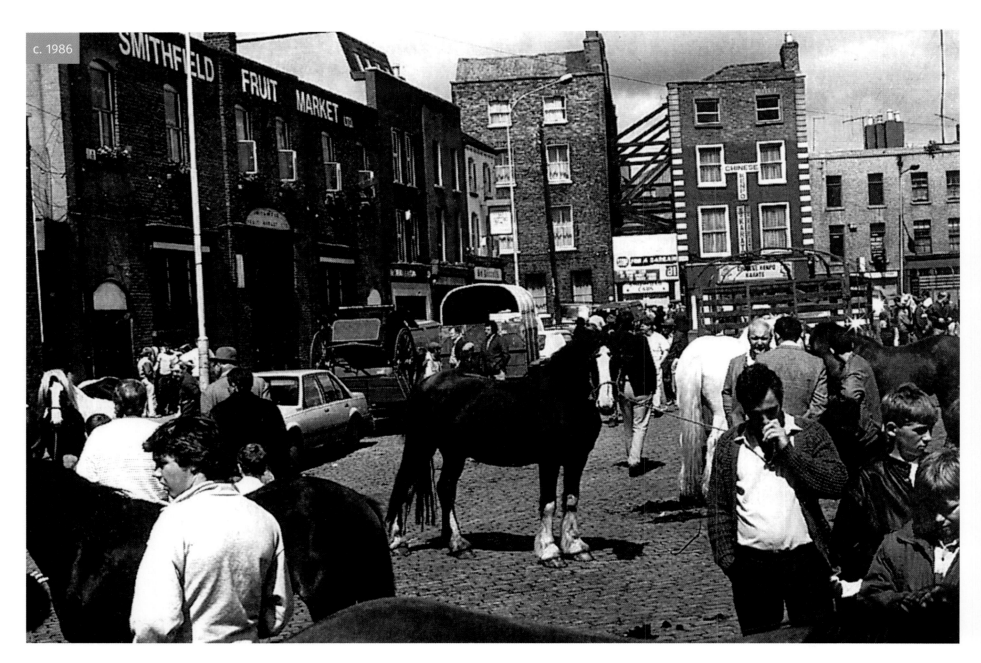

c. 1986

LEFT: Smithfield Square was laid out on the 1660s by Humphrey Jervis. Although it succeeded in attracting some Irish nobility to live there, notably the Earl of Bective, by the early eighteenth century it was a commercial and industrial centre. The Jameson distillery, founded on Bow Street in 1780, had expanded to the east side of the square by 1805. With Dublin's fruit and veg market to the east, and Stoneybatter's cattle market to the west, Smithfield was at the centre of Dublin's agricultural trade and markets. Smithfield was also home to the city's horse fair, which took place on the first Sunday of every month. Although it has been claimed that the fair dates from the eighteenth century, in reality it probably began in the twentieth century. The commercial nature of the square can be seen in this picture: Smithfield Fruit Market to the right and the horse fair take up the centre of the image. At the back-left corner the Cobblestone pub can just be seen. The family-owned pub has been closely linked with Dublin's traditional Irish music scene for over five generations.

BELOW: From the 1990s, controversy followed the fair. Violence and criminal activity became a part of the monthly gathering and it was condemned by animal rights groups such as the Dublin Society for the Prevention of Cruelty to Animals. The area was earmarked for regeneration under a city Historic Area Rejuvenation Project (HARP). Much of the west side of the square was torn down to be rebuilt as apartments and commercial units. Development took time but the area has fared better in recent years. The Jameson visitor centre and the Cobblestone pub attract many tourists to the area. The site where Smithfield Fruit Market once stood is now occupied by the Maldron Hotel and a supermarket. The Lighthouse Cinema, Generator hostel and market and restaurants on the square give the area a lively feel. In 2013 a city council by-law was passed to limit the horse fair to twice a year, and it now takes place each March and September.

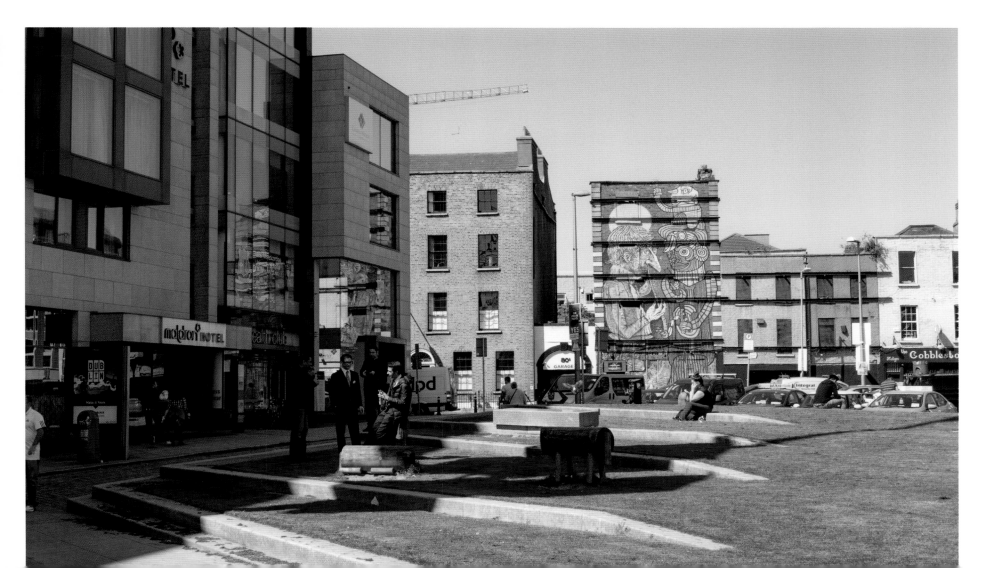

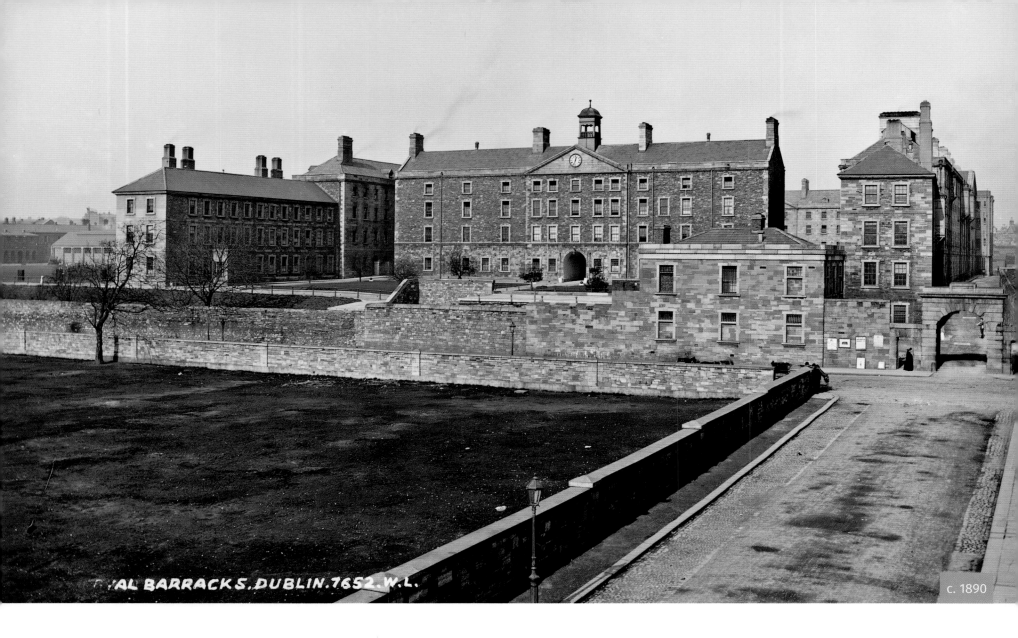

AL BARRACKS.DUBLIN.7652.W.L.

c. 1890

COLLINS BARRACKS

The largest barracks in Europe when constructed

ABOVE: In the aftermath of the Glorious Revolution, when the Protestant King William of Orange defeated Catholic King James at the Battle of the Boyne (1690), the government embarked on an ambitious project of building barracks throughout the country. The Royal Barracks in the capital was particularly important and it says much about the state of Ireland in this period, when a Protestant minority ruled over the Catholic majority. When it was built it was the largest military barracks in Europe. As well as being a recruiting and training centre, the barracks could house up to 5,000 soldiers. Although it lay outside the city when it was built, there was much hostility to having such a large force garrisoned so close to the capital. In the foreground of the picture is Croppies' Acre, which was used as a parade ground during the eighteenth century and later became a cemetery for dead rebels after the 1798 rebellion (the United Irishmen wore their hair in a 'cropped' French revolutionary style).

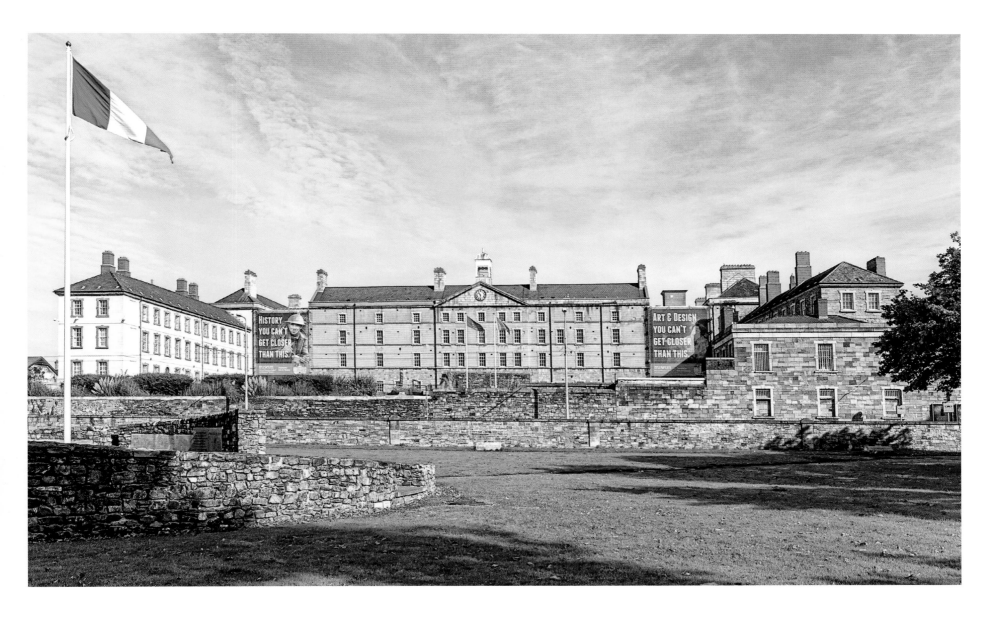

ABOVE: In 1922 the Irish Free State were handed control of barracks across the country as British troops withdrew. Although many of these barracks had been used during the Civil War, the state had little purpose for them and they were decommissioned in the aftermath of the conflict. Royal Barracks became Collins Barracks, named after Michael Collins, who was killed in 1922 during the Civil War. In 1998 plans were drawn by the Office of Public Works to have the buildings at the barracks converted for use as one of the wings of the National Museum. There are four divisions of the National Museum: the Museum of Country Life (Turlough Park in Mayo), Natural History Museum (Merrion Square, Dublin), Archaeology (Kildare Street, Dublin) and Decorative Arts at Collins Barracks. The barracks is also home to the museum stores and their permanent exhibitions include the Asgard boat (which was used by the Irish Volunteers to smuggle guns to Ireland during the build-up to the 1916 Rising), The Way We Wore (a history of Irish clothes) and Four Centuries of Irish Furnishing.

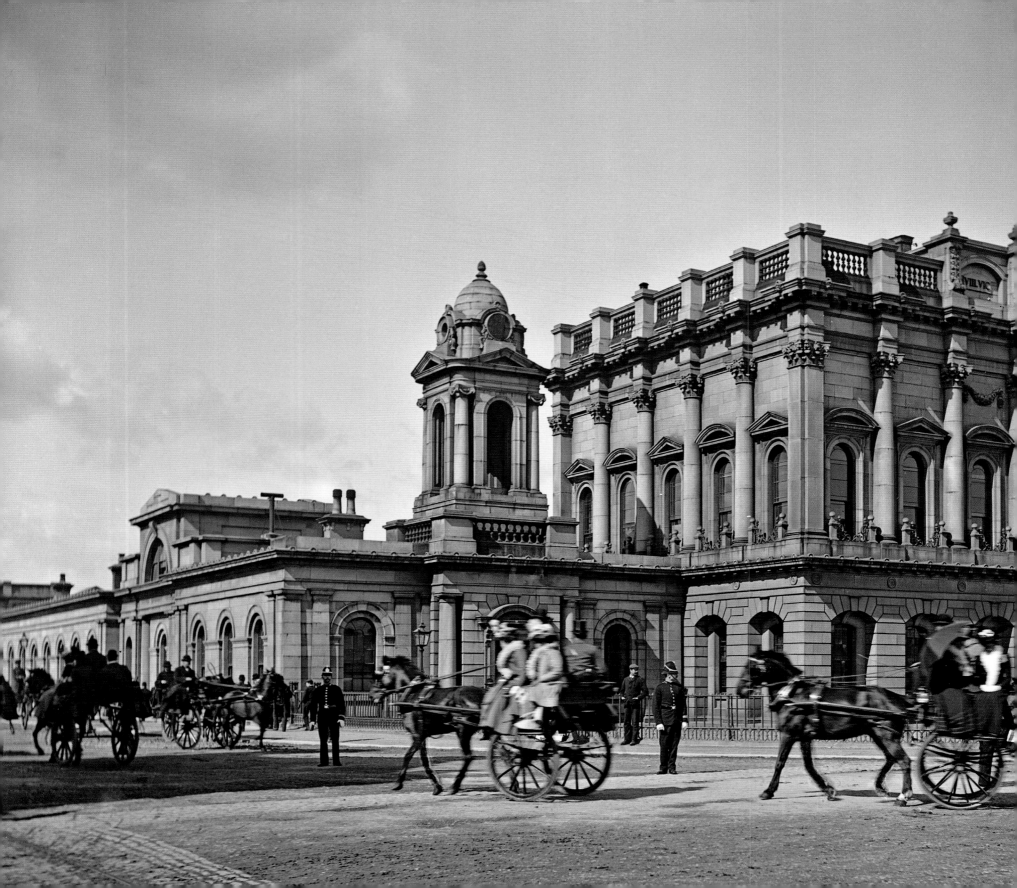

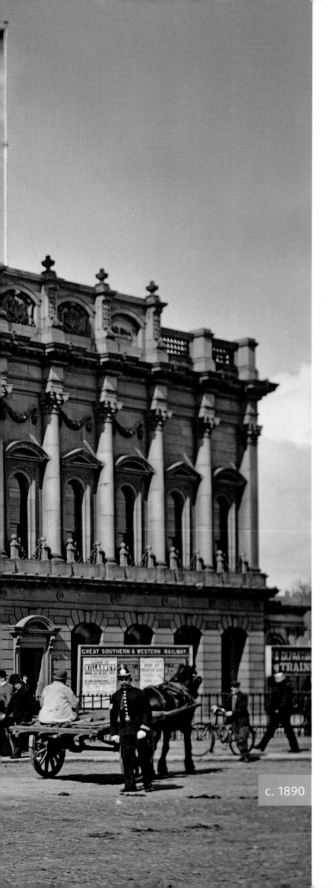

c. 1890

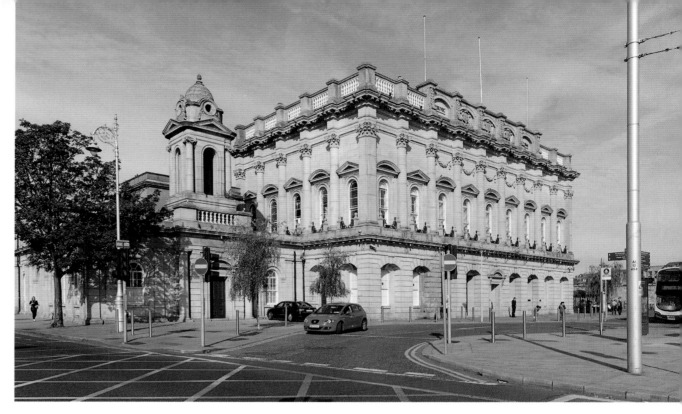

KINGSBRIDGE TERMINUS / HEUSTON STATION
Built in the great railway age of the early Victorian period

LEFT: The train shed opened in 1846 and was originally called Kingsbridge Terminus. It was designed by Sir John MacNeill. The station itself was designed by Sancton Wood and opened two years later. The station was a Dublin terminus of the Great Southern and Western Railway. Wood's building made room for a ticket office, company offices, and a dining hall (now gone) for company employees. The first train station in Dublin was opened on Westland Row in the city centre. Kingsbridge was built on the fringes of the city, where it would have been cheaper to open a railway line. From the 1840s train stations began to spring up all over the island, and Dublin, as the administrative and economic centre of the island, was the destination for many of these new routes. These train lines were open and operated by private companies and one of the challenges in later years was connecting these different railway lines to each other. The engineer William Dargan drove much of this early railway expansion and is known as the father of Irish railway.

ABOVE: By 1920 there were 3,500 rail routes operating to all parts of the island, but today there are less than half that number. Most surviving lines operate to and from the capital. Railway lines were badly damaged during fighting in the War of Independence. Greater damage was inflicted on the lines, which were used by government forces to move troops and supplies, during the Civil War. By the mid-twentieth century Irish trains were converted from steam to diesel. Routes were decommissioned as many passengers converted to buses and cars, which seemed to provide greater flexibility. During the fiftieth anniversary of the 1916 Rising, city stations all over Ireland were renamed after rebels who were executed in the aftermath of the 1916 Rising. Kingsbridge Station was renamed Heuston Station after the Irish Volunteer and railway clerk Seán Heuston. Today the station has nine platforms, eight terminating and one through-line on the Phoenix Park Tunnel line. Passengers can catch intercity services to Cork, Limerick, Waterford, Galway, Mayo and Kerry.

c. 1895

PHOENIX PARK
Established in the seventeenth century, it is double the size of New York's Central Park

LEFT: The foundations of the eighteenth-century architectural and cultural development of Dublin were laid in the 1660s. The Duke of Ormond returned to Ireland after the restoration of King Charles II and set about making Dublin a capital worthy of the name. As well as improving the castle and encouraging building throughout the city, he also laid out Phoenix Park. Ormond purchased 1,200 acres on the northside of the city and set about creating a deer park. Over £40,000 was committed to the project. Ormond erected a number of houses on the property, including Chapelizod House. The park became an important space for Dubliners. In the 1770s *The Freeman's Journal* published complaints about hurling matches in the grounds: 'The Sabbath is abused by permitting a hurling match to be played there every Sunday evening which is productive of blasphemous speaking, riot, drunkenness, broken heads and dislocated bones'. The 203ft-tall Wellington Obelisk, erected in honour of the Irish-born Duke of Wellington and his victories, can be seen here along the main avenue.

ABOVE: Phoenix Park is today the largest urban enclosed park in Europe. It comprises just over 1,730 acres and has retained its original function as a deer park. It remains an important recreational space within the city and is home to Dublin Zoo and the People's Park. Phoenix Park is also home to the Irish president, who lives at Áras an Uachtaráin, the former residence of the British viceroy. The Irish president is not head of government; his position is head of the Irish Republic, which is more of a figurehead role. Nevertheless, the position has become more prominent in recent decades and has been held by a number of prominent activists, including Mary Robinson (former high commissioner of the UN Human Rights Commission), Mary McAleese (a Belfast-born journalist who was actively involved in the Northern Irish peace process) and Michael D. Higgins (a poet and social reformer). The American ambassador's residence is also in the park.

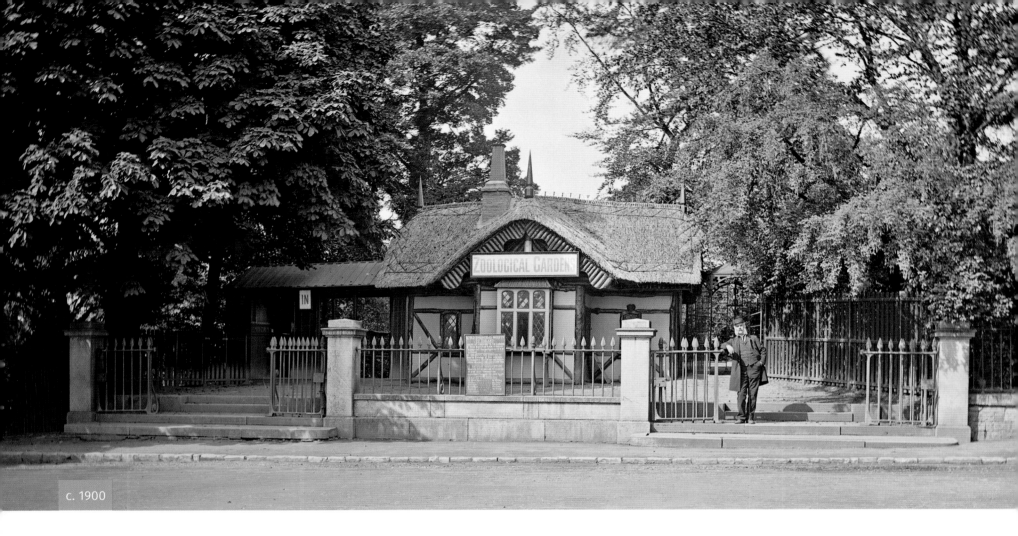

DUBLIN ZOO

Very possibly the home of the Metro Goldwyn Mayer lion

ABOVE: Dublin Zoo was founded in 1830 and opened its doors on 1 September 1831. It is the second-oldest zoo in the world. London Zoo was founded in 1828, so narrowly pre-dates Dublin Zoo. The 46 mammals and 72 birds on display when Dublin Zoo first opened its doors in Phoenix Park were donated by London Zoo. The original entrance fee to Dublin Zoo was sixpence, a high price that ensured only the wealthy and middle class could enter. This picture shows the former entrance to the zoo and the zookeeper's lodge, which was built in 1833 for just £30. In 1838 the zoo decided to mark the coronation of Queen Victoria with free entrance, and 20,000 people visited over the course of one day (which remains the highest number of visitors on any one day). The zoo added giraffes in 1844 and lions ten years later. By the end of the century there was also an elephant (see inset). The zoo remained one of the top tourist attractions in the city throughout the nineteenth century.

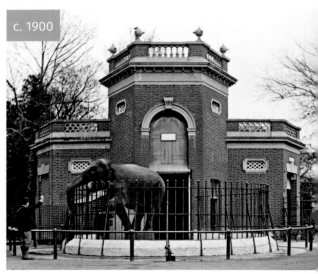

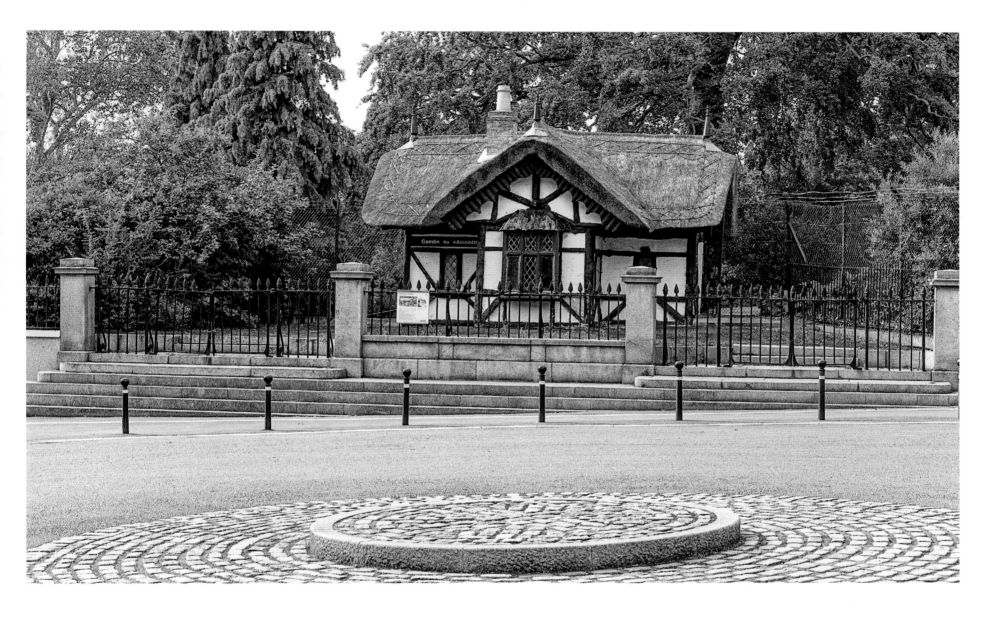

ABOVE: Today the zoo covers 69 acres of Phoenix Park, and rather than being focused on displaying animals and monitoring them for scientific study, today the zoo's mission is to 'work in partnership with zoos worldwide to make a significant contribution to the conservation of the endangered species on Earth'. During World War II, which was known as the Emergency in Ireland because the country remained officially neutral, the zoo became extremely popular, and Dubliners who were worried about the impact of rationing donated food for the animals. One of the zoo's claims to fame is that Metro Goldwyn Mayer were seeking a lion for the films credits, they shot a number of lions from the zoo, making it likely that their mascot Leo (shown at the start of all MGM films) was from Dublin. There are still a number of Victorian houses and enclosures in the zoo, giving visitors a glimpse of what a Victorian zoo would have been like. Dublin Zoo is a member of the European Endangered Species Programme. The entrance was moved in the early 1990s to help preserve the original lodge.

HOLE IN THE WALL PUB, BLACKHORSE AVENUE

The pub got its name through some stealthy enterprise

BELOW: The Hole in the Wall pub stands at one of the east gates of the Phoenix Park and claims to have the longest bar in Ireland as well as being the longest pub. It is older than the Phoenix Park itself, and was established in 1650 as a coach house to serve travellers on their way in and out of the city. The building dates from 1610, and when the coach house opened it did so under the sign of the Black Horse, which also lends its name to the avenue the tavern is located on. Daniel O'Connell is said to have stayed in the coach house, although it became exclusively a pub in the second half of the nineteenth century. The easternmost end of Blackhorse Avenue is close to Prussia Street in Stoneybatter, and the Prussia Street cattle market (founded in 1862) must have provided a good customer base for the pub. The erection of a military barracks at Blackhorse Avenue in 1893 would have augmented this trade.

c. 1905

HOLE IN THE WALL, PHOENIX PARK, DUBLIN 6937. W.L.

BELOW: British soldiers stationed at McKee Barracks within the Phoenix Park were not allowed to leave their garrison at night, and so the pub began the tradition of serving the soldiers through a hole in the Phoenix Park wall. The practice became so famous that the pub became known as the Hole in the Wall. The park remains an important customer point for the pub, which advertises itself today as the closest pub within walking distance of the park. It has been run by the McCaffrey family for over forty years. The pub remains a popular destination for Dubliners and tourists alike.

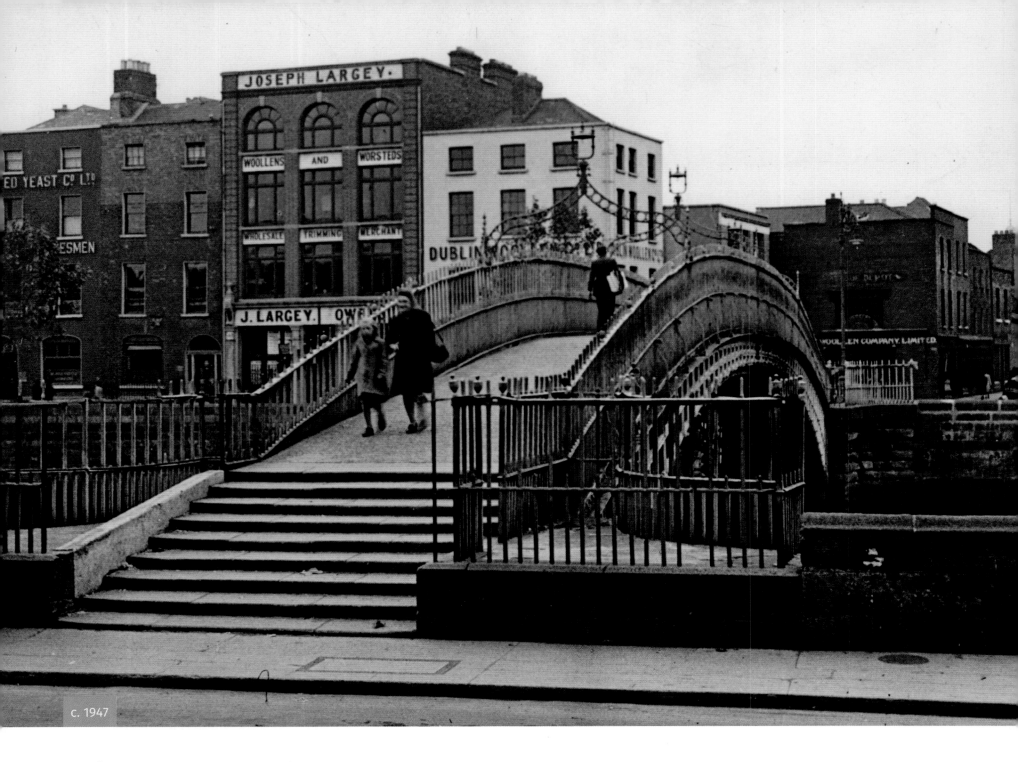

c. 1947

HA'PENNY BRIDGE

The toll to use it became its name

82

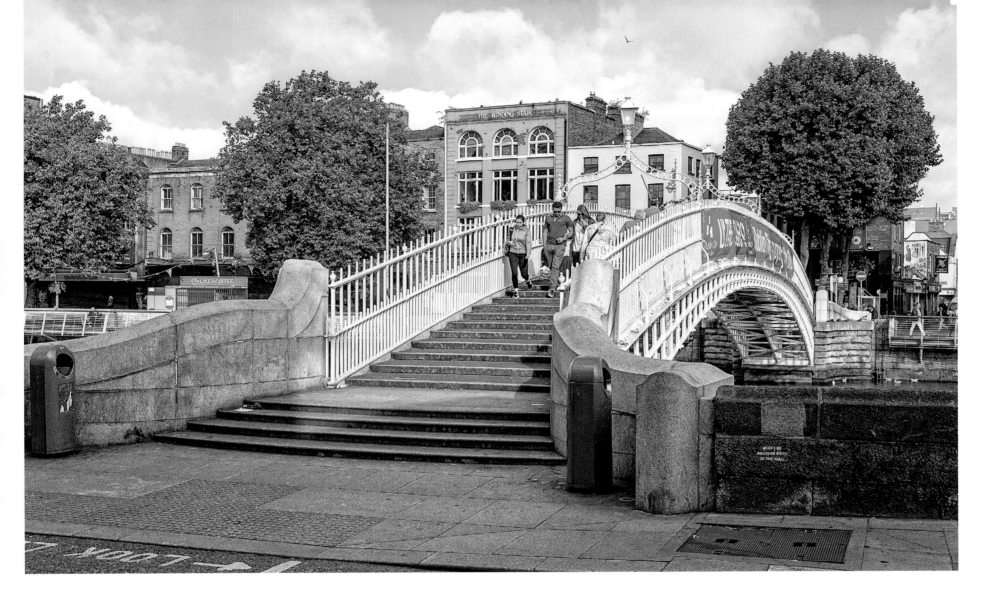

LEFT: In times gone by, getting across the city could be a challenge. To avoid dangerous city traffic, and traffic jams on the city's bridges, ferries were in use on the Liffey until the beginning of the nineteenth century. Dublin Corporation wanted to build a pedestrian bridge to decrease the time it took to get across the Liffey on foot, so they bought the Liffey's main ferry operator, William Walsh, out of his business. Walsh was given £3,000 and allowed to hold the lease on the bridge for 100 years if he maintained the structure. The bridge was one of the first wrought-iron structures of its kind and was built in Coalbrookdale in Shropshire, England. It is made up of three parallel arch ribs over a single elliptical iron arch. The price of crossing was set at a halfpenny, but to lure Dubliners in they were given ten days free of the toll. Although officially named Wellington Bridge after Dublin-born Arthur Wellesley, the Duke of Wellington, it unofficially became known as the Ha'penny Bridge. In 1916 the charge was dropped and the bridge was opened to the public for free.

ABOVE: From the 1930s and 1940s the bridge was used for advertising purposes, and hoardings hid the ribcage steel girders. During World War II, Ireland, which remained neutral and was outside regular wartime restrictions, became a tourist destination. The unsightly signs hid the beauty of the iconic bridge and were taken down towards the end of the 1950s to aid tourism. The bridge was painted silver during the 1960s but during its restoration in 2002 it was returned to the original white. By the 1990s the bridge was badly in need of repair and it underwent extensive conservation. In the past few years a tradition of attaching padlocks to the bridge has come about. This practice has been criticised by many locals and Dublin City Council, who argue that not only does it take from the overall appearance of the bridge but that the locks are expensive to remove and damage the overall structure. In 2016 the bridge's 200th birthday was marked in the city with much celebration, and a red carpet was rolled out over the bridge.

1969

MERCHANT'S ARCH

One of the city's busiest pedestrian routes

LEFT: Merchant's Arch is the busy thoroughfare people take to cross to, or from, the Ha'penny Bridge. The archway is part of the nineteenth-century merchants' guild hall, a three-bay, granite palazzo that was opened in 1821. This was a busy financial district in the early nineteenth century. The guild hall was a short walk from the Commercial Buildings on Dame Street, opened in 1799, where the Dublin stock exchange and many of the city's insurance companies were based. Dublin's economic fortunes declined badly from the 1820s. Although this is often blamed on the passage of the Act of Union, there were a number of reasons for the decline. Linen, a pillar of the eighteenth-century Irish economy, was not as much in demand in the nineteenth century. Many of the city's wealthiest inhabitants moved to the suburbs and refused to pay taxes in the city. Belfast also continued to expand, at the expense of Dublin. The building ceased to operate as a guild hall by the mid-nineteenth century and was used for a variety of purposes. By the 1960s there was a second-hand bookshop, used-furniture and clothing shops in the lane.

RIGHT: The Merchant's Guild Hall is the only surviving nineteenth-century guild hall in the city, although Tailor's Hall off High Street is older, dating from 1706. Although much of Temple Bar has changed since the 1960s, including the addition of a towering building that houses the Irish Central Bank, Merchant's Arch has remained a busy portal to the city's nineteenth-century past. The archway, along with the Ha'penny Bridge, is an iconic part of Dublin and is visited by many tourists. The building remains home to a variety of businesses, including a pub, restaurants and a shoe shop. In June 2016 the archway partially collapsed, and although no-one was seriously injured, the structure was assessed due to safety concerns. It is now undergoing restoration.

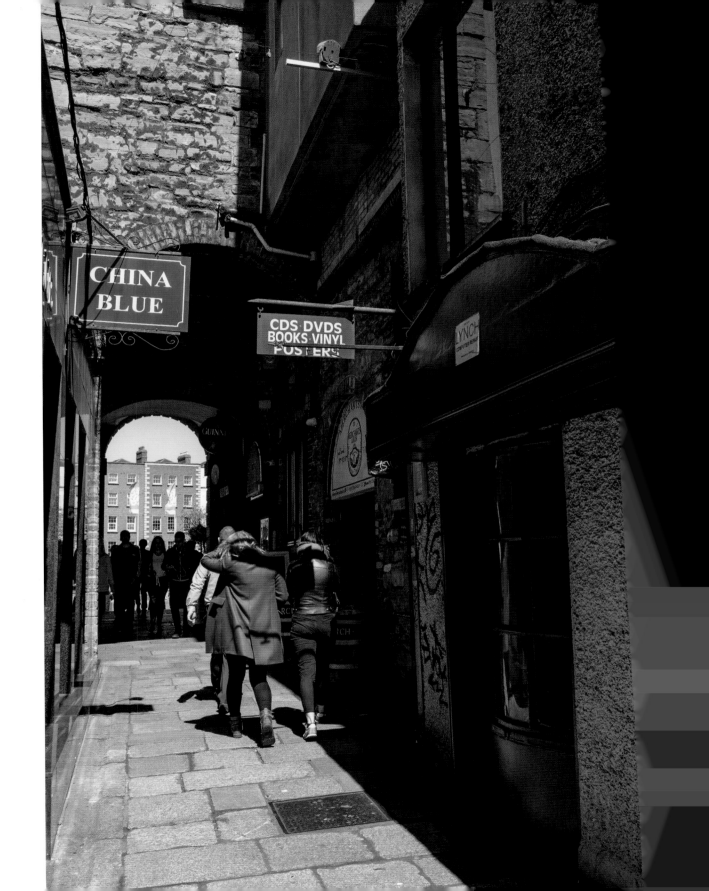

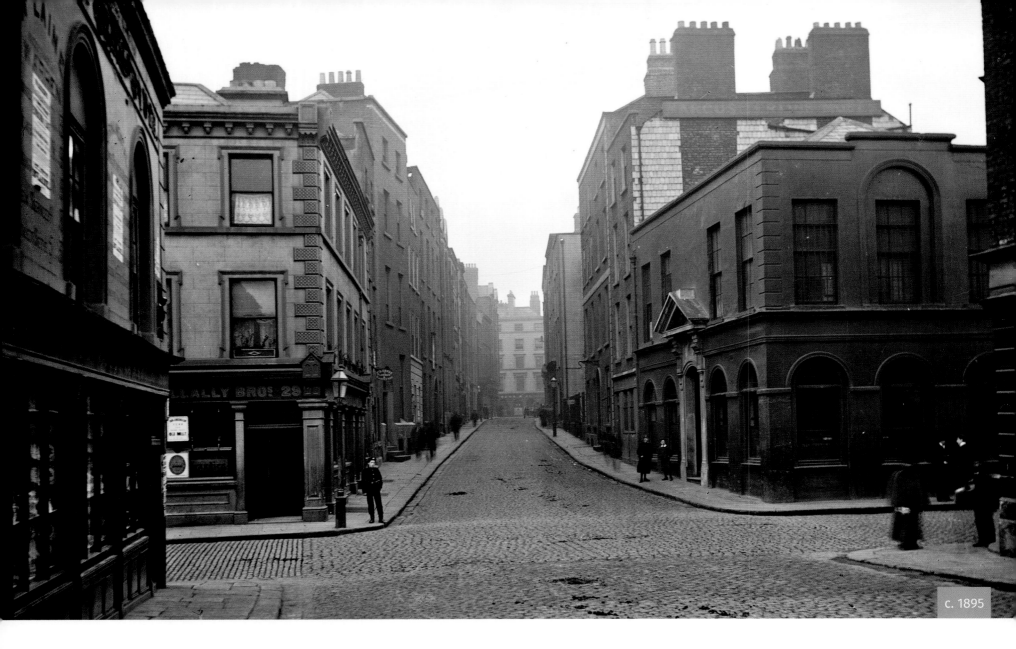

c. 1895

EUSTACE STREET, TEMPLE BAR
Built on land reclaimed from the river Liffey

ABOVE: When the Vikings settled in Dublin in the ninth and tenth centuries, the Liffey was wider in parts and stretched in sections from the current river bed towards Dame Street. Land was at a premium, even in the medieval city, and Eustace Street was one of the sections of the river bed to be reclaimed from the Liffey. Although the photographer has his back to the Liffey, the incline of the river bed can be seen in the image. During the eighteenth century and into the nineteenth century this was a religious quarter. The New Light Presbyterian Meeting House and a Quaker Meeting House were located on the Dame Street end of the street. The street was also home to the Eagle Tavern, which was said to be where the inaugural meeting of the Dublin Hellfire club took place in the 1730s. The Dublin branch of the United Irishmen was also founded in the Eagle Tavern in November 1791 by Theobald Wolfe Tone and like-minded radicals.

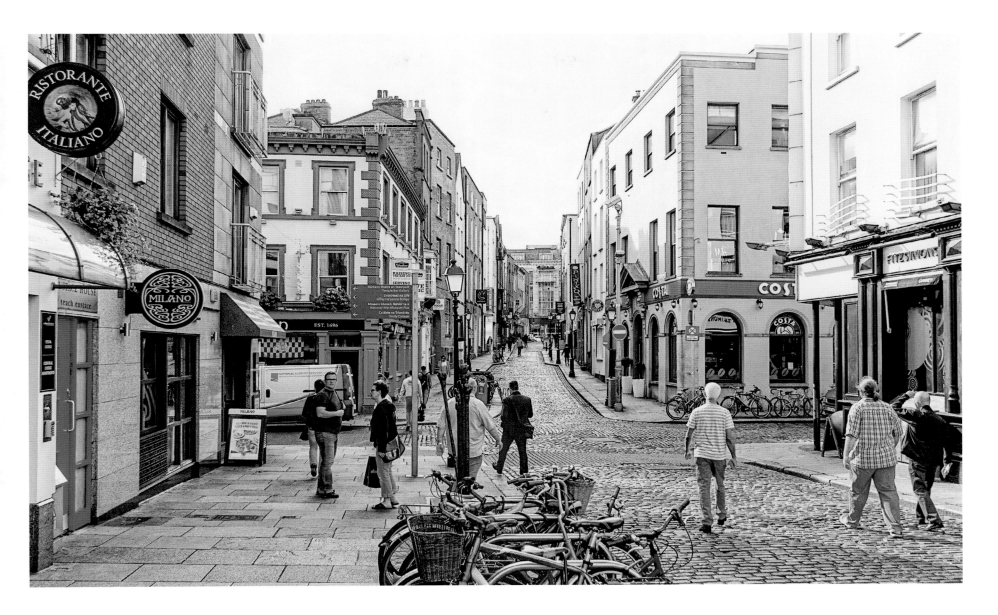

ABOVE: Eustace Street, and the wider area known today as Temple Bar, became very dilapidated and rundown in the twentieth century. In the 1980s the area was given government support to be developed as a cultural quarter, and a government-sponsored group, Temple Bar Properties Ltd, set about attracting businesses, cultural enterprises and tourists to the area. In September 1992 the Irish Film Centre (now Irish Film Institute) opened its doors on Eustace Street in the former Quaker Meeting House. It was joined in September 1995 by The Ark (a cultural centre for children), which moved into the former Presbyterian Meeting House. Meeting House Square, which lies behind this block of buildings, was designed as an outdoor venue for music, cinema and street theatre and hosts a large number of events throughout the year. It is also home to the National Photographic Gallery and the Gallery of Photography. Although Temple Bar may be best known for its pubs, it is also home to some of Dublin's most important cultural institutions.

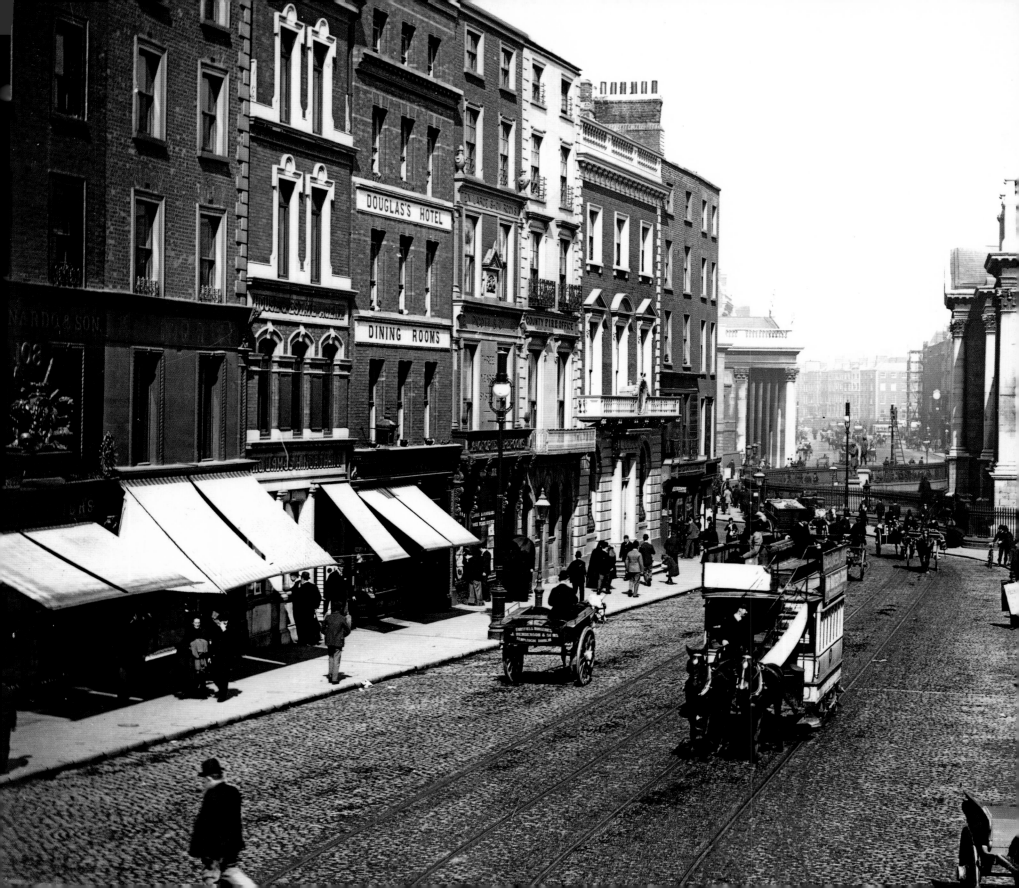

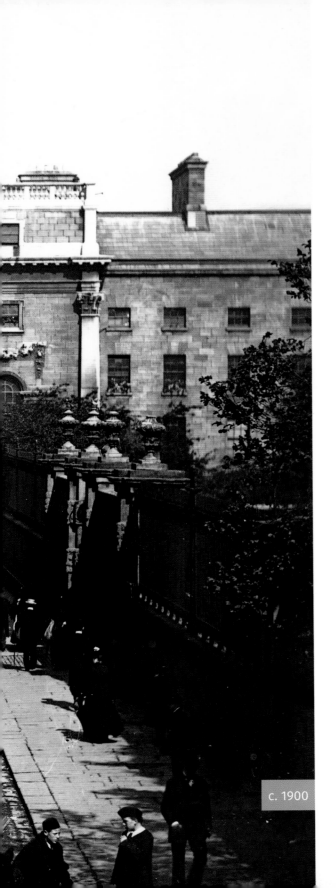

c. 1900

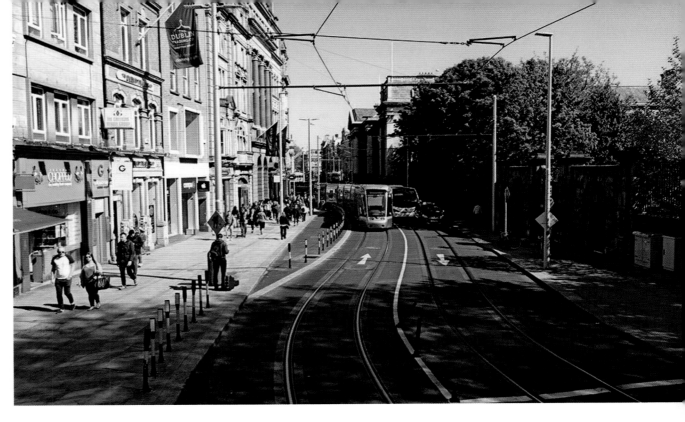

GRAFTON STREET
Still an upmarket shopping destination

LEFT: Grafton Street, named after Henry FitzRoy, the Duke of Grafton, runs the whole way from St Stephen's Green to College Green, although this image focuses on the north side of the street at the Nassau Street junction. The street grew from an eighteenth-century laneway to become one of the busiest shopping districts in the city. One of the oldest department stores—Brown Thomas—arrived on the street in 1848. The department store assisted in attracting more luxury shops, and by the 1860s an increasing number of the street's buildings had been converted to shops for luxury goods. These shops were joined by restaurants and hotels. By the time this picture was taken, there was already a variety of styles of buildings on the street dating from the eighteenth and nineteenth centuries. The west front of Trinity College can be seen in the right foreground, although the Provost's House is hidden behind a wall and greenery. The provost, or president of Trinity College Dublin, lived on campus in a mansion dating from the 1750s.

ABOVE: The nature of the street has changed little over the years—it remains the location of the city's most luxurious and expensive clothes shops. A 1940s guidebook to Dublin stated that 'Grafton Street is the morning promenade for the well-to-do fashionable members of both sexes'. The guidebook added that 'after half an hour's sauntering, these "fashion plates" waft into the stylish cafes for a cup of morning coffee and there they get down to the serious business of analysing and criticising each other'. The buildings on the street have evolved in different ways, but in the main these structures have remained late-eighteenth to mid-Victorian in origin. The street was pedestrianised between St Stephen's Green and Nassau Street in 1982 but the section of the street captured in this photograph remains open traffic. There have been increasing calls (and several plans) to shut this part of the city down to all traffic except the Luas tram, because it is recognised as an important part of the city's Georgian core.

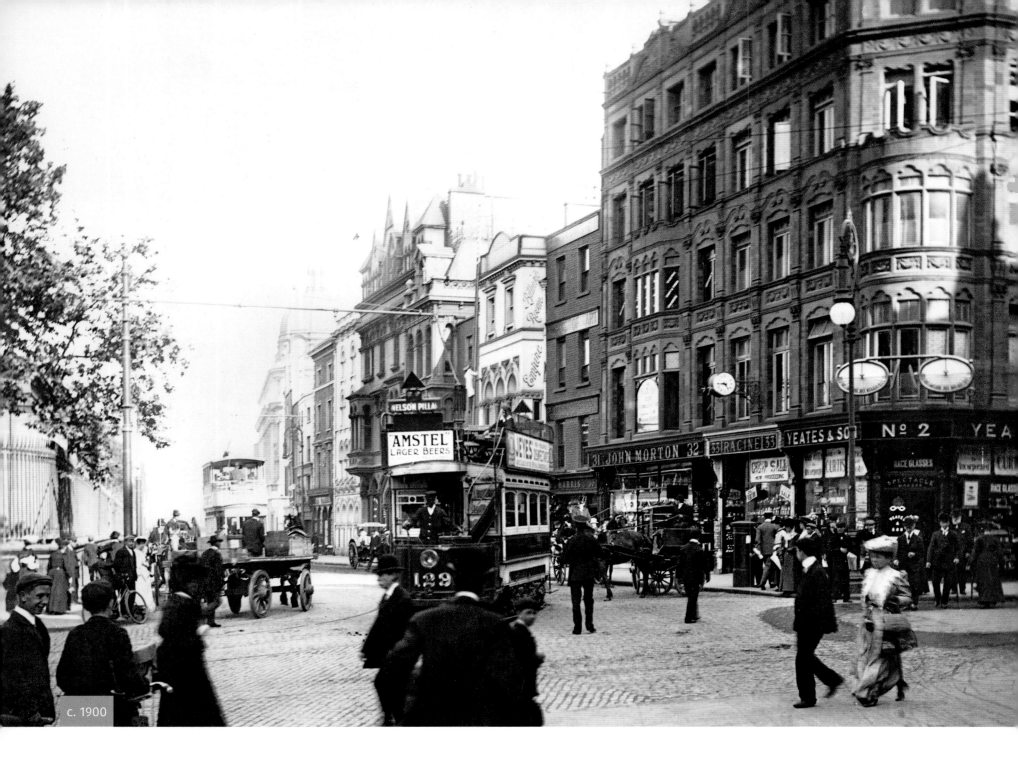

c. 1900

NASSAU STREET

Re-named Nassau Street from St Patrick's Well Street

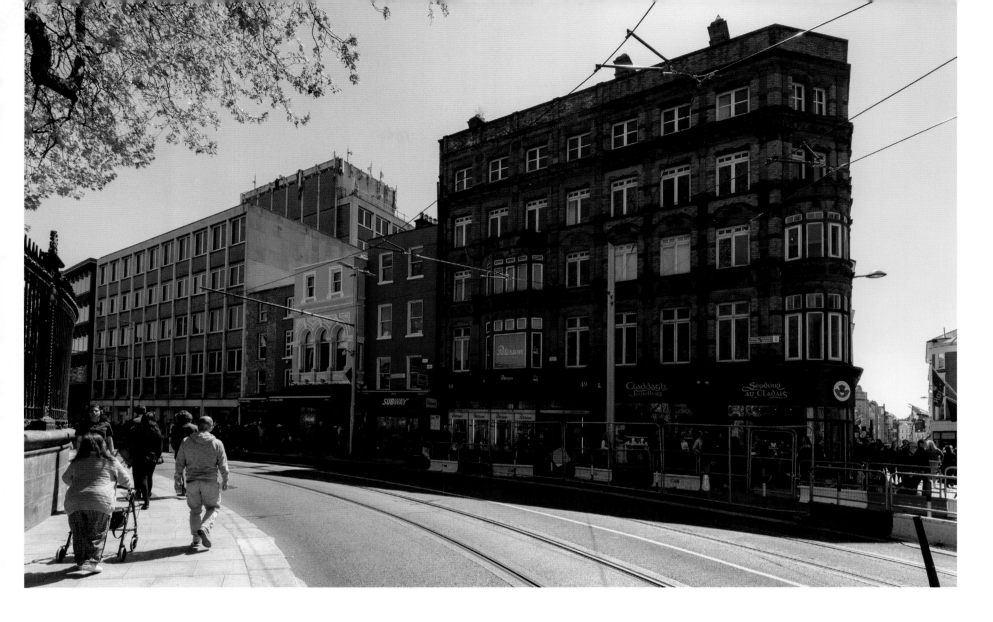

LEFT: Nassau Street is captured here at the west end of the street, at the Grafton Street junction. Its proximity to Trinity College Dublin and Grafton Street, one of the city's main luxury shopping streets, ensured that it was a busy spot. The street was re-named in the eighteenth century from St Patrick's Well Street to Nassau Street. William of Orange came from the Dutch House of Orange-Nassau and the re-name points to the victory of Protestant William over the Catholic Jacobites in the 1690s. The city had a majority Protestant population at the beginning of the eighteenth century, although this had changed by the end of that century. The re-name also reflects the changes which were occurring in this city at the time as the city corporation and property developers began to re-model the medieval streets into modern thoroughfares.

ABOVE: Although the street looks like any other busy shopping street in the city, it was the scene of tragedy during the Troubles. Nationalist and Unionist divisions have continued on the island throughout the twentieth century and to this day. This divisions led to the Troubles, a period of politically motivated violence between armed factions on both sides. These political divisions were felt on Nassau Street in a very real sense on 17 May 1974 when it, along with two other city-centre locations, were bombed in an Ulster Volunteer Force attack. Three simultaneously planted car bombs were detonated in the city centre at rush hour. Although trams were removed from the city centre in the middle of the twentieth century, a tram line reopened on Nassau Street in 2017.

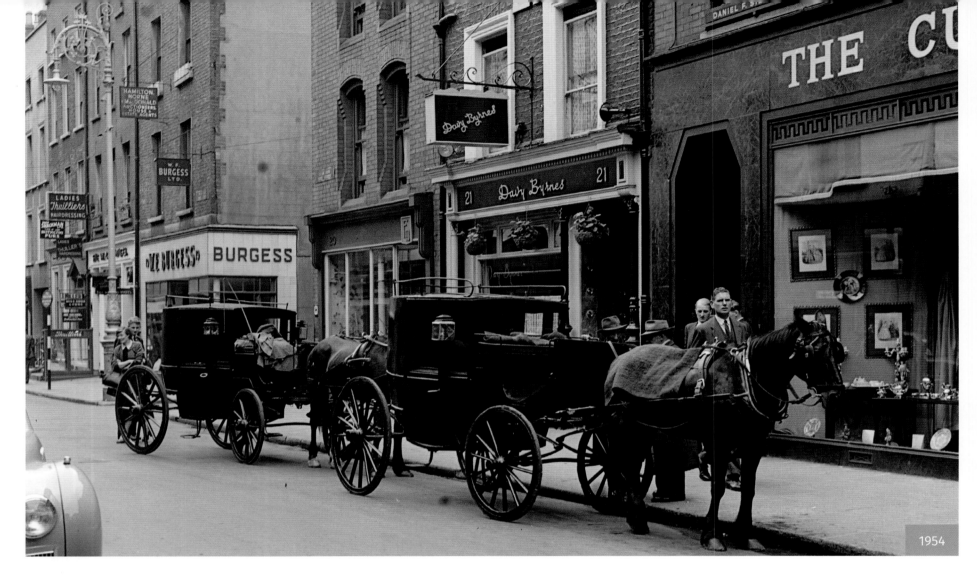

1954

DAVY BYRNES

Stopping-off point for Leopold Bloom in James Joyce's seminal novel, *Ulysses*

ABOVE: Davy Byrnes is one of the many pubs in which James Joyce's fictional character Leopold Bloom drank as he crossed the city on Thursday 16 June 1904 in the novel *Ulysses*. The book was first serialised in *The Little Review* between 1918 and 1920 and was not published in its entirety until 1922. It describes Edwardian Dublin in vivid detail. Joyce said his aim was that 'if the city one day suddenly disappeared from the earth it could be reconstructed out of my book'. The book has been hailed as one of the most important pieces of fiction

written in the English language, and Joyce is cited as one of the greatest writers of the twentieth century. In 1954, thirteen years after his death, the Irish poet Patrick Kavanagh and writer Flann O'Brien celebrated the fiftieth anniversary of the fictional journey by re-creating it. They travelled by horse-drawn carriage to locations mentioned in the book and read extracts from the novel. Eleanor Wiltshire photographed the journey, which started in Sandycove and took in Davy Byrnes. These image captures their stop at the pub.

1954

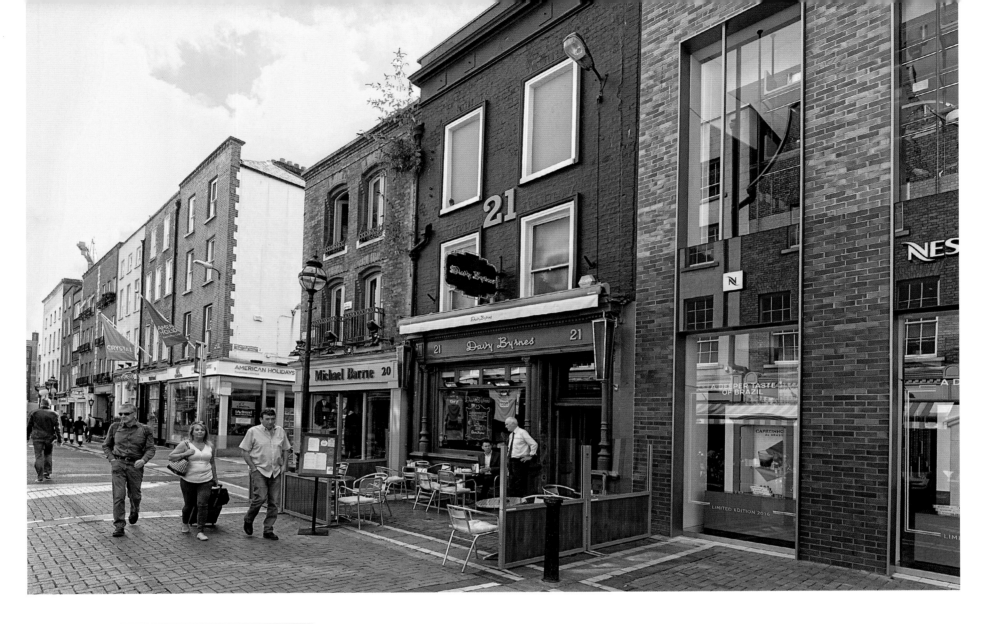

ABOVE: Although Davy Byrne retired in 1939, and the pub was bought by the Dorans—a well-known Dublin publican family—they retained the pub's original name. The interior Edwardian decor can still be seen, although alterations have been made. The pub continued to be connected with the Irish literary scene and has been described as 'the resort of the writing set in Dublin'. Brendan Behan, Liam O'Flaherty, Anthony Cronin and James Stephens were all regulars. After the inaugural adventure of Kavanagh, O'Brien and Wiltshire, Bloomsday—as the celebration came to be known—began to be marked in the city each year in celebration of Joyce's masterpiece. Every 16 June, people dress in Edwardian clothes and, starting at Sandycove's Martello Tower, make their way across the city reading extracts from the novel. The pub has remained a site of pilgrimage for *Ulysses* admirers. Joyce's book has grown in reputation and continues to be read and studied internationally. Bloomsday has become not just a national event but an international one, and today it is marked by readings, usually in a pub, by fans around the world.

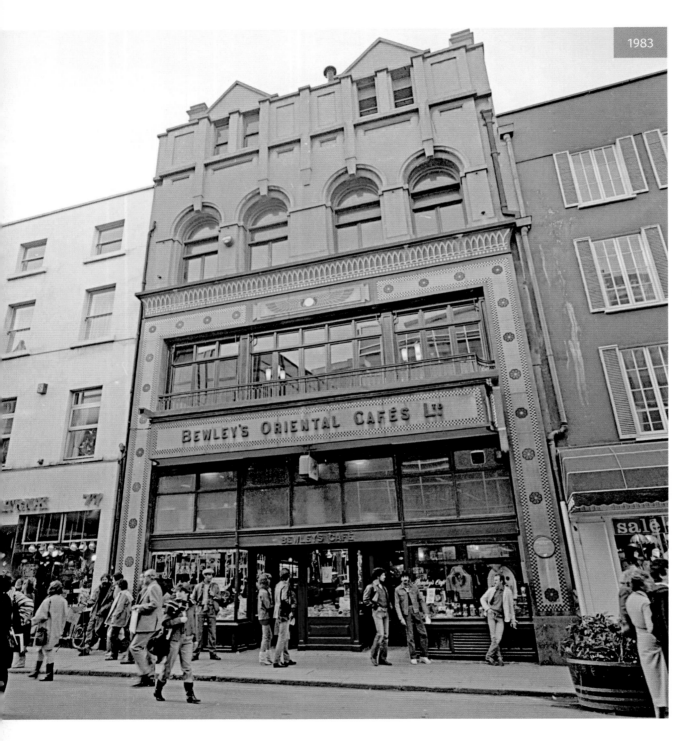

BEWLEY'S, GRAFTON STREET

An Irish institution mercifully relaunched

LEFT: Father and son Samuel and Charles Bewley first introduced tea into Ireland when they imported over two thousand tea chests to Ireland in 1835. This was the first time tea was imported by a group independent of the East India Tea Company and was an attempt to break their monopoly. The China Tea Company, later Bewleys, was officially founded in 1840 by Samuel's sons Charles and Joshua and took advantage of Ireland's thirst for the new beverage. The Bewley family were Quakers who were heavily involved in the famine relief fund. The company expanded into cafes in 1894 when they opened their first café on George's Street and in 1927 their flagship Grafton Street café was opened. The interiors reflect the Art Deco style favoured in the 1920s. Perhaps the most noteworthy aspect of the interiors are Harry Clarke's stained-glass windows. Clarke was apprenticed to his father's stained-glass studio from school and these windows are one of the best examples of his work. This photo was taken in 1983, just a year after Grafton Street became pedestrianised.

RIGHT: Bewleys cafés spread throughout Ireland in the twentieth century with a branch in many cities and towns all over Ireland but by the early 2000s Ireland's tastes were changing. By 2004 several branches of Bewley's Cafés had closed their doors due to a decline in customer numbers. In November 2004 the Grafton Street branch followed suit and shut. Hugh Ogram, author of a history of Bewleys café, wrote in the *Irish Times* 'Dublin is very much the poorer for the passing of such iconoclastic meeting places as Bewley's cafés'. The failure of the café was seen as a sign of the changing tastes of the offspring of Celtic Tiger Ireland. While a restaurant chain took over the building after this, it did not last long and Bewley's Ltd. took back control of the building. They undertook a twelve million euro renovation of the building and it reopened its doors in November 2017.

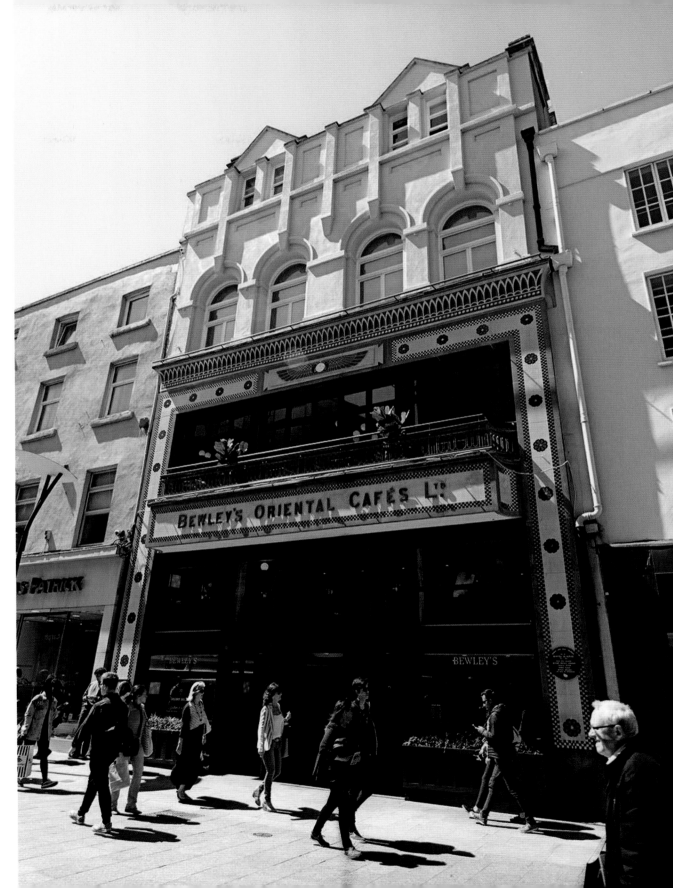

NOBLETT'S CORNER

Once the site of a prominent city confectioner

BELOW: The Art Deco-style Noblett's Corner was added to the busy Grafton Street junction with Stephen's Green in 1932. It was not a new building but a refurbishment of a three-storey building that already stood on the site and was owned by Noblett's confectioners. Noblett's also had shops on Dawson Street and O'Connell Street. The company's location in this city-centre spot guaranteed a large footfall from pedestrians visiting St Stephen's Green, a large public park nearby. When renovations were completed, the building was broken into three commercial units: one facing on to Grafton Street, one on to South King Street and one on to St Stephen's Green. The architectural historian Merlo Kelly says, 'with its stripped back demeanour of travertine shopfront, bronze windows and modernist turret, Noblett's corner would have added to the glamorous and fashionable shopping experience along Grafton Street'. The building is ultra-modern in style and in the 1960s, when this image was taken, it was still the most modern-looking building on this section of the street. The three units that took up the building were sold by Noblett's in 1954.

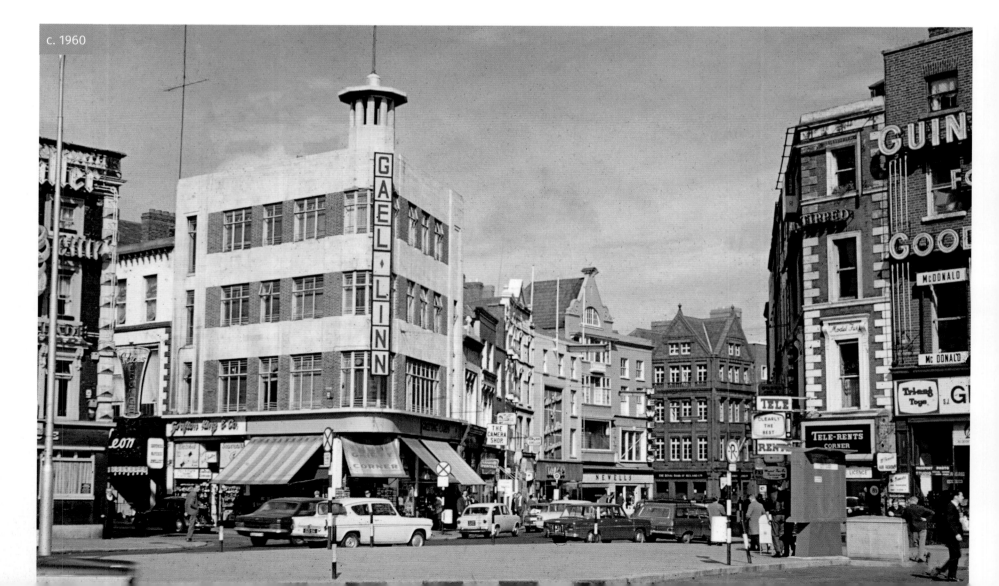

c. 1960

BELOW: The ground floor of Noblett's Corner has been dramatically altered in the decades since the first photograph was taken, although the rest of the building has been preserved. The greatest change to this corner of Grafton Street has been the opening up of St Stephen's Green Shopping Centre in 1988. Constructed of curved glass and ornamental ironwork, the shopping centre is reminiscent of the Crystal Palace built in Hyde Park, London, in 1851 to host the Great Exhibition. The shopping centre has had the effect of minimising the modernist aesthetic of Noblett's Corner and making it appear more dated. Nevertheless, this style of commercial building is unique within Dublin city centre and provides a snapshot of twentieth-century shopping history.

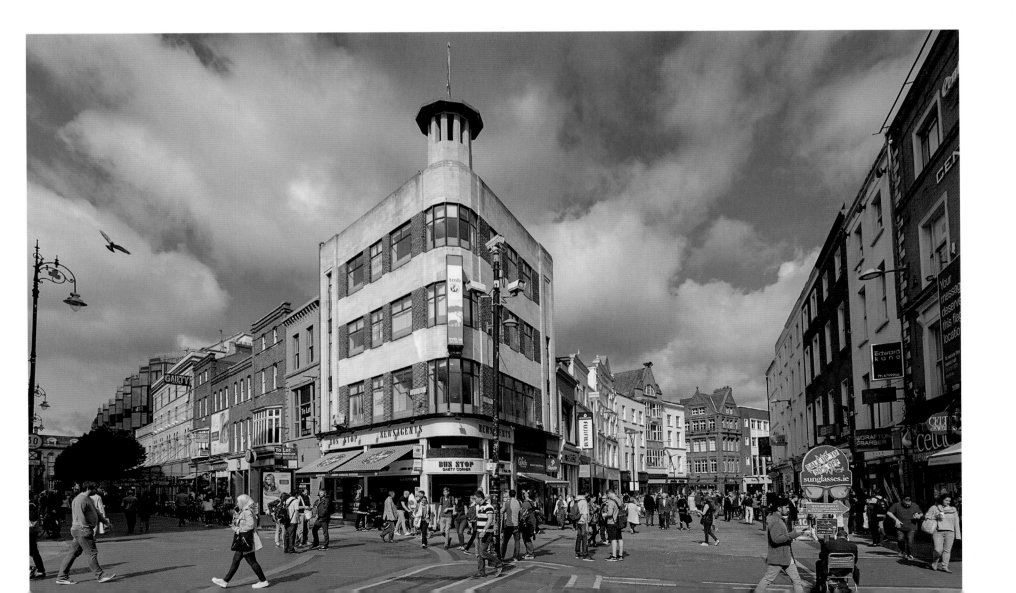

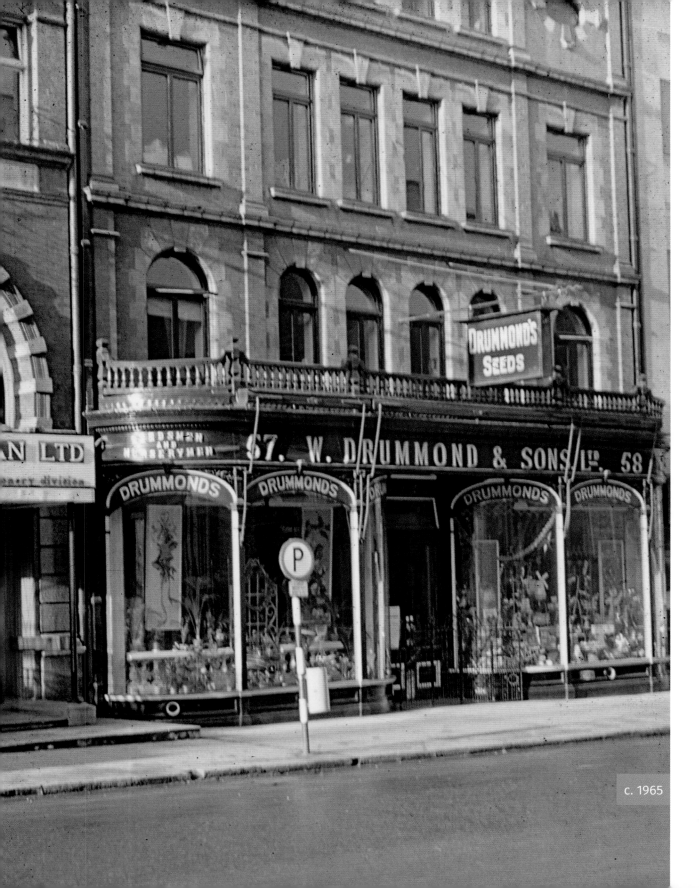

c. 1965

DRUMMOND & SONS / HODGES FIGGIS, DAWSON STREET

Stocking the largest variety of books in Dublin

LEFT: In the 1960s, 56-58 Dawson Street was home to Drummond & Sons, a nursery and agricultural supplier. Drummond's had been on Dawson Street since the mid-nineteenth century and remained there for almost 140 years. The business was incorporated in 1895 and began to plan a more appropriate premises for their expanding business. The Dawson Street premises was extensively refurbished by Thomas Manly Deane for offices, and a shop was opened in 1903. It is this refurbished shop that is captured here. The large curved windows were the most modern type of Edwardian shopfronts of their day; these had evolved to display as many goods as possible and to entice customers in with elaborate window displays. After the 1916 Rising the firm claimed over £19 for damages caused during the fighting. The damages were not only at their Dawson Street premises, but also at printing blocks they held on Middle Abbey Street. These damages were relatively small compared with some of the losses incurred by city-centre shops.

RIGHT: Drummond & Sons continued to trade at this Dawson Street premises until the 1980s, when Hodges Figgis took control of the building. Hodges Figgis is the oldest bookshop in Dublin, dating from 1768. The shop passed through a number of city-centre locations in its long and colourful history. It was located on Nassau Street after the 1916 Rising and was attacked by Black and Tans during the War of Independence. The bookshop acted as a publisher from the eighteenth century through to the early twentieth century, publishing titles on Irish history, Celtic studies and Irish literature. The shop moved to its current location in the 1980s, and the green shopfront and Hodges Figgis sign have become an iconic part of Dawson Street. The bookshop is no longer an independent retailer, however, as the name and premises were purchased by Waterstones in 2011. Although the claims by Hodges Figgis to be largest bookshop in Dublin may be contentious, it stocks the largest variety of book titles of any city-centre bookshop.

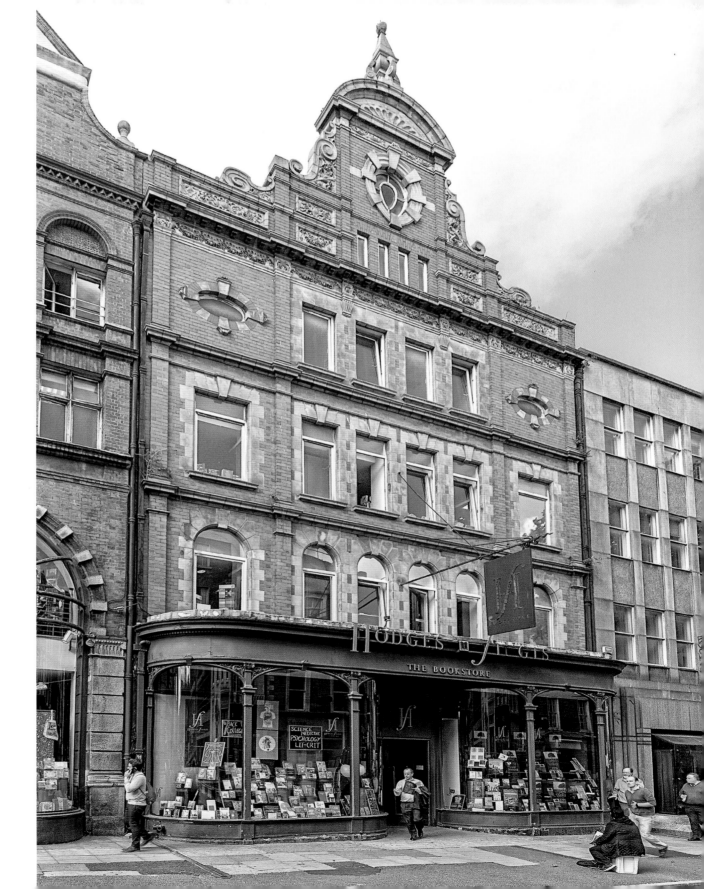

THE IRISH TIMES BUILDING

No longer the 'old lady of Dolier Street'

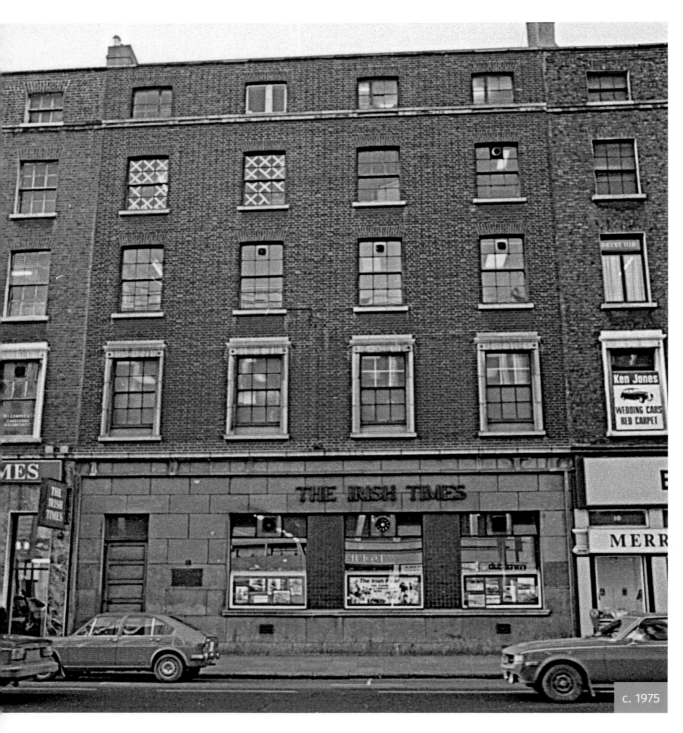

c. 1975

LEFT: *The Irish Times*, a daily Irish broadsheet, was launched in 1859. It was originally based on Middle Abbey Street, but the newspaper moved to this D'Olier Street premises in 1895 and was here for over one-hundred years, becoming known to Dubliners as 'the old lady of D'Olier Street'. The premises included offices for journalists and editors, and printing of the newspaper took place in the basement. The newspaper began life as a Protestant, unionist publication but this political slant changed in the twentieth century. The newspaper challenged the status quo, particularly in its coverage of the Troubles in Northern Ireland and its condemnation of the Catholic Church's influence over the Irish government. The newspaper shop can be seen on the far right of the photo. The newspaper employed a number of prominent Irish writers over this period, including Maeve Binchy, John Banville and Flann O'Brien. In 1974 a non-charitable trust took control of the newspaper.

RIGHT: The newspaper moved from its D'Olier Street premises in 2006 to a new home on Tara Street. In its farewell to the old premises, author and journalist Hugh Oram said 'newspaper life is far more sober, perhaps a little less congenial and a lot more competitive'. The newspaper on D'Olier Street experienced the shift from letterpress to hot-metal type, to linotype machines, to computer. Although these technological shifts meant news could be printed and circulated more quickly, the move to digital has been far more damaging to newspapers such as *The Irish Times*. Its print circulation has been threatened, and the company faces growing competition from other online outlets. This building was converted to high-end apartments, offices and retail units when the newspaper moved to large glass-fronted modern offices not far away. Oram concluded 'the newspaper moves to the silent, smoke-free, largely sober confines of a gleaming new office—all has changed, changed utterly.'

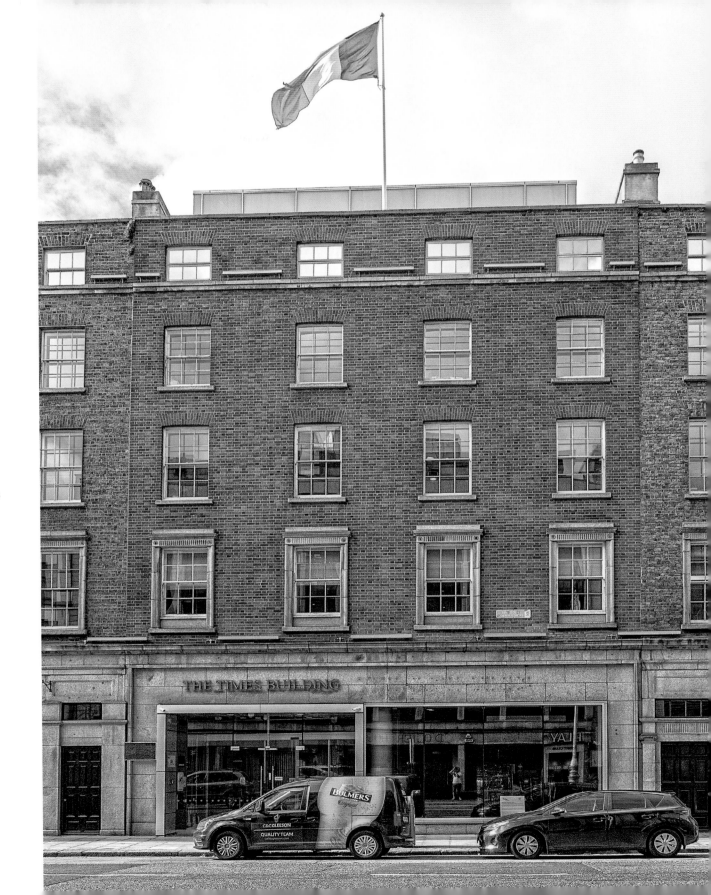

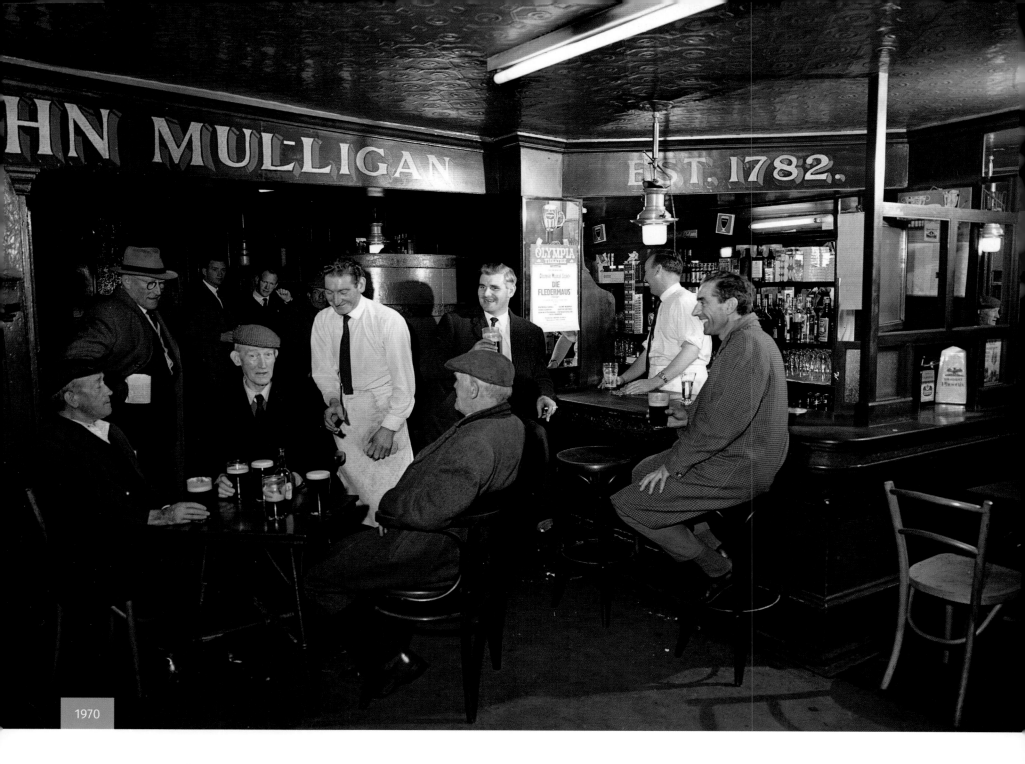

MULLIGAN'S, POOLBEG STREET

An archetypal Irish pub, as marketed by the tourist board and visited by John F. Kennedy

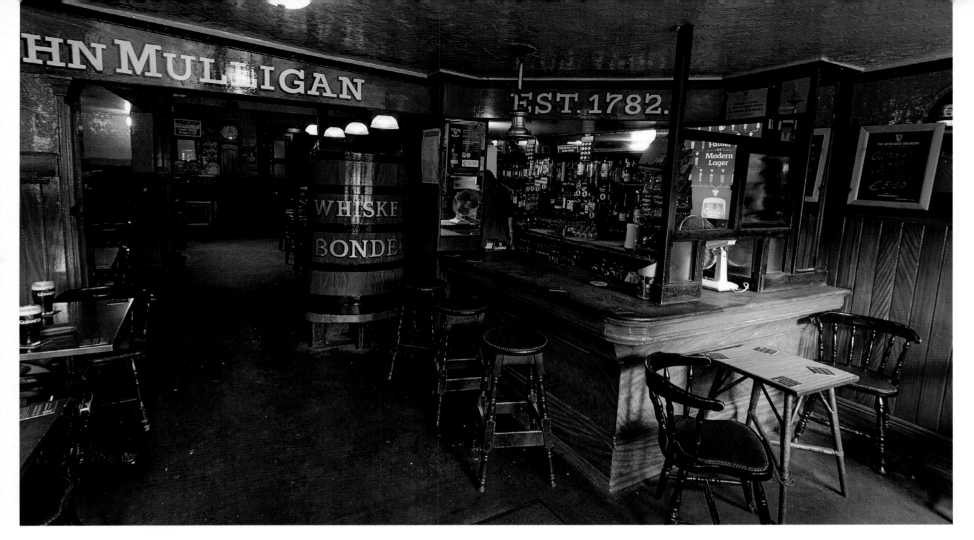

LEFT: There has been a Mulligan's pub in Dublin since 1782. This eighteenth-century pub was located on Thomas Street and moved to its current location on Poolbeg Street in 1854. In 1935 Theatre Royal, a large Art-Deco-style theatre, opened up on Hawkins Street, and the theatre's back door led on to Poolbeg Street. Many of the actors who performed in the theatre frequented Mulligan's, including Judy Garland. John F. Kennedy enjoyed a pint in the pub on his visit to Dublin in 1963. This photograph from the 1970s was a publicity shot taken by Ireland's tourist board, Fáilte Ireland. The Irish pub, with its friendly and convivial atmosphere, was one of the key selling points of Fáilte Ireland's campaigns from the 1950s onwards, and the picture draws on the idea of the obliging Irish barman and friendly pub regulars.

ABOVE AND RIGHT: Mulligan's was located close to the offices of the *Irish Press*, which closed its doors in 1995. The pub was the local for many of the typesetters, printers, journalists and editors who worked for the paper. The celebrated *Irish Press* sportswriter Con Houlihan was often seen propping up the bar and, on his death in 2012, his photograph was added to a wall of the pub as a memorial. As this image shows, the interiors of the pub remain unchanged, and Mulligan's is one of the few local pubs that has resisted the introduction of a television set. The pub is a tourist favourite and is also beloved by Dubliners. The pub claims that the remains of one American visitor to the pub were returned there as ashes and are stored in one of the clocks. Mulligan's is said to serve one of the best pints of Guinness in the city.

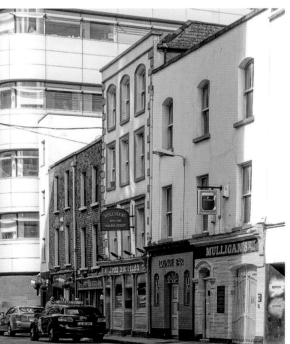

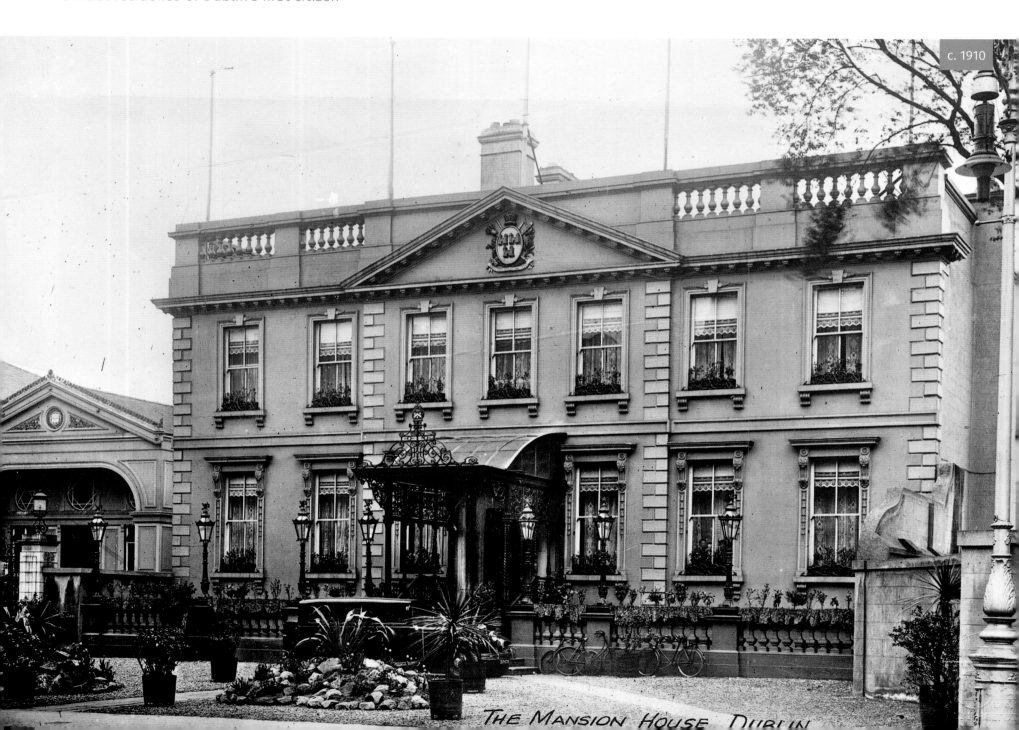

MANSION HOUSE
Official residence of Dublin's first citizen

c. 1910

THE MANSION HOUSE DUBLIN

LEFT: The Mansion House is the residence of Dublin's first citizen, the Lord Mayor. The house was completed in 1710 by Joshua Dawson, who laid out Dawson Street. It is the city's oldest free-standing house. The townhouse was purchased by Dublin Corporation in 1715 for £3,500, an annual ground rent of 40 shillings and a sugar loaf at Christmas. The building was originally of redbrick, as was the fashion of the day. In 1851 the front of the building was remodelled to give it a more modern look, and stucco, balustrades and pediments were added. The iron porch was added in 1886. Perhaps the most significant addition to the building was the Round Room, the entrance to which can be seen on the left-hand side of this picture; this room was added in 1821 and served as a hall for state banquets. King George IV was entertained here on his visit to the city in July 1821.

BELOW: The Mansion House remains the home of Dublin's serving Lord Mayor. This position changes hands annually, and the occupant is selected through a vote by members of the city council. The house itself has undergone few alterations since the nineteenth century. An exception is the Round Room, which was converted to a venue and later restaurant. The building played an important part in national as well as local politics. When Sinn Féin won a landslide victory in the general election of 1919 (the first since the 1916 Rising), the elected MPs refused to take their seats in Westminster. Instead they established the first Irish parliament or Dáil. This assembly first sat at the Mansion House on 21 January 1919. On the same day, two Royal Irish Constabulary officers were shot dead by Irish republicans in Tipperary. These events marked the start of the War of Independence. As well as serving as residence for the Lord Mayor, the Mansion House is also used for civic events throughout the year.

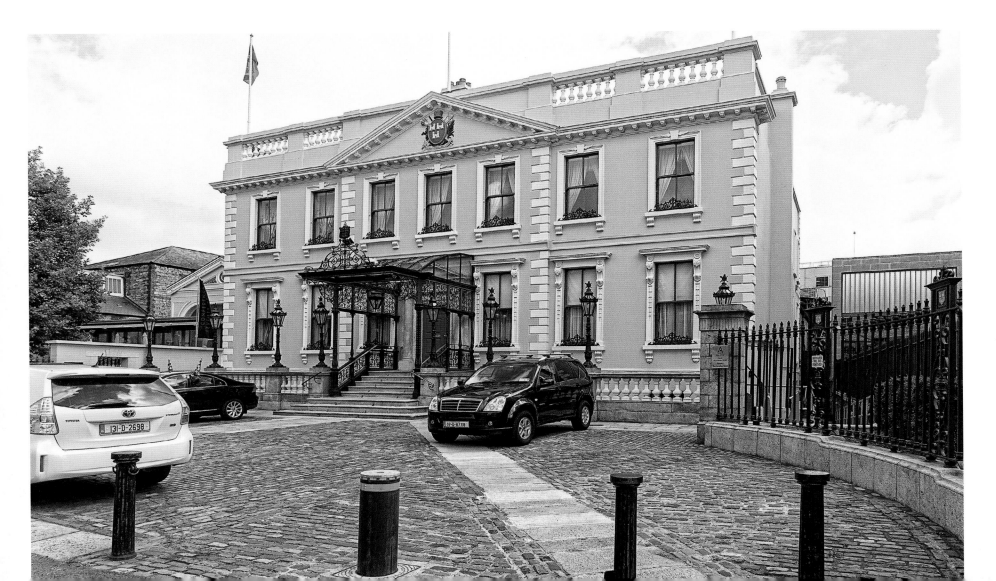

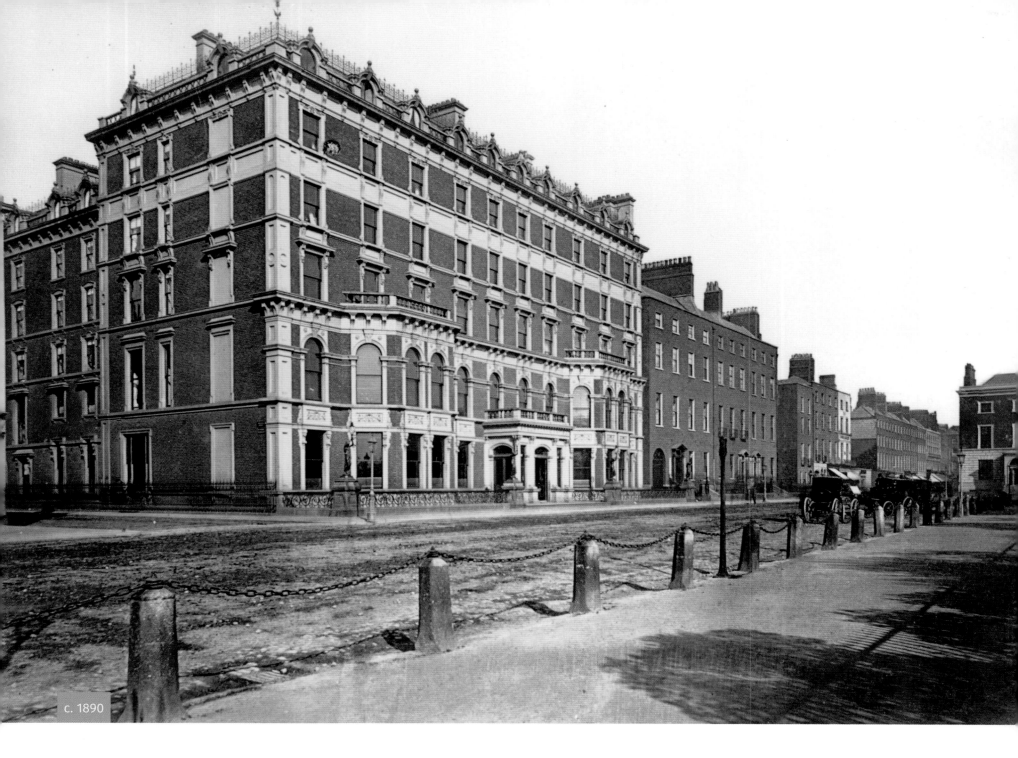

c. 1890

SHELBOURNE HOTEL FROM ST STEPHEN'S GREEN

A hotel that is rapidly approaching its bicentenary

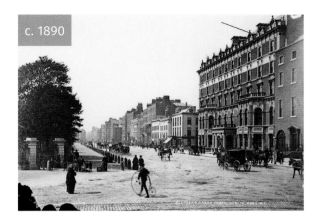

c. 1890

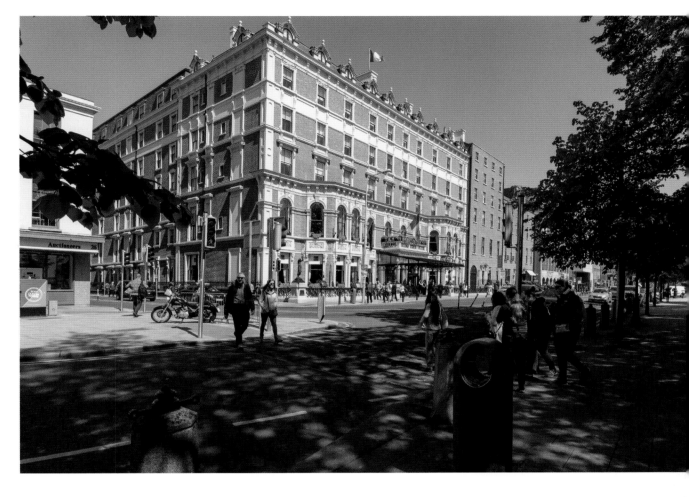

LEFT AND ABOVE: St Stephen's Green was laid out in the late seventeenth century by Dublin Corporation, which was seeking to raise revenue after a war-torn century. The plots were slowly leased and houses erected and the square in the centre became a recreational space for well-to-do Dubliners. The north side of the green, featured here, became known as Beaux Walk. The park was enclosed by railings after a parliamentary act of 1814. In 1877 Sir Arthur Guinness sponsored a bill for the park to be renovated. He paid for the cost of laying out the park, which was designed by William Sheppard and reopened in 1880. A luxury hotel, the Shelbourne, was opened on the north side of St Stephen's Green in 1824. The Shelbourne's ballroom was added in 1856. In an ill-advised military decision, the park opposite was occupied during the 1916 Rising. Imitating World War I tactics, the Volunteers dug trenches in the park, but British snipers seized the hotel and from their vantage point, picked off the Volunteers in the park.

ABOVE: St Stephen's Green is open to the public today and remains one of the busiest parks in the city centre. The nineteenth-century layout of the park, as initiated and paid for by Arthur Guinness, has been maintained, although a number of additions have been made to the park, including a children's playground, public art and monuments to figures such as Theobald Wolfe Tone. The Shelbourne Hotel had become the most exclusive place to stay in Dublin by the mid-twentieth century. Celebrity guests who stayed at the hotel included John and Jacqueline Kennedy, James Cagney, Maureen O'Hara, John Wayne, Stan Laurel, Oliver Hardy, Elizabeth Taylor, Richard Burton, Rock Hudson, Orson Welles and Rita Hayworth. The hotel underwent an extensive restoration project in 2005, its first since 1867.

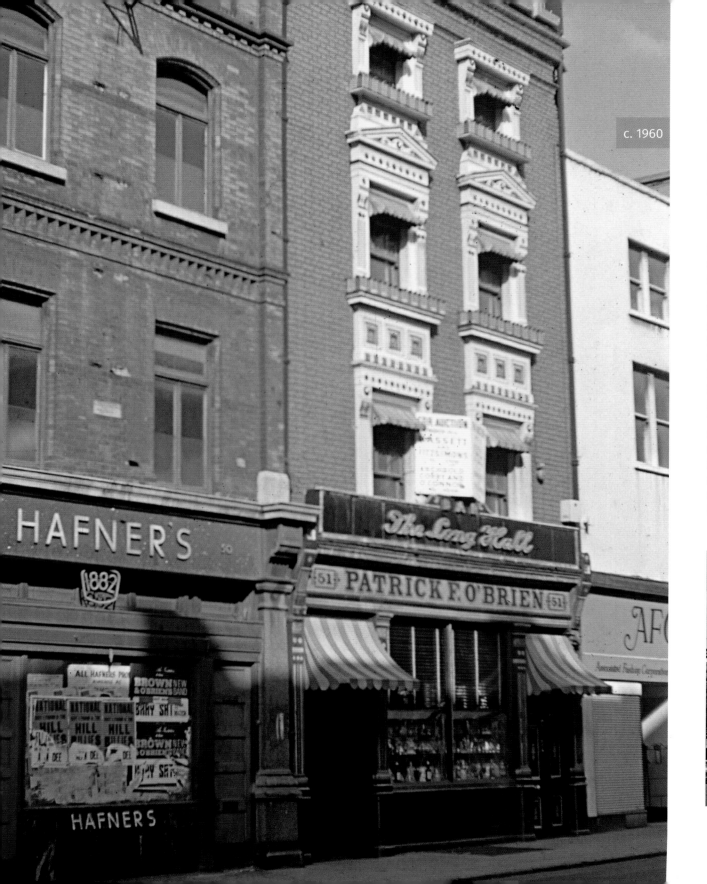

c. 1960

THE LONG HALL, SOUTH GREAT GEORGE'S STREET

Little changed since the Victorian era

LEFT: The Long Hall pub, with its iconic two-bay facade and red-and-white awnings, dates from 1756, although the current building dates from the 1860s. The South City Markets opened on South Great George's Street in 1881, and although it progressed slowly, the market steadily developed and expanded along George's Street. Market customers and traders would have made up a large part of the Long Hall's clientele. The pub's interiors have changed little over the past 150 years and the Victorian interiors have largely been preserved. Patrick F. O'Brien, who owned the pub in the 1950s and 1960s, was an avid collector of antiques and adorned the walls with his purchases. These antiques added to the pub's novelty and attracted tourists. South Great George's Street remained an important shopping district into the 1960s and 1970s, with large department stores such Cassidy's close to the Long Hall (see inset).

c.

RIGHT: Ugly office blocks were added to the middle of South Great George's Street in the 1970s, and many of these office workers would have frequented the pub. Patrick F. O'Brien sold the pub in 1972, and there was a separate auction for the many antiques and contents of the pub, which included two Jack B. Yeats paintings. The new owner paid £10,000 to keep some of the antiques—including antique rifles, engravings and clocks—and they still adorn the walls to this day. The Long Hall, which looks like it belongs to another century, has something of a cult status. The pub featured in the music video for Thin Lizzy's song *Old Town;* in it, Phil Lynott strolls through the pub while regulars sip pints at the bar. The pub is also an occasional haunt for celebrities staying in Dublin; in recent years Rihanna and Bruce Springsteen have been snapped having drinks at the bar.

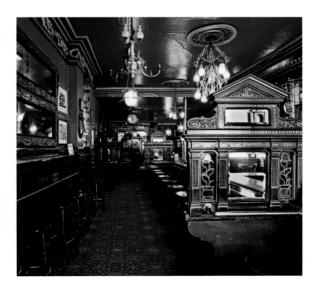

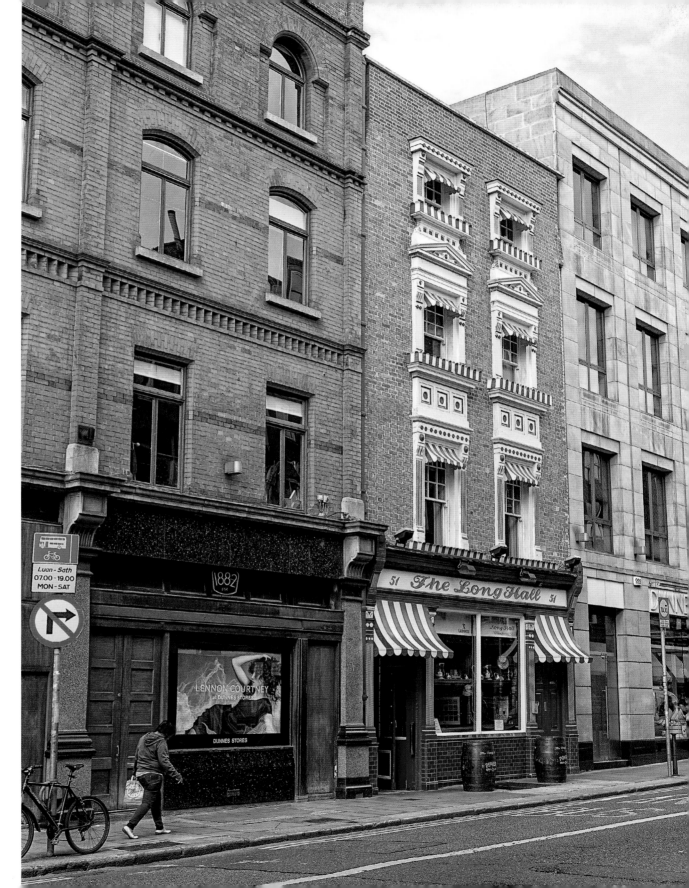

SOUTH CITY MARKETS / GEORGE'S STREET ARCADE

A grand market hall that has become an architectural icon

ABOVE: The central focus of South Great George's Street is the Victorian-terracotta South City Markets. It was designed by the British architects Lockwood & Mason and built between 1878 and 1881. It was the first purpose-built shopping centre in Ireland when it opened in 1881. It featured a central arcade for markets, with additional commercial units facing the street. When it opened, many Dubliners complained that English architects and builders had been employed to design and build the building rather

than using Irish firms, and the market was slow to develop. However, when the building was gutted by a fire on 27 August 1892, there was a public outpouring of sympathy. A fund was established to assist the retailers and stall holders affected by the fire. Irish craftsmen restored the building, which reopened in September 1894. The market took off from the 1890s and has been an important city-centre retail unit ever since. The arcade was home to food stalls, shops and flower stalls.

1895

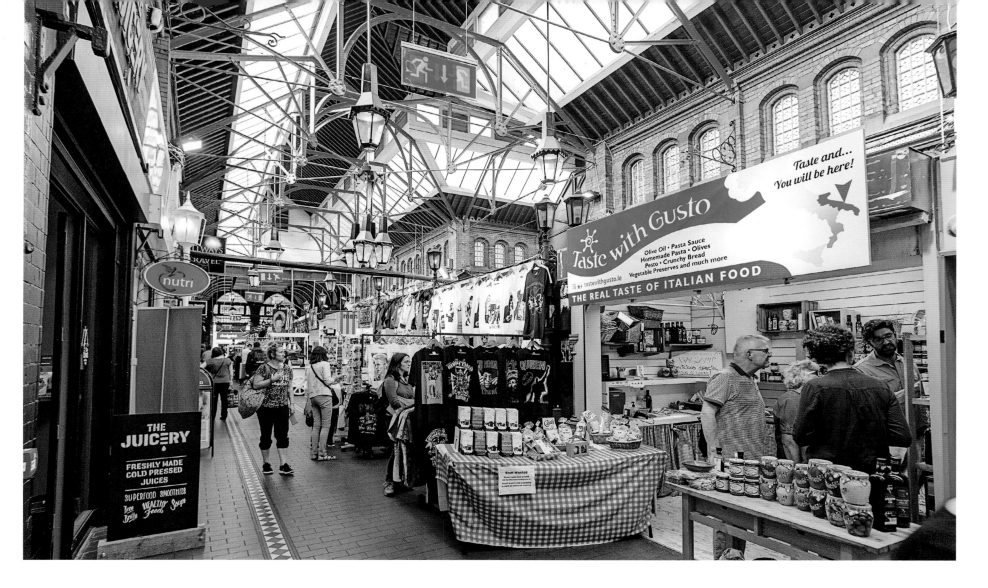

ABOVE AND LEFT: The South City Markets are now known as George's Street Arcade. The well-preserved shopping arcade remains a popular shopping destination for Dubliners, and its terracotta brick has become an iconic part of the city's architectural landscape. There are almost forty units in the market complex today, including in the centre of the arcade where the old market stalls would have been set up. The food market, which took up this main arcade space, is now gone, although there are a number of food outlets and restaurants within the space. The business with the longest connection to the markets is Stokes Books, an antiquarian and rare books bookshop that has been trading from the market since 1989.

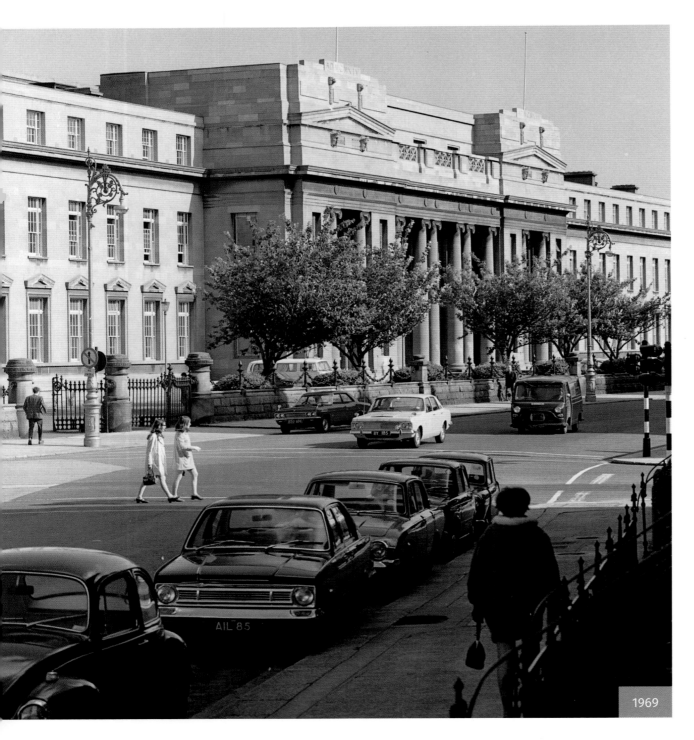

1969

EARLSFORT TERRACE
The impressive university building has been converted into a concert hall

LEFT: In 1969 Earlsfort Terrace was home to University College Dublin. The university has its roots in the Catholic University of Ireland, which was founded by John Henry Newman (later a cardinal) in 1854. In 1880 the Catholic University became University College Dublin, and under the Irish Universities Act of 1908 it became one of the three constituent universities of the National University of Ireland. Although the original university began at St Stephen's Green, where it still has a presence, by the early twentieth century it was in desperate need of more space. The Royal University and Grand Exhibition buildings, which occupied this site and dated from 1865, were acquired to allow the university to expand. A new building was designed that incorporated aspects of the old. It was designed by R.M. Butler and built by G & T Crampton, and was inspired by Gandon's Custom House. Construction began in 1914 and the building opened in 1919. Earlsfort Terrace has been described as a 'modern building in classical clothes'.

RIGHT: Earlsfort Terrace was designed to accommodate 1,000 students, but University College Dublin expanded rapidly in its new site and by 1959 the campus catered for 2,800 students. A further 1,200 students were located at Merrion Street on a campus that had been designed to hold 200 students. Pressed for space and unable to expand further within the confines of their current campuses, the university acquired a 350-acre site in Belfield, Dublin 4. The university relocated to this new site in the late 1960s. In the meantime the large Earlsfort Terrace complex moved into the hands of government, and in 1981 it reopened as the National Concert Hall, which, as well as being a live music venue, contains a bookshop, bar, a restaurant and offices and is home to the RTÉ National Symphony Orchestra.

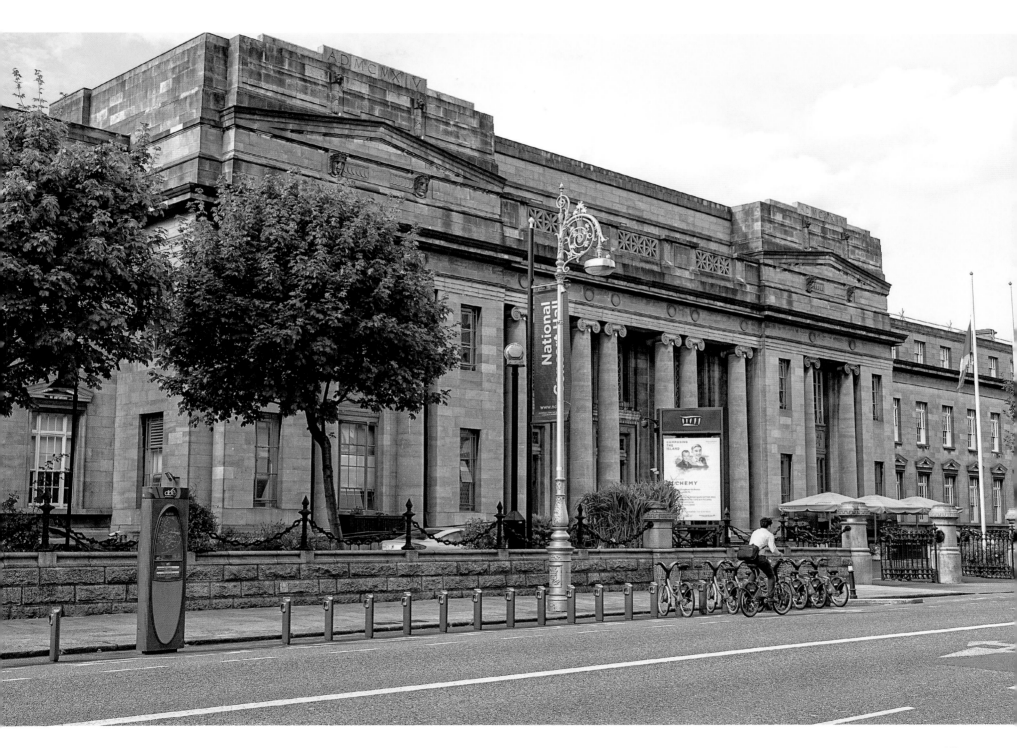

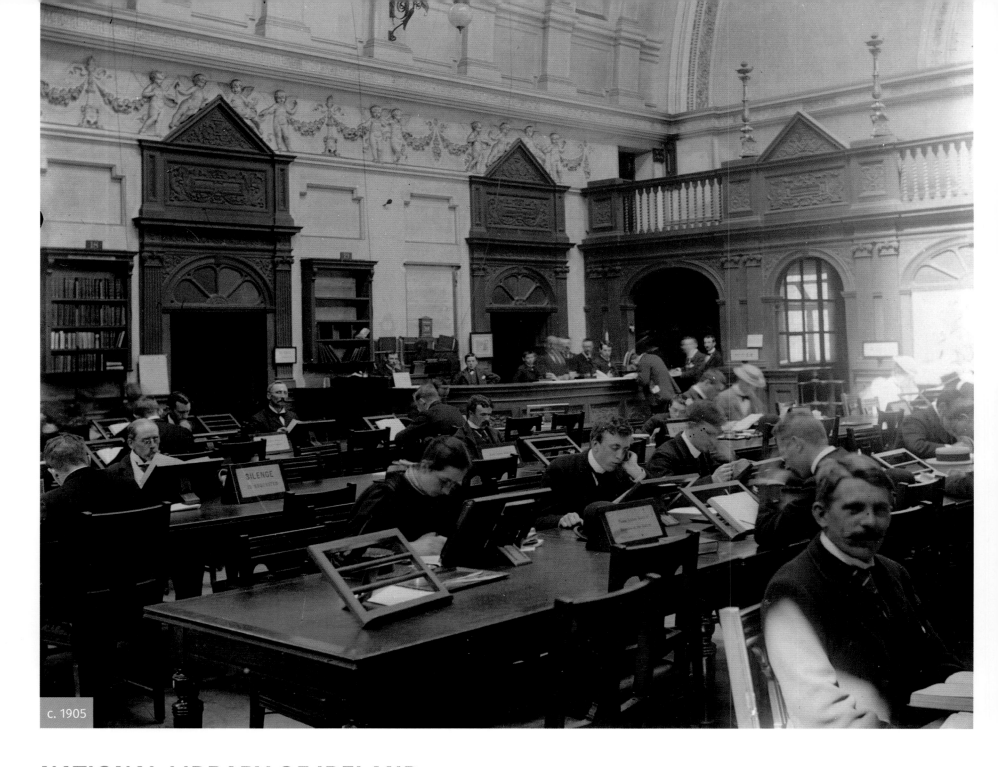

c. 1905

NATIONAL LIBRARY OF IRELAND

Repository of the papers of James Joyce, W. B. Yeats, Seamus Heaney and Roddy Doyle

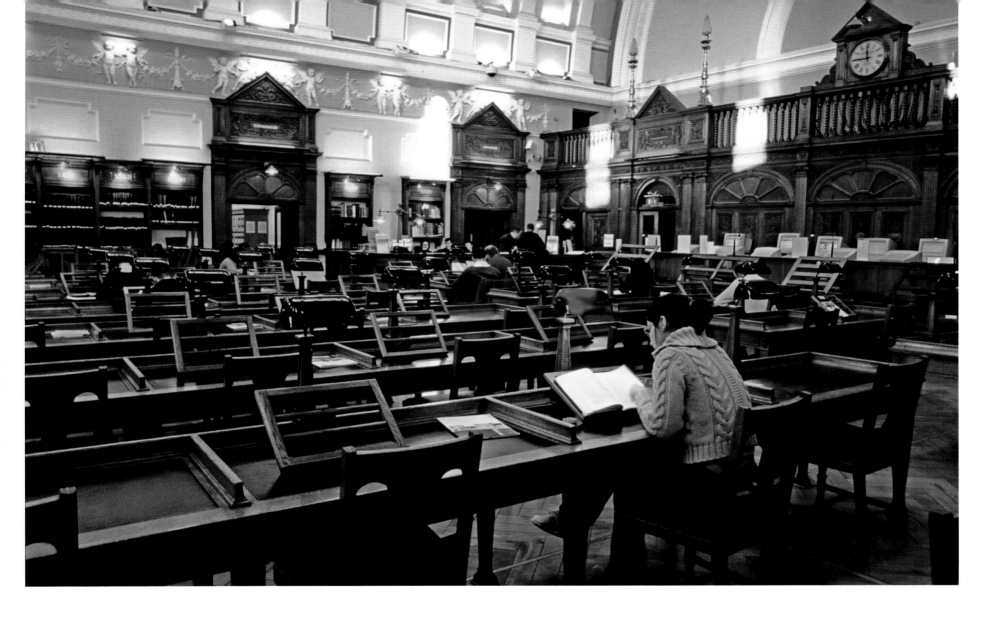

LEFT: The National Library and National Museum, which book-end Leinster House, have a shared history. Under the Dublin Science and Art Museum Act 1877 the collections of the Royal Dublin Society were transferred to a new National Library of Ireland and National Museum of Ireland. Thomas Newnham Deane designed the two buildings that would house these collections. The reading room of the National Library of Ireland, semi-elliptical in shape and with a stucco-decorated ceiling, was the centrepiece of the library. A noteworthy feature of this picture is the woman studying among male readers. Irish women were making contributions in a number academic disciplines throughout the eighteenth and nineteenth centuries, but by this period they were formally entering academia. In 1904, around the time this photo was taken, women were allowed to undertake degrees at Trinity College Dublin, and they began to enter University College Dublin in 1908.

ABOVE: When the Free State was founded in 1922, the library passed into the hands of the Department of Education. In 1986 it moved to the Department of An Taoiseach (the Irish prime minister). The collection at the National Library of Ireland continued to expand and it holds material from all periods of Irish history. This printed material includes not just books but newspapers, periodicals, official publications and maps. The library has the most complete collection of Irish newspapers of any repository in the world. It contains two additional divisions: manuscripts and photography. There are a number of significant collections held at the library, including parish records. The Seamus Heaney literary papers were acquired by the library in 2011, and the library also holds the papers of James Joyce, Colm Tóibín, W. B. Yeats, Michael D. Higgins, Seamus Heaney and Roddy Doyle.

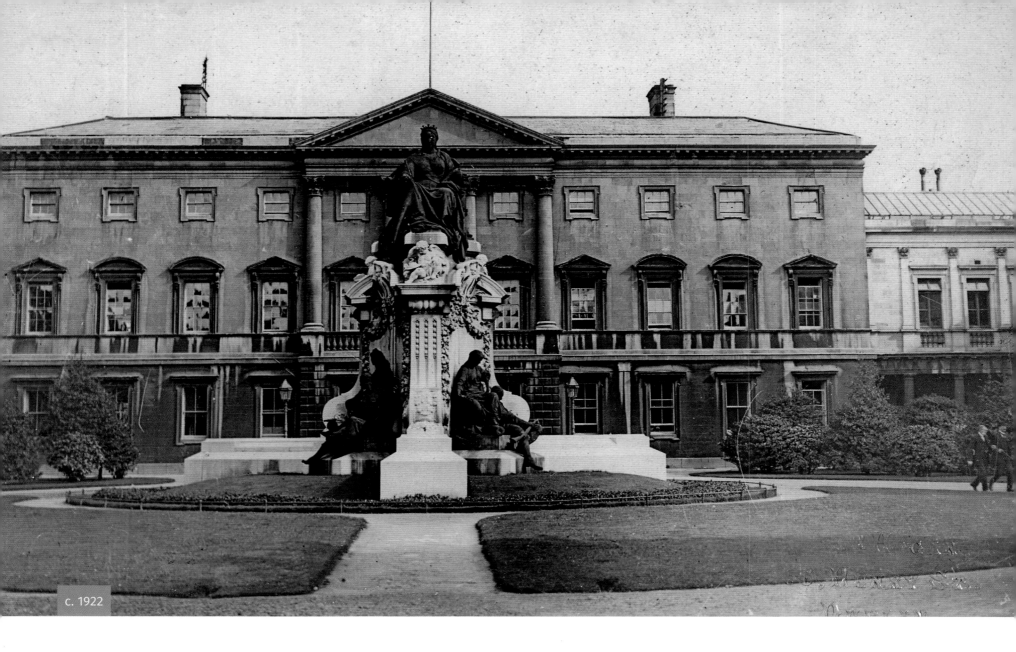

c. 1922

LEINSTER HOUSE

Home to the first parliament of the Irish Free State

ABOVE: Leinster House was designed by Richard Cassels. It was built between 1745 and 1748 to act as the city residence for the Earl of Kildare, who was later elevated to the title Duke of Leinster. The house can be viewed from two streets: facing Kildare Street, or, as in this image, facing on to Merrion Square. The building passed into the hands of the Royal Dublin Society (RDS) in 1815. The RDS, an agricultural and improving society, held lectures on various science and arts subjects for the education of the public.

The society erected a statue to Queen Victoria in 1908. The addition of this statue on the society's lawn came at a time when an increasing number of nationalist public monuments were appearing on the city's streets and public spaces, including the monument to Charles Stewart Parnell on O'Connell Street. The statue, by John Hughes, makes plain the allegiance of the RDS to the British union.

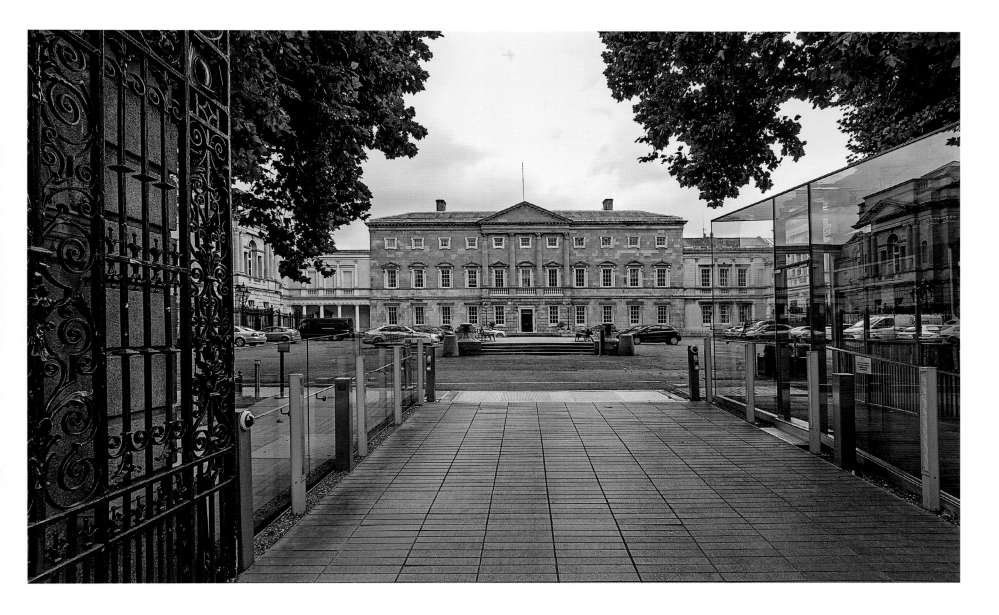

ABOVE: When the Irish Free State came into being in 1922, the new government needed a parliament building. The Mansion House had been used during the War of Independence, but it was inadequate for the needs of an expanded Dáil. Although many people advocated a return to the parliament house on College Green, this building was in use by Bank of Ireland as its headquarters. The bank did not want to give up its building. Rooms were rented from the RDS in Leinster House by the government in 1922, and the government decided to purchase the building outright in 1924. The RDS's lecture theatre became the Dáil chamber. The statue of Victoria in the new parliament's forecourt was problematic for the new nationalist government, with change the order of the day. In 1948, during Éamon de Valera's government, the statue was removed and put into storage. Nevertheless, some argued for the merits of the statue, and in 1986 it was gifted to the people of Australia. Today the statue stands outside a Sydney shopping mall.

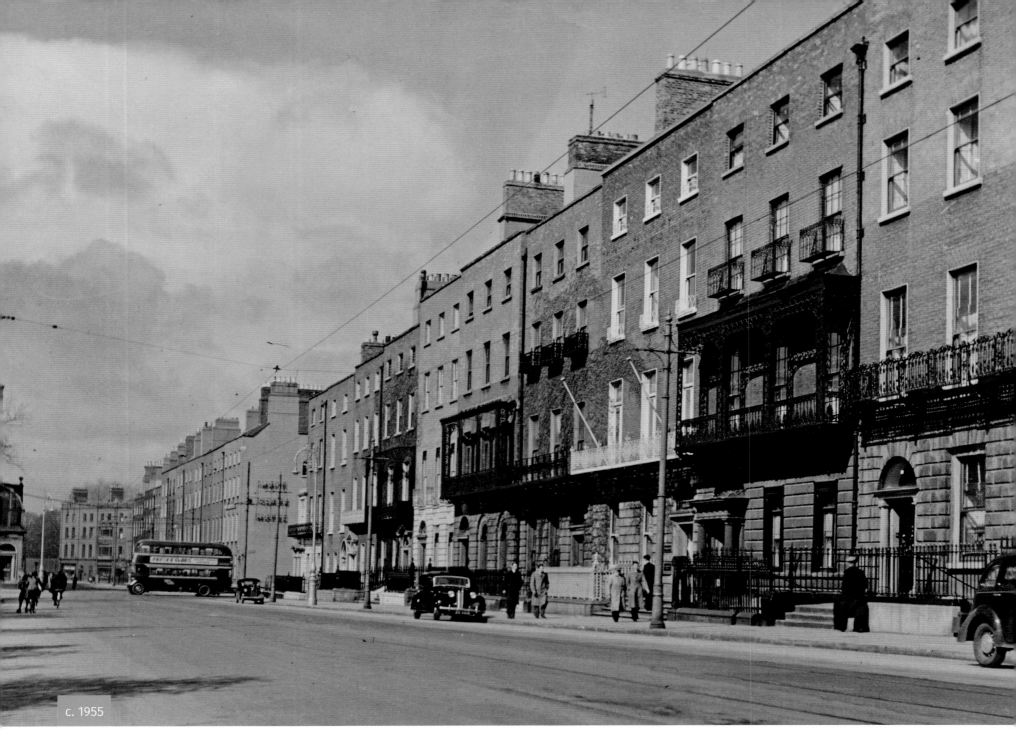

c. 1955

MERRION SQUARE

One of Dublin's best-preserved Georgian squares

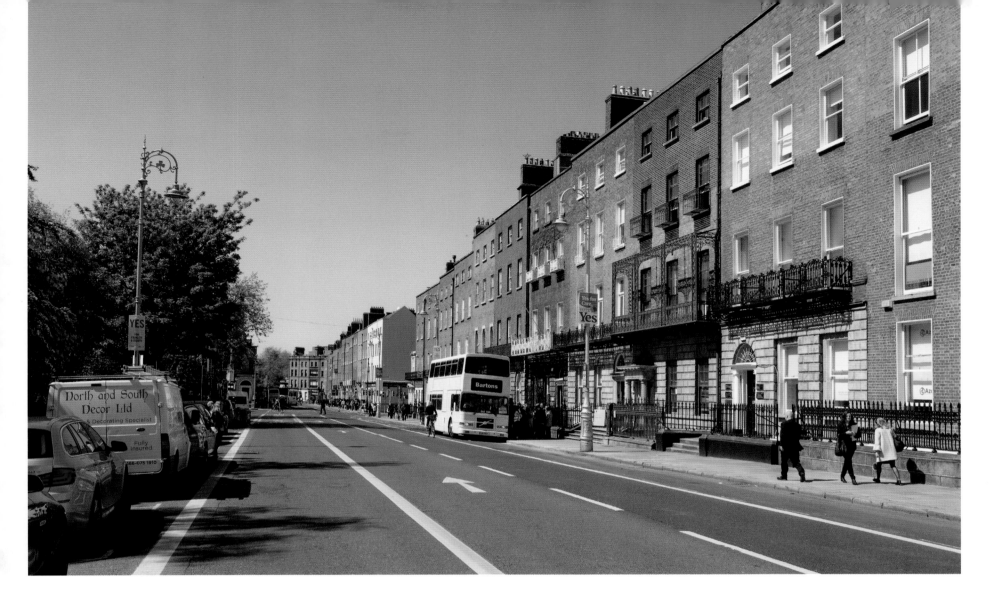

LEFT: In the 1740s, when the Earl of Kildare built his townhouse on the unfashionable southside of Dublin, he is said to have declared 'wherever I go, fashion will follow'. Merrion Square, the Georgian square laid out around his townhouse in the 1760s, became the heart of fashionable Dublin. Oscar Wilde lived at 1 Merrion Square, in a building visible in this photograph, just before the junction where the bus is emerging. Daniel O'Connell and W.B. Yeats lived on the south of the square, out of range of this image. The wrought-iron balconies were added in the late nineteenth century and early twentieth century during the visits of Queen Victoria and her son King Edward. These monarchs would have travelled through Merrion Square en route to their lodging in Phoenix Park. The balconies were built to allow a better view of the royal carriage as it passed. From the early twentieth century, the square was increasingly occupied by professional practices and offices, and in the 1950s, when this picture was taken, the square would have been busy with office workers coming and going.

ABOVE: The fact that Merrion Square continued to prosper after the Act of Union, unlike many of the northside's Georgian streets, means that the buildings are well-preserved and have retained much of their original interior and exterior features. Stucco plasterwork, room layout and original details such as locks and fanlights have been maintained. As such, Merrion Square is the finest Georgian square in the city. The architectural historian Christine Casey says that 'as streetscape', it 'is unequalled'. Although no longer a residential square, there are a number of significant institutions here, including the Royal Institute of the Architects of Ireland, the Irish Red Cross, the Keough Naughton Notre Dame Centre and the embassies of France and Slovakia. The square has retained its close association with Oscar Wilde, and there is a statue of the writer in the northwest corner of Merrion Square Park, facing on to his former home at 1 Merrion Square.

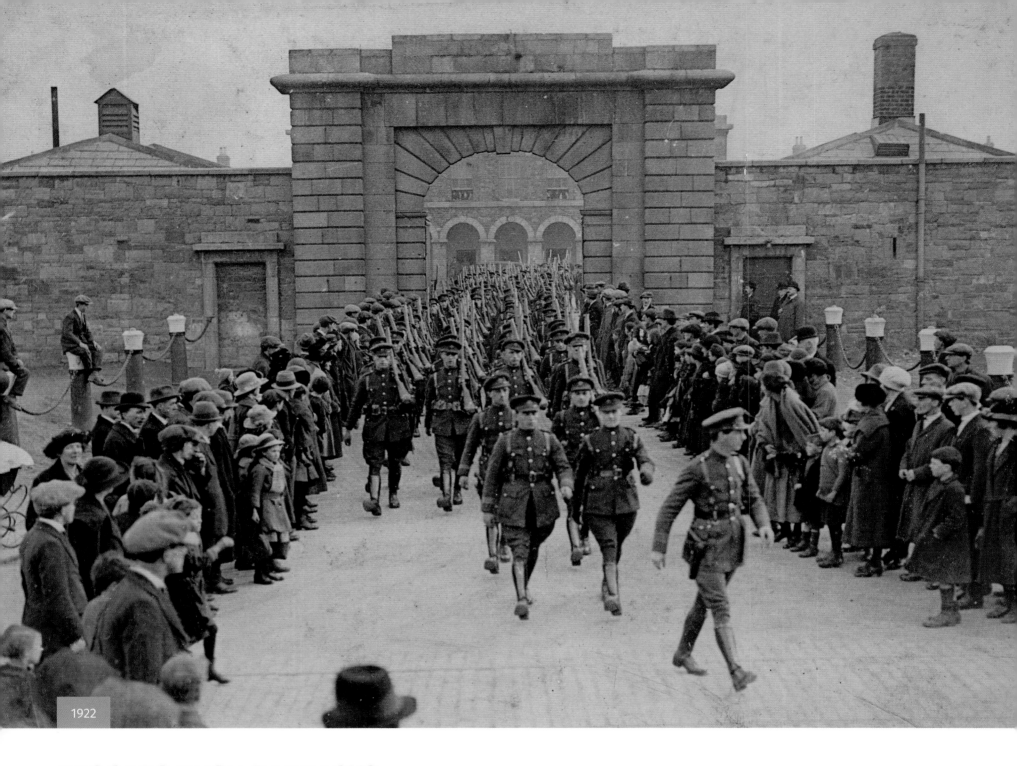

1922

BEGGARS BUSH BARRACKS

After high-profile executions during the Civil War, it was decomissioned in 1924

120

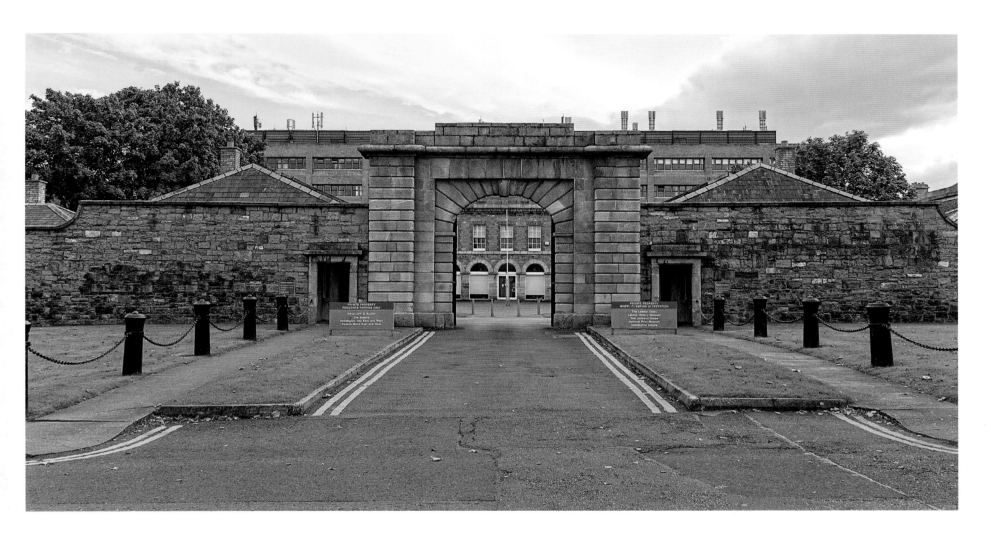

LEFT: Beggars Bush Barracks was established in 1827 as a military barracks on the edge of an expanding city. The barracks acted as a recruitment and training depot for members of the British army. Dublin was a poor city with an underemployed working class, and a soldier's wage was a good one and attracted many Dublin recruits. Over 200,000 Irish men fought in British uniforms during the Great War. On 31 January 1922 a number of military barracks were handed over by the British army to the new Free State army. This picture depicts the Free State army marching out of Beggars Bush Barracks to take up possession of one of the other military barracks in the city. The ceremony marked a new phase of autonomy, both military and political, for the Irish people.

ABOVE: Although the withdrawal of British troops seemed to indicate that Ireland could become peaceful, a minority of republicans rejected the agreement with Britain for denying them a full republic. The Irish Civil War that ensued, from June 1922 to May 1924, saw one-time friends and allies turn guns on each other. Beggars Bush Barracks, and many other barracks, remained in operation as military stations throughout this period. The Free State carried out a number of high-profile executions during the Civil War in Beggars Bush Barracks, including that of Erskine Childers (author of the novel *The Riddle of the Sands*). Childers was sentenced to death for possession of a gun, rumoured to have been gifted to him by Michael Collins during the War of Independence, and was executed in the barracks on 24 November 1922. The barracks was decommissioned in 1924 and is now home to a number of state offices, including the Labour Court.

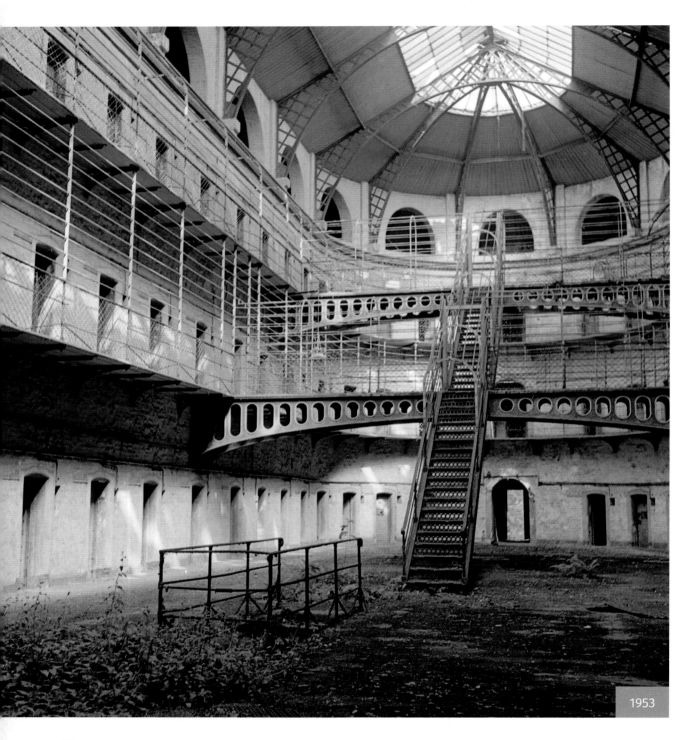

1953

KILMAINHAM GAOL
Now an important tourist destination

LEFT: Kilmainham Gaol opened as a prison in 1796. In the mid-nineteenth century the jail expanded, and the east wing, pictured here, was added. The prison is known as 'the Irish Bastille' for the large number of prominent political prisoners who have been incarcerated within its walls. The leaders of the 1916 Rising were executed in the prison grounds (executions took place at the entrance to the prison until the 1840s). Kilmainham Gaol was used by British forces throughout the War of Independence, but by the time of the Civil War it was used by the new Free State government and functioned as a women's prison. Five-hundred women were incarcerated in the jail between February and September 1923 for their part in the fight against the treaty. It was decommissioned as a prison in 1924 and fell into disrepair. Although some people argued that the prison was an important historical building and should be restored, others (notably some who had been imprisoned there) argued that it had been a weapon of the British government and should be torn down. By the 1950s, when this picture was taken, the prison was in poor condition.

RIGHT: Despite its unique links to the past, preservation of Kilmainham Gaol remained a difficult political decision. Successive governments discussed preserving the prison but nothing was done. This inaction prompted a Dublin engineer, Lorcan Leonard, to rally local Kilmainham residents into action. A provisional restoration committee of local volunteers was formed in 1959 and it produced a proposal for the government to take control of the building and carry out the necessary repairs. The plan was approved by government in February 1960, and the restoration work was undertaken by a large team of volunteers, who effectively saved the building. The newly preserved site opened in 1971 as a tourist destination and is one of the biggest heritage attractions in Dublin. The prison received additional government funding in the run-up to the centenary celebrations of the 1916 Rising. In 2016 Kilmainham's visitor centre expanded into the Kilmainham Courthouse to allow for the increased numbers of tourists who were visiting. With over 300,000 visitors each year, preservation of this exceptional link to Ireland's past is a big challenge.

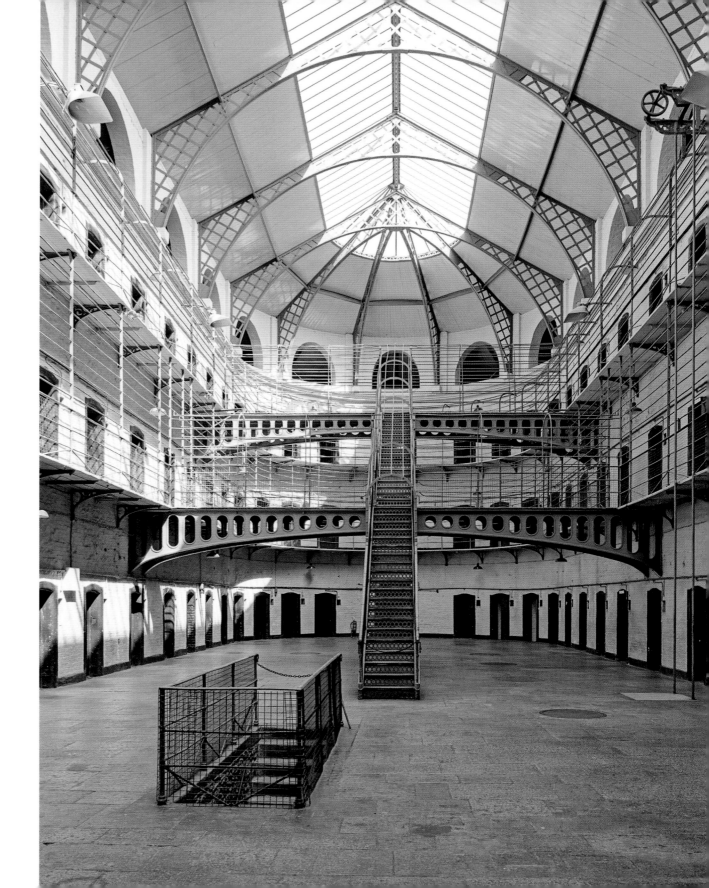

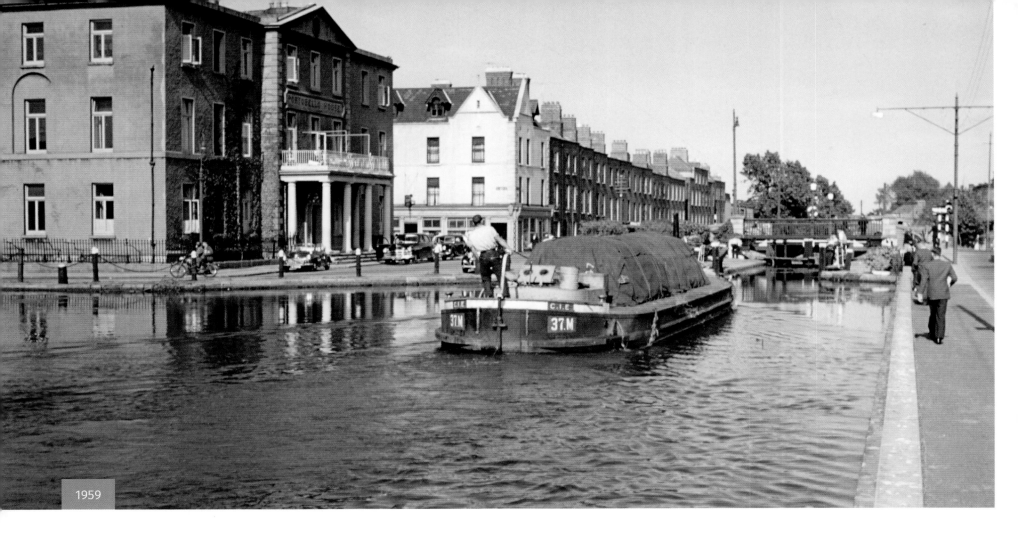

1959

GRAND CANAL, PORTOBELLO
Originally the canals marked the city boundary

ABOVE: Two canals run through the city: the Grand Canal and the Royal Canal.
Originally the canals marked the city boundaries: everything within the canals was
classified as Dublin city, whereas outside was classified as County Dublin. The purpose
of the Grand Canal was to connect the River Shannon (the longest river in Ireland) to
Dublin with a waterway that would allow goods and people to be transported through
Munster, Leinster and Connacht. Construction began on the Grand Canal in 1756,
and although the work continued in piecemeal fashion due to a shortage of funds, it
was completed in 1804. The canal was used for its original purpose of transporting
commercial goods well into the twentieth century. Both canals were particularly
important during the Emergency as barges could run on coal and other types of fuel
were in short supply. Portobello House, which can be seen on the left mid-ground of
this picture, was one of five hotels built on the Grand Canal in the early nineteenth
century for people travelling on the waterway.

1959

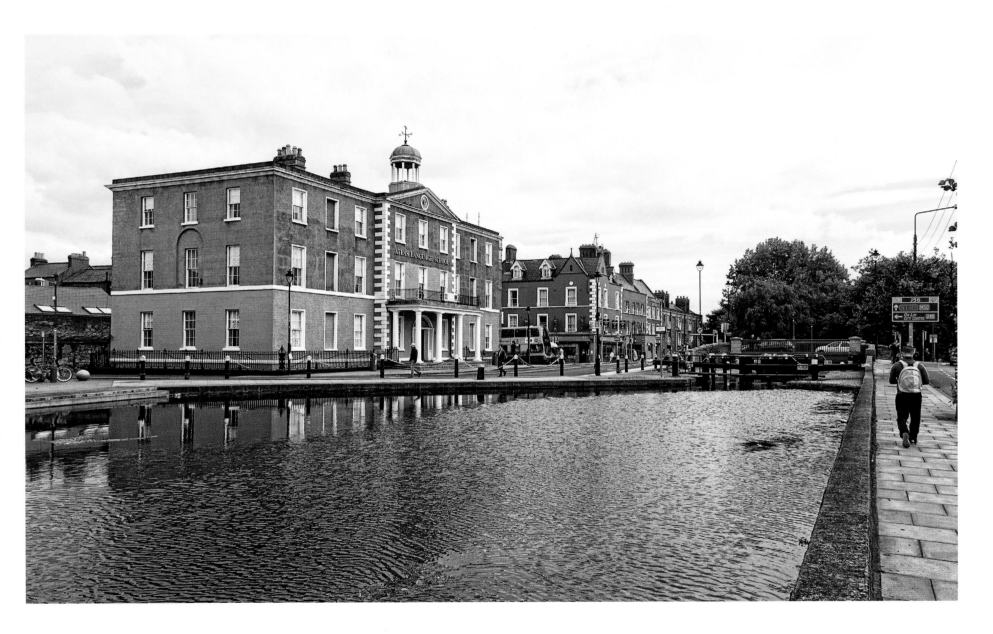

ABOVE: The canal network was used for the transportation of goods until 1960. Due to cheaper fuel and the progress of the motor car, road haulage companies took over the work of the barge. Irish canals were taken over by Córas Iompair Éireann (CIE), which in turn gave control of them to the Office of Public Works (OPW) in 1986. The canals were used for recreational purposes throughout this period. In 1999, under the Good Friday Agreement that helped to bring peace to Northern Ireland, Waterways Ireland was established. This body is one of only six all-island institutions and was set up to govern and maintain all inland navigable waterways used for recreational purposes across the island. The Grand Canal comes under this jurisdiction. Portobello House was taken over in 1989 by a private college before passing into the hands of Dublin Business School in 2009.

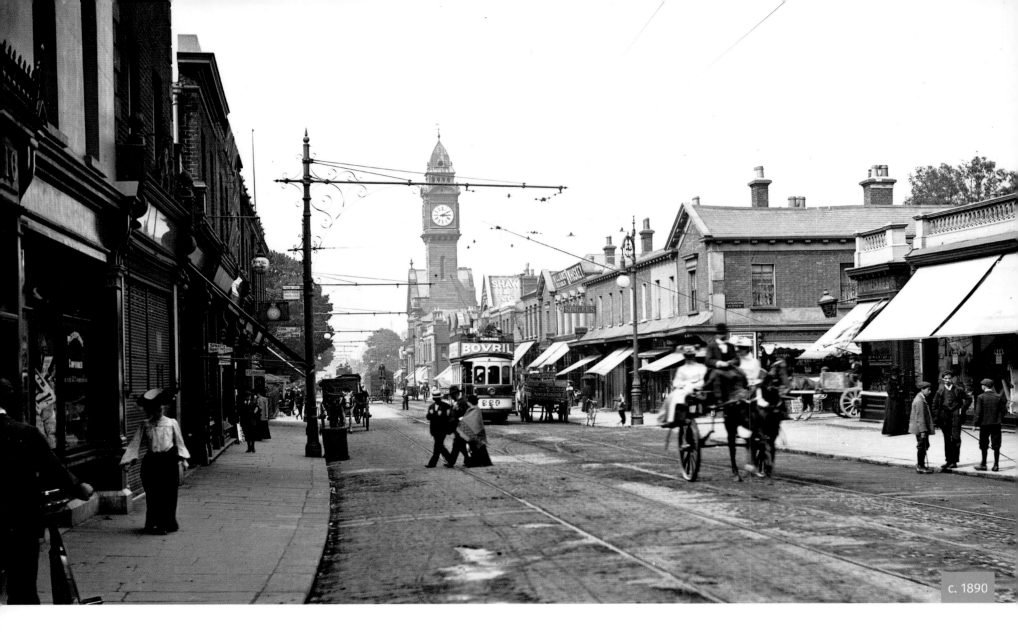

c. 1890

RATHMINES

A township developed as a middle-class suburb away from the city centre slums

ABOVE: Rathmines is one of several townships that developed beyond the city boundaries (just outside the canals) in the mid-nineteenth century. These suburban estates were developed to meet the needs of middle- and upper-middle-class people who were escaping the poverty, cramped conditions and unsanitary environment of the city centre. The majority of those who moved to these new suburban estates were Protestants. The economic historian Mary Daly has referred to this as 'the flight of the Protestant population' from a city where the majority were increasingly Catholic.

Trams, which can be seen in this picture, made this move more convenient and allowed workers quick, cheap and easy access to their workplaces in the city centre. Shops and services emerged to meet the demand of this expanding population, and this picture captures the busy commercial nature of the village. The clock tower in the centre marks Rathmines Town Hall and is a reminder of the autonomous nature of these suburbs, which had town councils and power to pass local by-laws.

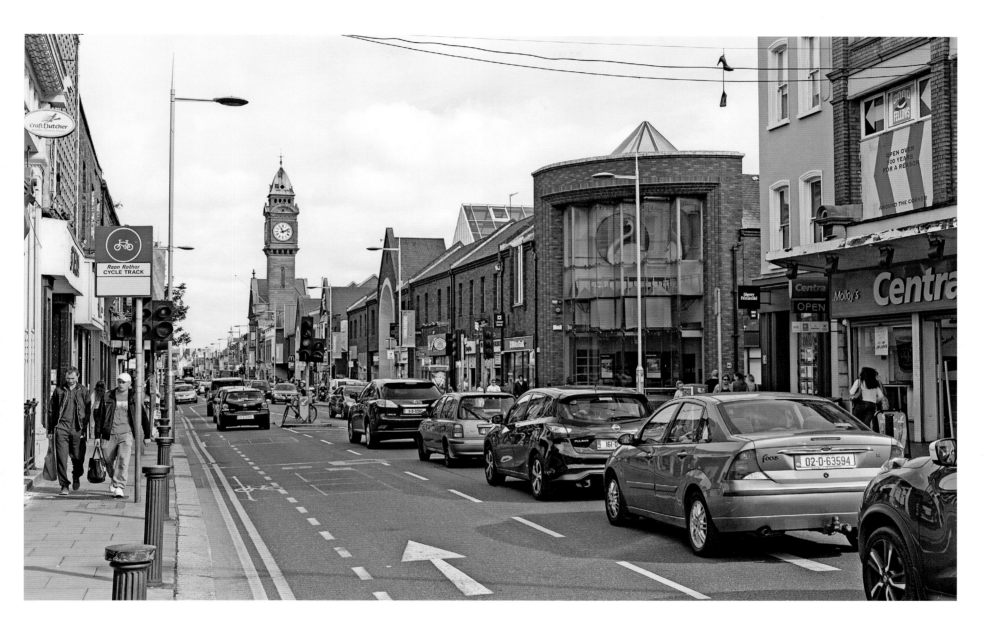

ABOVE: The township of Rathmines remained largely Protestant and unionist into the 1920s, although it produced some noteworthy nationalist figures. They include Dr Kathleen Lynn, Grace Gifford, Madeleine ffrench-Mullen and Cathal Brugha, chief of staff of the Irish Republican Army during the War of Independence. Rathmines has remained a thriving residential and commercial part of the city, although today the city boundaries have widened to include this suburb. In 1930 the Rathmines township was incorporated into Dublin Corporation. Its close proximity to the city centre and third-level institutes meant that the area remained a highly desirable address. From the mid-twentieth century, many of the Victorian houses were subdivided to take larger numbers of tenants, and by the 1990s the area became known as 'flatland'.

c. 1910

SANDYCOVE MARTELLO TOWER
Built to protect Dublin from the Napoleonic threat

LEFT: France posed a significant security threat to the British government in Ireland in the late eighteenth century. The French had attempted to land a force of 15,000 men at Bantry Bay, County Cork, in 1796 and had succeeded in landing a force at Killala, County Mayo, in 1798 (although that force was quickly defeated). During the Napoleonic Wars the British government was concerned with a threat to the Irish and British coastlines and in 1804 began constructing Martello Towers along Ireland's south and east coast and the southeast coast of England. Fifty towers in all were built, stretching from Cork Harbour to Millmount in County Louth. The towers were similar in design, about 40 feet high, round, and with walls that were about eight feet thick. This tower at Sandycove is one of sixteen forts built on the Dublin coastline, a particularly high density of towers and a reminder of the importance of keeping the capital protected. Sandycove Martello is the most famous of the towers because of its connection to James Joyce, who spent six nights sleeping in the tower in 1904.

ABOVE: Although Joyce slept in the tower in 1904, it would not become famous until the publication of *Ulysses* in 1922. The novel opens in Sandycove Martello Tower on 16 June 1904, and an argument between Buck Mulligan and one of the book's principal characters, Stephen Dedalus (considered to be something of an alter ego of Joyce). Dedalus decides he will not return to the tower and sets off on a day around the city and seeks a place to stay for the night. In 1954 a number of Dublin intellectuals retraced the fictional steps of Dedalus and Leopold Bloom (the other central character) around the city to mark Bloomsday, starting at this Martello Tower and making their way into the city centre. In 1962 the tower opened as a museum to James Joyce, allowing visitors to step back in time and see what living in the tower would have been like in 1904.

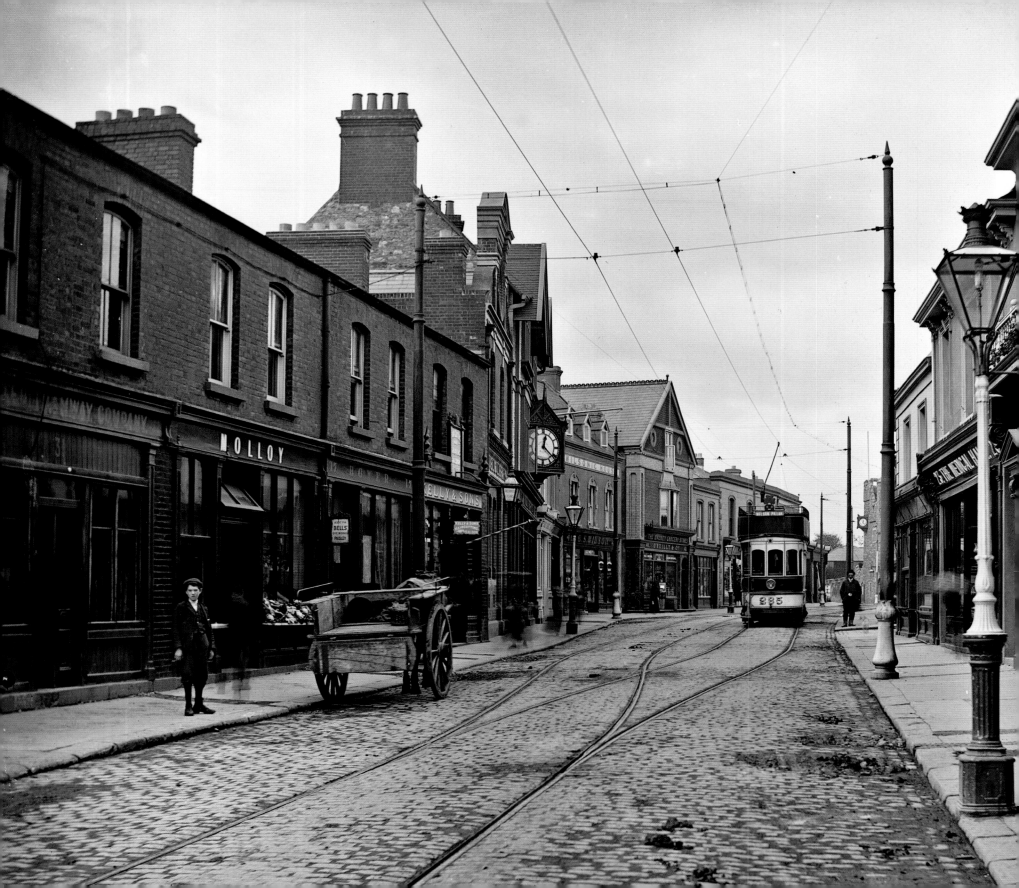

1910

CASTLE STREET, DALKEY
Dalkey is home to many Irish celebrities

LEFT: The south County Dublin seaside village of Dalkey dates from the middle ages. The village remained semi-autonomous and elected its own 'King of Dalkey' into the eighteenth century. This picture shows Castle Street (although the castle is out of shot), which was the main commercial street in the village. Dalkey's tram stop opened in 1879, with trams running the fifteen kilometres from the village to Nelson's Pillar. The tram line made Dalkey accessible and people could travel to and from there in one day with hours to spare. The village became a thriving seaside destination for people who lived in the city centre and its suburbs. The expansion of tram lines meant Dubliners could take greater advantage of their one day off a week (Sunday) to move outside the city and enjoy themselves. The advertisement for 'tea and wine rooms', which can be seen in the far-right foreground of this picture, is indicative of some of the luxuries the village provided for these tourists.

ABOVE: Little seems to have changed on Castle Street over the past century. Shops and businesses remain the dominant occupants on the street. The village remains a quiet suburban town and tourist destination. Dalkey is now one of the wealthiest addresses in Dublin, and a number of Irish celebrities call the village home. They include Bono, Enya and Van Morrison. The writers Maeve Binchy and Hugh Leonard lived in the area, and TV and radio presenters Pat Kenny and Ryan Tubridy also live nearby. The last tram ran from Nelson's Pillar to Dalkey on 9 July 1949, and the main street is now dominated by cars instead. Tourists to the village can enjoy Dalkey Castle and Heritage Centre, the Writers' Gallery and the tenth-century St Begnet's Church and graveyard.

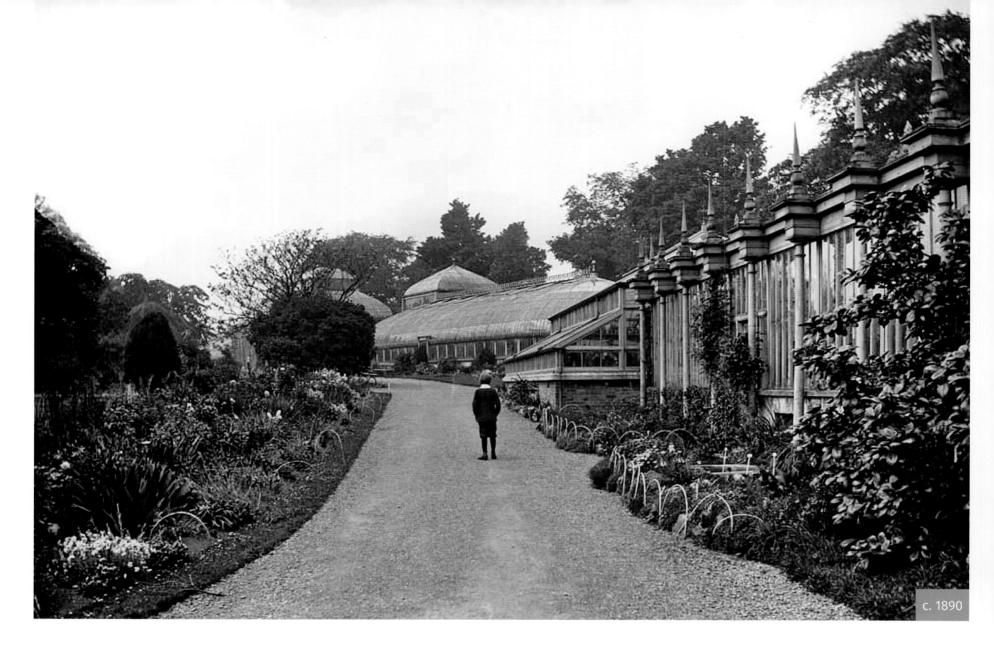

c. 1890

THE NATIONAL BOTANIC GARDENS OF IRELAND

A site of horticultural research and home of the National Herbarium

ABOVE: The Botanic Gardens were founded by the Dublin Society in 1795 to promote scientific learning and to promote better practice in Irish agriculture and horticulture. There was an emphasis on the scientific and agricultural in its early years, but the Botanic Gardens also collected interesting or beautiful plants to forward the knowledge of botany in Ireland. In 1795 a suitably large site of 48 acres was found in Glasnevin and was bought for £1,800. In 1843 £5,000 was spent on erecting new greenhouses, one of which can be seen in this picture. The gardens were open to the public and became an important public space for Victorian Dubliners seeking to escape the city and suburbs and take in the fresh air and open spaces which the gardens offered. In 1861, when the Dublin Society first decided to open the gardens on a Sunday, a record-breaking 15,000 people visited.

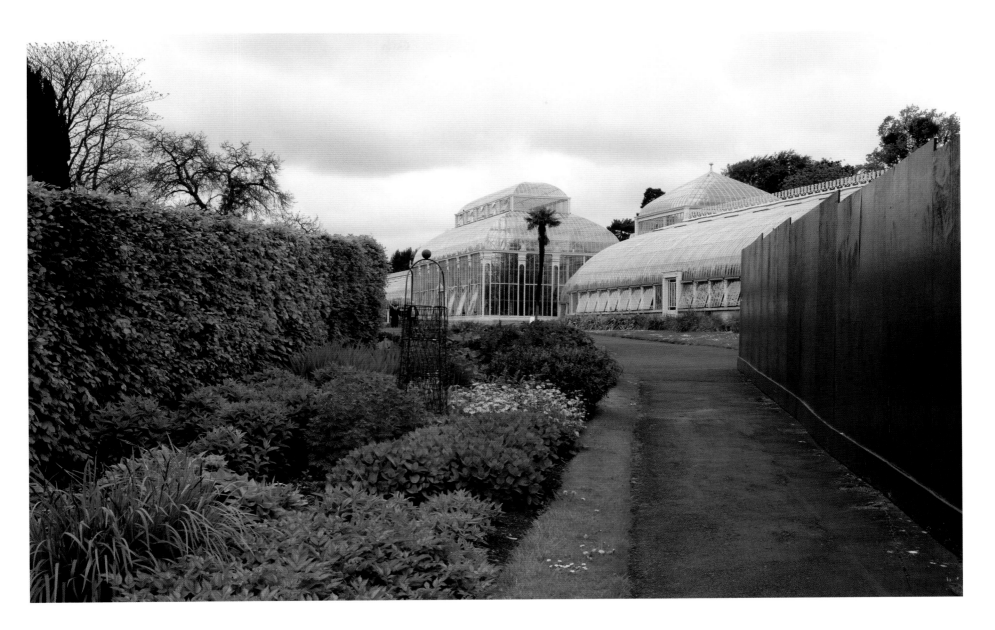

ABOVE: The Botanic Gardens were handed into state care in 1878 and now come under the jurisdiction of the Office of Public Works (OPW). The gardens have remained a tourist destination and are also now a centre for horticulture research and training. Ireland's National Herbarium is on site and its collection contains over 20,000 specimens. The Botanic Gardens' collection of orchids, which dates from the nineteenth century, is particularly important. The Botanic Gardens remain a popular visitor attraction for Dubliners looking for calm. The facilities have expanded, and a visitor centre with a lecture theatre and exhibition space was opened in 2002. The Victorian greenhouses are of architectural significance and they underwent extensive restoration in 2003. In April 2013 a gate was opened between the gardens and the adjoining Glasnevin Cemetery, creating the second-largest green space in the city, after Phoenix Park.

1891

GRAVE OF THE IRISH CHIEF.
GLASNEVIN CEMETERY.

GLASNEVIN CEMETERY
Dublin's most prominent cemetery and resting place of major republican figures

LEFT: Glasnevin Cemetery opened to the public in 1832 after a campaign by Daniel O'Connell for a multidenominational cemetery that would allow both Catholic and Protestant graveside prayers. The cemetery was laid out in the fashion of the day, as a garden cemetery. These Victorian cemeteries sought to create an atmosphere of rest and peace, surrounded by nature. O'Connell was posthumously thanked for his part in helping to found the cemetery by being buried under the round tower, which can be seen in the left background of this photo. After O'Connell's burial in 1848, the cemetery became the fashionable place for important political figures to be buried. This photograph was taken shortly after the death and burial in 1891 of Charles Stewart Parnell, land reformer and leader of the Home Rule movement. Although the Home Rule movement was divided on the death of Parnell, he remained a hugely popular and influential figure and this is reflected in the size of his plot and the large number of flowers on his grave.

RIGHT: Glasnevin Cemetery is said to have over one million Dubliners buried within its walls today. The tradition of burying nationalist and republican figures continued right through the twentieth century. The republican leader Thomas Ashe, who died on hunger strike in 1917, was interred in the cemetery. Michael Collins and Arthur Griffith, signatories of the Anglo-Irish Treaty and early leaders of the Free State, were also buried in the cemetery. Although executed in London, Roger Casement was reinterred in the cemetery in 1965. Parnell's grave is the largest of these political plots and remains a much-visited pilgrimage. The Glasnevin Cemetery Museum and Visitor Centre was opened in 2010 and provides guided tours and genealogical assistance. The graveyard is unique as a heritage attraction as it is still operational as a cemetery. The crematorium that was added in 1982 was the first in Ireland.

1924

CROKE PARK
Still one of the largest stadiums in Europe

ABOVE: In 1908 Frank Dineen, a former GAA President, purchased Croke Park for £3,500 in trust for the Gaelic Athletic Association who bought it from him in 1913. It was named Croke Park after Archbishop Thomas Croke and is colloquially known as 'Croker'. The stadium became the venue for the Gaelic football and hurling All-Ireland finals each year. These indigenous sports date from the middle ages, and in the nineteenth and twentieth centuries Irish emigrants carried them far and wide around the world. Gaelic football had a heavy influence on Australian Rules football, and hurling

clubs were established in London and New York. The Hogan Stand, pictured here, was opened in 1924 to seat sports fans attending the Aonach Tailteann Games, a sort of Gaelic version of the Olympic Games featuring teams from the 'Celtic' world—including Scotland, Wales, Brittany, Canada and America—competing in Irish sports. This event ran until 1932 and then petered out. The stand is named after Michael Hogan, one of sixteen civilians killed in November 1920 when the Black and Tans opened fire on the crowd on what came to be known as Bloody Sunday.

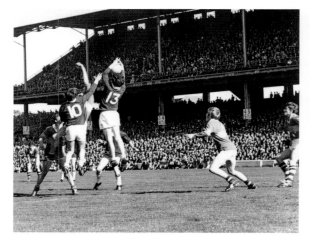

ABOVE: In 1959, to mark the 75th anniversary of the foundation of the GAA, a New Hogan Stand was opened. Croke Park is the largest sporting venue in Ireland to this day, and although the GAA is an amateur sporting organisation, it remains at the forefront of Irish sport. The Celtic connection to the sports has remained strong, and at the outset the GAA did not allow their members to play 'foreign' games, including rugby and soccer. As a consequence, these games were not historically played within the stadium. This changed, however, in 2005. The closure of Lansdowne Road for renovation meant that Irish rugby had no home for international matches. In that year Croke Park opened its doors first to rugby and later to soccer. As well as being used for sports, the stadium is also occasionally used as a concert venue. A GAA museum is attached to the stadium.

1941

NORTH STRAND

The Luftwaffe claimed that the bombing of Dublin was an accident

1941

LEFT AND ABOVE: The North Strand is a suburban road that stretches across the Dublin 1 and Dublin 3 area of the city. Despite Ireland's neutrality it was bombed by the Luftwaffe during World War II. Irish neutrality leaned heavily in favour of the Allies, however, and the government provided resources and information to Allied forces. German bombs were dropped on parts of Dublin and other parts of the state during the war, but it was claimed by the Reich that these were due to pilots losing their way and being distracted by the lights of the Irish capital (Britain was in blackout). On the night of 31 May 1941, the first fatal bombing within Dublin occurred when bombs were dropped on the northside of the city. One bomb damaged Áras an Uachtaráin, the residence of the Irish president in Phoenix Park, and other bombs were dropped on North Strand. Twenty-eight civilians were killed, ninety were wounded and 300 houses, some of which can be seen here, were destroyed in the attack.

ABOVE: Many people believed the North Strand bombing was in reprisal for assistance the Irish government had given during the Belfast blitz and an attempt to draw the Irish government into the war. In June 1941 the German government accepted responsibility for the bombing, claimed is was an error and promised compensation. Those who lost their homes were initially taken in by the Red Cross and were later rehoused in council houses in Cabra and Crumlin. Although the North Strand bombing saw the last fatalities of the Emergency period in Ireland, two more sets of bombs were dropped in the state before the end of the second world war. As a result £9,000 in compensation was paid to the state in 1943. North Strand remains a busy residential area. A plaque was erected at Charleville Mall Library to the victims on the sixtieth anniversary of the bombing.

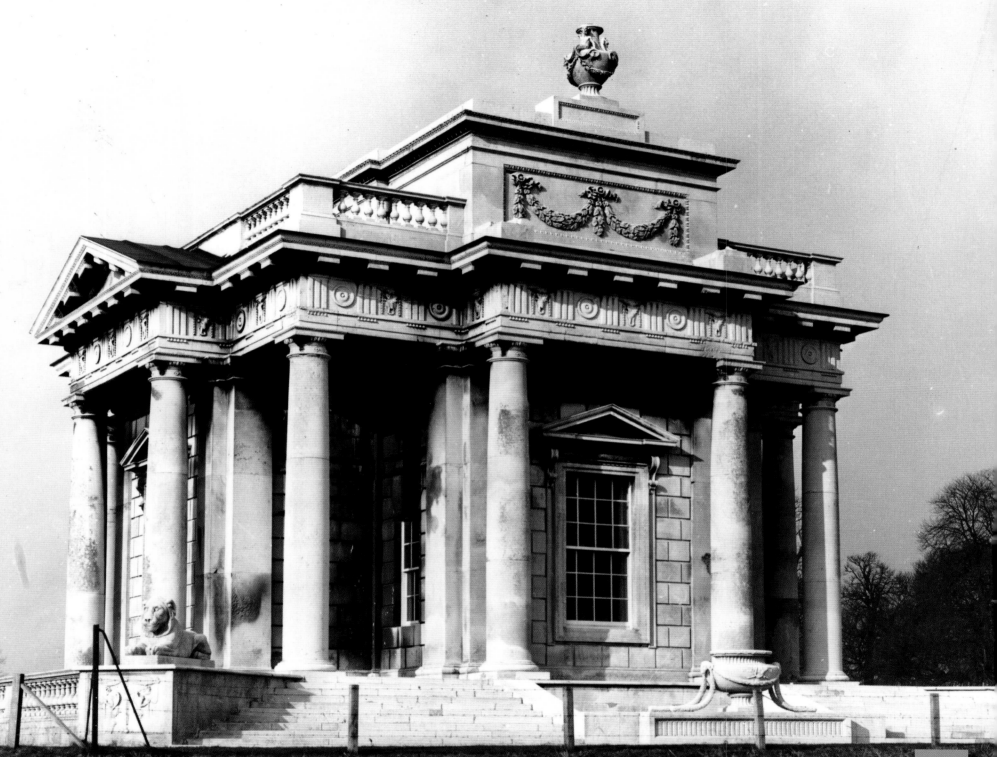

c. 1910

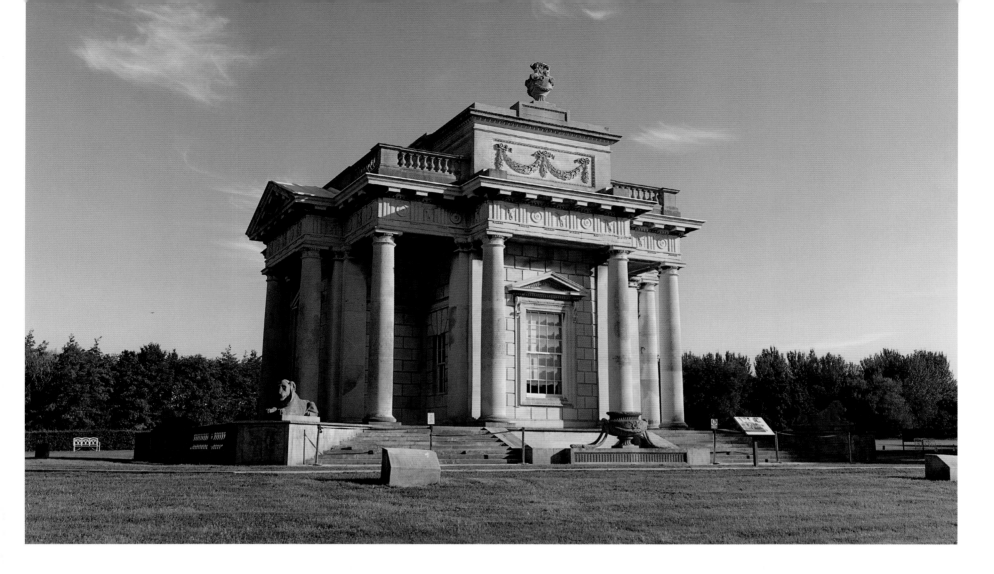

THE CASINO AT MARINO
A deceptively scaled building with three floors and sixteen rooms

LEFT: The Casino at Marino has been hailed as the most important neoclassical building in Ireland. It was designed by Sir William Chambers as a garden house for the Marino estate of James Caulfield, the Earl of Charlemont. After undertaking a nine-year grand tour of Europe, Caulfield returned home. He had been hugely influenced by European fashion, art and architecture during his time away. The building was begun in 1755 and completed in the mid-1770s. It is particularly deceptive in size and scale. It is laid out in the shape of a Greek cross and appears from the outside to be just one room. In fact there are three floors and sixteen rooms inside. The building plays with your perceptions throughout. Four of the neoclassical columns act as drains for rainwater, and the Roman urns on top of the building are actually chimneys. The name of the house comes from the Italian *casa*, meaning 'little house'.

ABOVE: After the Charlemont estate was sold in 1881, the Casino was neglected and fell into poor condition. Under the 1930 National Monuments Act, legal provision was made for the protection and preservation of built heritage. The Casino was acquired by the state and came under the jurisdiction of the Office of Public Works. The building was suffering from dry rot, while many of the architectural features and stucco work had been stolen, and the roof was close to collapse. The building was patched up, but it did not undergo a complete restoration until the 1970s. After this ten-year project, the Casino was opened to the public in 1984 and can be visited today. It is one of the most architecturally significant buildings in Ireland.

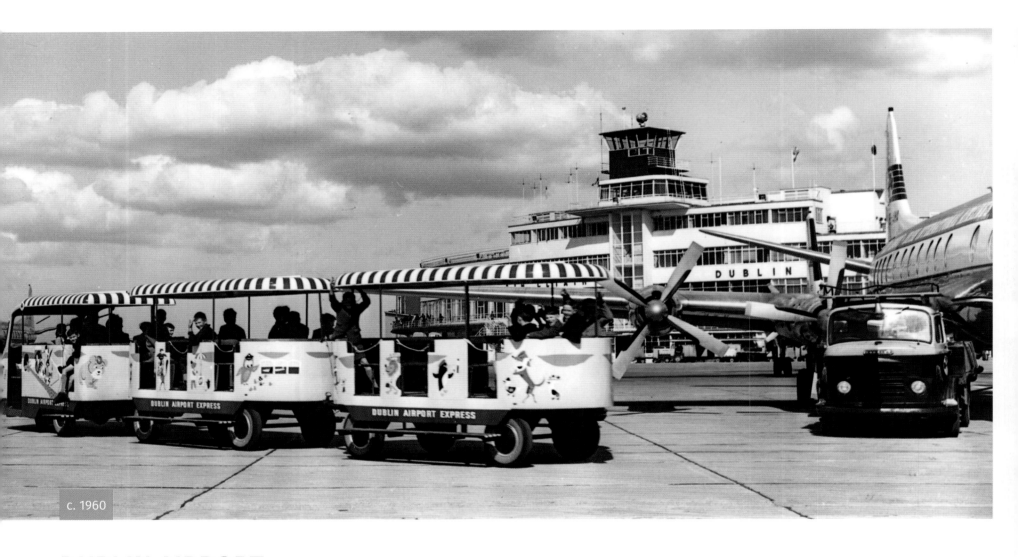

c. 1960

DUBLIN AIRPORT

The airport opened with a daily scheduled service to Liverpool

ABOVE: Aviation began to take off in Ireland in the years after the Great War. In the 1930s the government supported the fledgling industry by financing the building of an airport terminal at Collinstown in County Dublin. The terminal opened in 1937 and was one of the most important public buildings erected by the young state. The building, designed by Desmond FitzGerald (brother to the politician Garret FitzGerald) and his company of architects, was curved and designed to be reminiscent of an ocean liner. The building included open balconies for the public to watch aircraft arrive and depart, a reflection of how novel aviation was in 1930s Ireland. There was so much interest in the building that, for a period after its opening, dances were held there. The building won many awards. The first flight left Dublin Airport on 19 January 1940. The airport initially had only one route, operating daily flights to Liverpool. However, even that service was cut back during World War II as flights to Liverpool were reduced to just two a week.

ABOVE: Aviation began to expand slowly in Ireland after the war. Between 1948 and 1950 new concrete runways were added. It is estimated that in the first ten years 920,000 passengers passed through the airport. By the late 1950s an expanding economy and increased tourism necessitated a new terminal. The north terminal building was added to deal with arrivals while the original terminal became the place for departures. Passenger traffic continued to grow and in 1972 a new terminal (now known as Terminal 1) was opened at a cost of £10 million. This terminal saw a huge increase in aviation traffic, particularly from the 1990s, when the privately owned airline Ryanair and the then state-owned airline Aer Lingus increased their routes. The new terminal grew around the original terminal and almost encases this historic building. The expanding Celtic Tiger economy also facilitated this growth. In 2010 Terminal 2 was opened with a capacity for thirty million passengers a year.

INDEX

OTHER TITLES AVAILABLE

ISBN 9781910496954

ISBN 9781910904787

ISBN 9781910496947

ISBN 9781910904114

ISBN 9781910904053

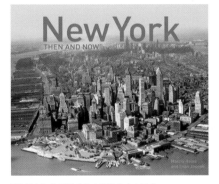

ISBN 9781910904121

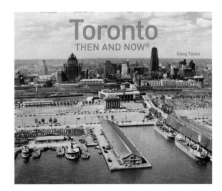

ISBN 9781910904077

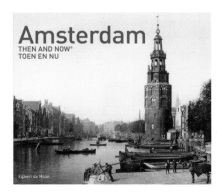

ISBN 9781910904855

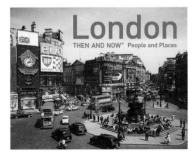

400 pages - smaller format
ISBN 9781910904404